To: Steven with
love at Xmas
from
Mary + Tom.

THE FLAME
AND
THE LOTUS

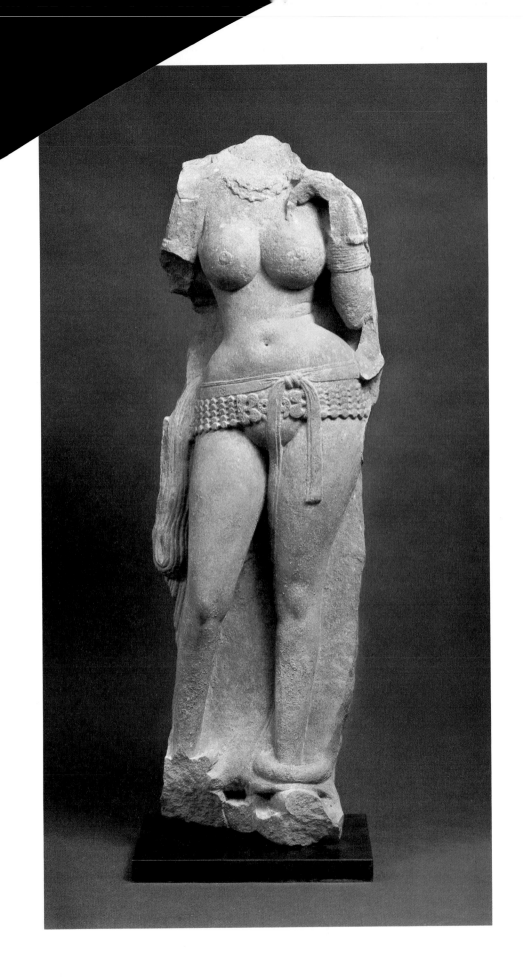

THE FLAME AND THE LOTUS

Indian and Southeast Asian Art
from The Kronos Collections

Martin Lerner

The Metropolitan Museum of Art, New York
Harry N. Abrams, Inc., Publishers, New York

This book was published in connection with an
exhibition at The Metropolitan Museum of Art, New
York, from September 20, 1984, to March 3, 1985.

Photographs by Peter Johnson

Published by
The Metropolitan Museum of Art, New York
Bradford D. Kelleher, Publisher
John P. O'Neill, Editor in Chief
Joan Holt, Project Manager
Sue Potter, Editor
Michael Shroyer, Designer

Copyright © 1984 The Metropolitan Museum of Art
Library of Congress Cataloging in Publication Data
Lerner, Martin.
The Flame and the lotus.
Bibliography: p. 185
Includes index.
1. Art, India—Exhibitions.
2. Art, Southeast Asian—Exhibitions.
3. Art—Private collections—Exhibitions.
4. Metropolitan Museum of Art (New York, N.Y.)—Exhibitions.
I. Metropolitan Museum of Art (New York, N.Y.) II. Title.
N7301.L45 1984 709'.54'07401471 84-10810
ISBN 0-87099-374-7
ISBN 0-87099-401-8 (pbk.) ISBN 0-8109-0935-9 (HNA)

Jacket illustration: Seated Buddha, Sri Lanka, Anuradhapura style,
ca. 7th century (No. 13)

Frontispiece: Standing *Yakshi*, India, Mathura, Kushan period,
2nd–3rd century (No. 8)

Contents

Director's Foreword 6

Collector's Note 7

Acknowledgments 8

Introduction 9

Maps 12

Catalogue 15

Selected Bibliography 185

List of Works of Art 189

Director's Foreword

Until recent years Indian and Southeast Asian art has been poorly represented in the Museum's collections, not through any deliberate policy of neglect but rather through passivity fostered by insufficient public interest in this field. Historically, Indian and Southeast Asian art has not been the highest priority of the Department of Far Eastern Art. Since the appointment of Martin Lerner as curator, however, this area of collecting has had a strong advocate on the Museum's staff. As museums are in effect a palimpsest of successive curatorial biases, it was inevitable that the imbalance would eventually be redressed, and over the past ten years we have accomplished a great deal toward strengthening our holdings of Indian and Southeast Asian art. We have been strongly supported in our efforts by an enthusiastic public response and, no less significantly, by a dedicated group of collectors, connoisseurs, and generous donors.

The Kronos collection of Indian and Southeast Asian art, formed in a relatively short period, is a model of what can still be accomplished in this field. Keen judgment, sensitivity, and a good eye have shaped a collection of uncommonly high quality and of surprisingly broad range. Those responsible for creating the collection have been most generous in sharing their treasures, and I am happy to have this opportunity to express my gratitude for the significant gifts made to the Metropolitan from the Kronos Collections over the last few years. These gifts have not only markedly enriched the Museum's holdings but they have also, most notably in several instances where the objects are both beautiful and unique, advanced our knowledge of the Asian civilizations they represent.

We are pleased to reaffirm the Metropolitan's commitment to Indian and Southeast Asian art and to pay tribute to all those who have worked to promote the field, particularly Martin Lerner for his untiring and catalyzing efforts both within the Museum and outside of it. We hope this exhibition will engender further interest in the great artistic traditions of India and Southeast Asia, which deserve a place of pride beside the art of the other civilizations represented in the Metropolitan's collections.

Philippe de Montebello
Director
The Metropolitan Museum of Art

Collector's Note

Some collections are planned, others, by chance or accident, merely evolve. Asian art has long held a special appeal for me. When I was very young I was fascinated by the magnificent Asian galleries at the Museum of Fine Arts in Boston, and at Yale University I studied the history of both Far Eastern art and Buddhism. But it was not until the late 1970s that I began to form this collection, which is now being exhibited for the first time.

I have sought objects that quintessentially express the ethos of the Eastern civilizations represented here. Over and over, I have been led away from the later, more stylized traditions and drawn to works of art that manifest the intense spirituality of the early periods in the history of these cultures. An immediacy of impact, combined with an unusual refinement of execution in which even the smallest details speak poignantly, has always made a sculpture or painting irresistible to me. This exhibition therefore represents a specific attitude toward collecting, and toward art.

Collections are not merely assemblies; bringing art together creates an entirely new context that cannot help but alter the way in which it is perceived. The early Sinhalese Buddha (No. 13) and the Burmese Buddha (No. 24), seen separately, are unmistakably fine works of art. Set side by side, they are also a striking lesson in how wide and varied a range of expression and mood could be evoked by a canonical image produced in two different cultures. These objects play off one another, inviting new connections and comparisons, stimulating new paths of inquiry, while at the same time they reveal the collector's viewpoint and insights.

Collecting is also not simply finding objects; one of its greatest joys is being able to recognize the qualities that make something unique. The Andhra gold earrings (No. 2) are a case in point. At first, I was shown only one of them, as the original pair had been split. While the approximate date of manufacture could be surmised, no one was certain of what these objects were, for nothing like them was known. I thought both the conception and the craftsmanship of the one I had seen so startling and marvelous that my main concern was to reunite the pair. When I was finally able to do so, two did indeed prove more enlightening than one. I was able to show that these were in fact an extraordinary pair of earrings and to discover their probable historical context.

In the final analysis, however, if this collection has a focus, it is an aesthetic one. These objects have not been chosen purely for their historical or stylistic importance. Above all else, they were assembled to be enjoyed. And I am particularly pleased that they are being exhibited at the Metropolitan at a time when the Museum is working so assiduously toward the development and installation of its Indian and Southeast Asian collections.

I would like to express my thanks to Martin Lerner for his advice and counsel on the formation of the collection, as well as for his excellent catalogue of the exhibition. I have learned a great deal from him. His love and enthusiasm for the field is informed not only by encyclopedic knowledge, but also by a rare sensibility. I would also like to thank my family, whose shared enthusiasm and support have made the Kronos Collections possible.

Steven M. Kossak
New York, 1984

Acknowledgments

I would like to record my indebtedness and gratitude to the following people who were so crucial to this catalogue: Philippe de Montebello, the Director, whose love for this field has provided the encouragement for this exhibition; Carol Cardon, for her efficient coordinating skills; Dick Stone and James Frantz of the Museum's Objects Conservation Department, for patiently sharing with me their extensive knowledge of materials and techniques; Nina Sweet and Tasia Pavalis of the Department of Far Eastern Art, for the long hours they spent typing the manuscript; Joan Holt of the Editorial Department, for her good sense in overseeing the development of the catalogue; Sue Potter, the editor, for her skill and judicious taming of my usually flamboyant prose; and Peter Johnson, for photographs that to my eye are of a quality and sensitivity rarely encountered in publications of this type. And finally, my thanks go to Steven M. Kossak and his family, without whom there would be no Kronos Collections.

Martin Lerner

Introduction

The history of collecting in the field of Indian and Southeast Asian art, with few exceptions, has not been particularly rich or rewarding in the metropolitan New York area. Before and during the Second World War, at the time of the formation of the great collections of Chinese art, there was little interest in the arts of South Asia. During the late 1940s, the collections of South Asian art at local public institutions, accumulated mostly through bequest rather than through any purposeful acquisition policies, were modest in both quality and scope. The Metropolitan Museum of Art, for example, could by 1955 take considerable pride in its excellent Chinese collection, which, with the exception of paintings, was almost synoptic in scope, and its fine Japanese collection, though not as large, was also of considerable importance. In contrast, the small Indian and Southeast Asian collection, containing only a handful of masterpieces, could best be described as in a nascent stage of development.

In that atmosphere of benign neglect, a few committed dealers and enlightened collectors—perhaps a half dozen of the former and probably even fewer of the latter—labored to elevate interest in these areas. That such a small group should have been the proverbial keepers of the flame for such an enormous part of the artistic legacy of mankind is indeed remarkable. By collecting in fields that brought little social recognition, that taxed the intellect and required a fresh aesthetic perspective, they set themselves apart as men of vision and courageous taste.

What was once considered exotic and at times bizarre is now intellectually more understandable and aesthetically more approachable. In the New York area, in particular, our understanding of India and the rest of South Asia is now continually enhanced by exhibitions, films, literature, theater and dance, and, not least of all, by food. That the logical result of the early collectors' endeavors and their love affair with South Asian art has been a greater public awareness of the history and culture of South Asian nations, along with an increase in collecting activity, is not surprising. What is surprising is that the change was so long in coming.

The Kronos collection of Indian and Southeast Asian art stands unquestionably in the front rank of the newer generation of collections. It has been assembled with the primary purpose of exemplifying the apex of the artistic traditions of the cultures of South Asia, and was never envisioned as an attempt to include a representative example of every major art historical period. Its scope, like any other collection's, was limited by the available material and the unpredictability of the art market, but this collection has been more than usually responsive to the opportunities of the specific moment. There has been a boldness in its formation that could only have come from a confident collector with a highly developed eye, refined taste, and a keen sensitivity to objects.

As with any collection, certain prejudices can be discerned. A decided preference for schools of art in their earlier phases of evolution and development has directed the collection toward works

whose religious intensity strongly resonates across the centuries. There is nothing particularly arcane in this, it is simply an irresistible quality in some sculptures and paintings. There has also been a particular emphasis on the small object of refined craftsmanship. The many exquisite small sculptures demonstrate the collector's understanding that size is not a measure of quality, that small objects can convey a sculptural presence and radiate a grandeur greatly in excess of their physical dimensions. The extraordinary range of shapes and forms varies from the most basic, nearly two-dimensional objects (No. 1, for example) to others of almost extroverted complexity (No. 48); but no matter how simple or complex, all are examples whose forms are arranged intelligently and harmoniously, and all are crafted with consummate skill.

While the collection is a compendium of rare and fascinating objects, the common denominator throughout is quality, and sculptures and paintings are included because they are aesthetically superior works of art. But this is not merely a one-dimensional assemblage of aesthetic delights. More important, it is a collection of the highest quality that both instructs and, because of some of the remarkable objects it includes, provides a catalyst for charting new courses for future art historical studies. The collection also reflects an awareness that quality is not restricted to the obviously beautiful. Though some of the sculptures are certainly that, others are possessed of such an intense spirituality and profound dignity that aesthetic considerations become secondary. Despite a

certain unfamiliarity with names and iconography, many of these paintings and sculptures have about them the sense of total appropriateness and inevitability that is the mark of all great art.

I would be greatly remiss if I did not mention the personal pleasure I have derived from my involvement with the Kronos Collections. The formation of any collection is a delightful voyage of discovery, and I feel privileged to have been invited along. Whatever intellectual justifications may be ascribed to the collecting impulse, no great collection was ever formed without a sense of consuming admiration for the material collected, an admiration with which the collector pays the greatest homage and respect to the artists and cultures represented. And it is to the new collectors of South Asian art that this catalogue of the first exhibition of a private collection of Indian and Southeast Asian art at the Metropolitan is respectfully and affectionately dedicated.

Because the nature of this collection introduces many art historical problems of unusual interest, it has seemed more useful to replace the standard brief introduction to the history of Indian and Southeast Asian art with catalogue entries that are at times lengthier than usual. In order to introduce a sufficient amount of background information to make this approach both meaningful and rewarding, I have concentrated on those individual sculptures and paintings that, by reason of their rarity or, in a few cases, uniqueness, prompt detailed and specific examination, but within broad and general contexts.

The arrangement of the sculptures and paintings is neither strictly chronological nor geographical. Rather, I have in some instances grouped together certain types of objects to retain their didactic value as a specific category; in other instances, guided by the nature of the collection, I have tried to arrange the entries so as to illustrate distinct sylistic affiliations.

In an attempt to make this material available to both scholars and the public as soon as was feasible, some time-saving measures were necessary, and the results of this first publication of the Kronos Collections should be considered somewhat tentative. Many of these objects are so crucial to the art history of India and Southeast Asia they will undoubtedly be published often, and I am confident that subsequent writers will correct the mistakes that appear here. As there has not been time for proper analysis and testing, the identification of materials should also be considered tentative. Note that transliterated words and names have been printed without diacritical marks, and the spelling of place and proper names has often been adjusted for phonetic convenience.

<div style="text-align:right">

Martin Lerner
*Curator of Indian and
Southeast Asian Art*

</div>

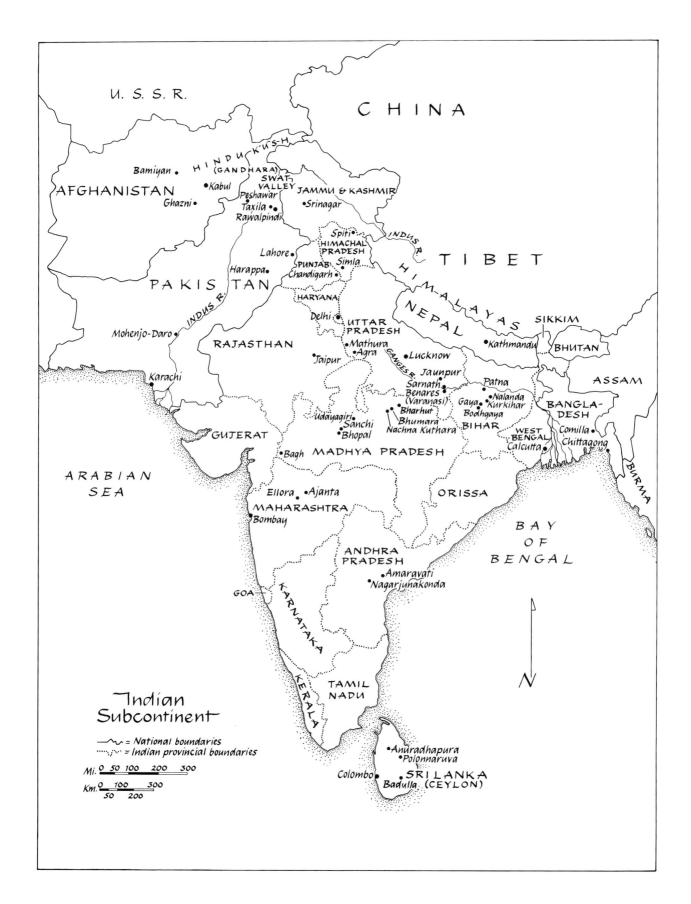

U. S. S. R.

CHINA

AFGHANISTAN

HINDU KUSH
(GANDHARA)

Bamiyan

Kabul

Ghazni

SWAT
VALLEY

Peshawar
Taxila
Rawalpindi

JAMMU & KASHMIR

Srinagar

INDUS R.

TIBET

Spiti

HIMACHAL
PRADESH

Lahore

Harappa

PUNJAB
Chandigarh

Simla

HIMALAYAS

NEPAL

SIKKIM

BHUTAN

HARYANA

PAKISTAN

INDUS R.

Mohenjo-Daro

Karachi

RAJASTHAN

Delhi

UTTAR
PRADESH

Jaipur

Mathura
Agra

GANGES R.

Lucknow

Kathmandu

ASSAM

Jaunpur

Patna

Sarnath
Benares
(Varanasi)

Gaya

Nalanda
Kurkihar

BANGLA-
DESH

GUJERAT

Udayagiri
Sanchi
Bhopal

Bharhut
Bhumara
Nachna Kuthara

Bodhgaya

BIHAR

WEST
BENGAL

Comilla

Chittagong

Bagh

MADHYA PRADESH

Calcutta

ARABIAN
SEA

ORISSA

BURMA

Ellora

Ajanta

MAHARASHTRA

Bombay

BAY
OF
BENGAL

ANDHRA
PRADESH

Amaravati
Nagarjunakonda

N

GOA

KARNATAKA

KERALA

TAMIL
NADU

Indian
Subcontinent

= National boundaries
= Indian provincial boundaries

Mi. 0 50 100 200 300
Km. 0 100 300
50 200

Anuradhapura
Polonnaruva

Colombo

SRI LANKA
(CEYLON)

Badulla

12

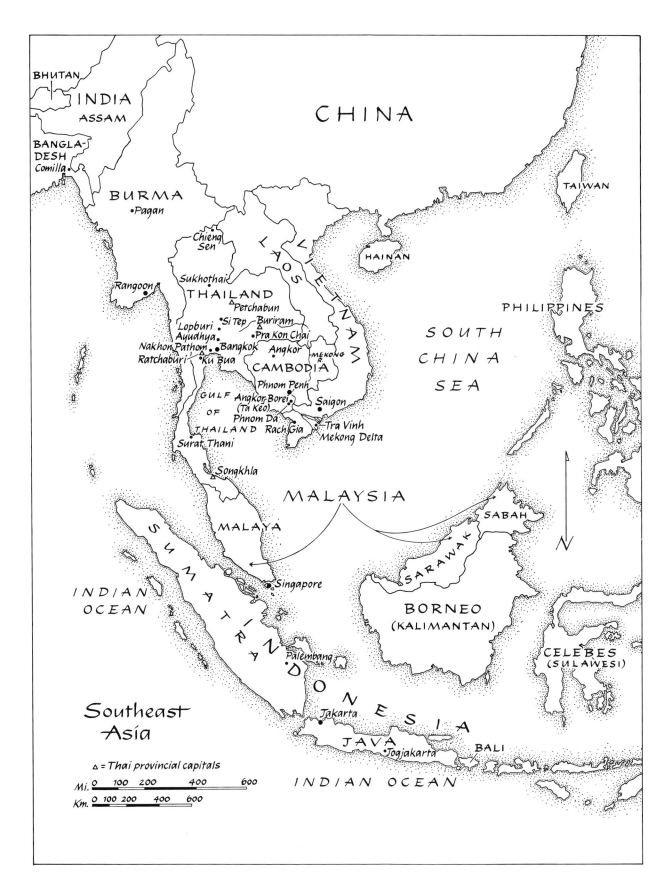

BHUTAN

INDIA

ASSAM

CHINA

BANGLA-
DESH
•Comilla

BURMA

•Pagan

Chieng
Sen △

LAOS

VIETNAM

HAINAN

TAIWAN

Rangoon

Sukhothai•

THAILAND
△Petchabun

PHILIPPINES

SOUTH

Lopburi• •Si Tep •Buriram
Ayudhya• △Pra Kon Chai
Nakhon Pathom• •Bangkok
△ Angkor
Ratchaburi• •Ku Bua

MEKONG
R.

CHINA

CAMBODIA

SEA

•Phnom Penh

GULF
OF Angkor Borei•
(Ta Keo) •Saigon
Phnom Da
THAILAND Rach Gia
•Tra Vinh
Mekong Delta

Surat Thani•

•Songkhla

MALAYSIA

SABAH

MALAYA

SARAWAK

INDIAN
OCEAN

•Singapore

BORNEO
(KALIMANTAN)

CELEBES
(SULAWESI)

SUMATRA

INDONESIA

•Palembang

Southeast
Asia

△ = Thai provincial capitals

Mi. 0 100 200 400 600

Km. 0 100 200 400 600

•Jakarta

JAVA
•Jogjakarta BALI

INDIAN OCEAN

13

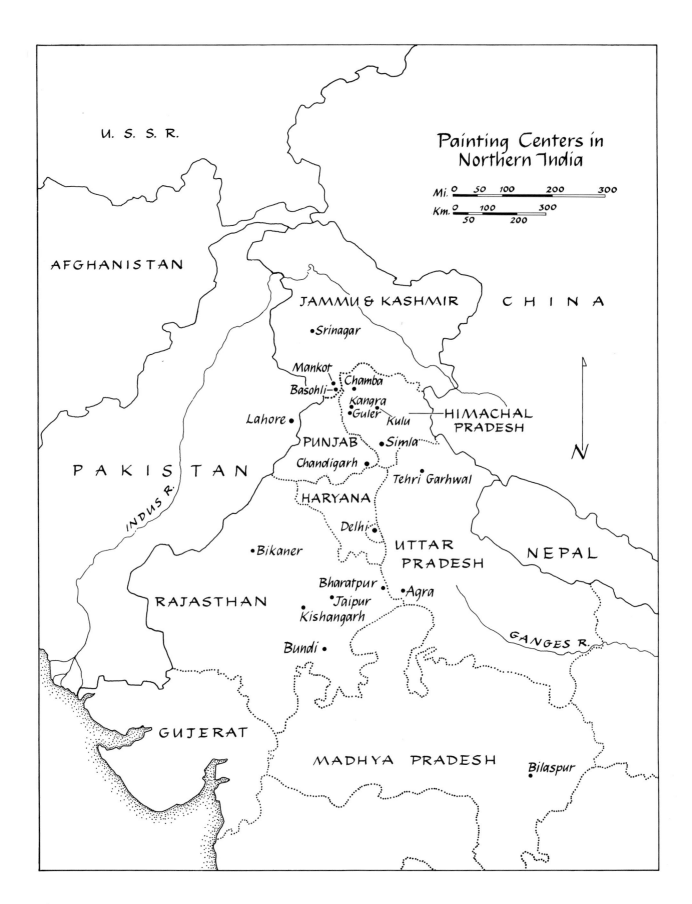

Painting Centers in
Northern India

Mi. 0 50 100 200 300
Km. 0 100 300
 50 200

U. S. S. R.

AFGHANISTAN

JAMMU & KASHMIR

C H I N A

•Srinagar

Mankot
•Chamba
Basohli•
Kangra
•Guler
Kulu
HIMACHAL
PRADESH

Lahore •

PUNJAB
•Simla

Chandigarh•

Tehri Garhwal

HARYANA

P A K I S T A N

INDUS R.

Delhi•

UTTAR
PRADESH

N E P A L

•Bikaner

Bharatpur
•Agra

RAJASTHAN
•Jaipur
Kishangarh

GANGES R.

Bundi •

GUJERAT

MADHYA PRADESH
Bilaspur
•

Catalogue

1 THREE ANTHROPOMORPHS AND
 FOUR HARPOONS
 India, Uttar Pradesh, ca. 1500 B.C.
 Copper; harpoons: (a) H. 13⅜ in. (34 cm),
 (b) H. 14 in. (35.6 cm), (c) H. 12½ in. (31.8 cm),
 (d) H. 10⅜ in. (26.5 cm), tip missing;
 anthropomorphs: (a) H. 8⅞ in. (22.5 cm),
 W. 12¹⁄₁₆ in. (30.6 cm), (b) H. 8½ in. (21.6 cm),
 W. 8¼ in. (21 cm), one "arm" missing, (c) H. 8¼ in.
 (21 cm), W. 11½ in. (29.3 cm)

In India, find spots for ancient copper objects are widely distributed. The vast majority, however, have been recovered from Uttar Pradesh, Bihar, Orissa, and Madhya Pradesh. Copper hoards discovered mostly in the Gangetic basin, and particularly in the modern state of Uttar Pradesh, have for a long while been a source of major interest for archaeologists and students of ancient India. The hoards, primarily celts, harpoons, rings, and "anthropomorphs," date to a period of Indian history about which little is known. At various times, it had been hypothesized that these copper implements were made by the Vedic Aryan invaders, or, perhaps, by peoples entering the Gangetic basin from the Indus valley after the collapse of the Harappa empire.[1] Recent scholarship, however, seems to indicate that they were created by an indigenous Gangetic basin people.[2]

In 1971, knowledge regarding both the approximate date of manufacture and the identity of the people who produced the copper implements was significantly enhanced through excavations conducted by B. B. Lal at Saipai, in Etawah District in Uttar Pradesh.[3] Prior to this, none of the copper objects had been found in a systematic scientific excavation; consequently, there was much speculation about what kinds of pottery and other artifacts would normally have accompanied a copper hoard. Based on the pottery sherds Lal discovered at Saipai, he was able to conclude that "it would appear that the Copper Hoard culture flourished in the first half of the second millennium B.C., if it did not have an earlier beginning."[4]

There are four harpoons in the Kronos Collections, all purported to have been found in Uttar Pradesh. They are of a standard type: cast in a mold, with a strong medial rib, a long, tapering blade, and projecting, incurved barbs — three pairs on one harpoon, two pairs on the others. Below the barbs, there is a hole through which a cord would have passed to permit the harpoon to be attached to a shaft. The attenuated shape and the relationship of the individual parts make these harpoons rather elegant objects.

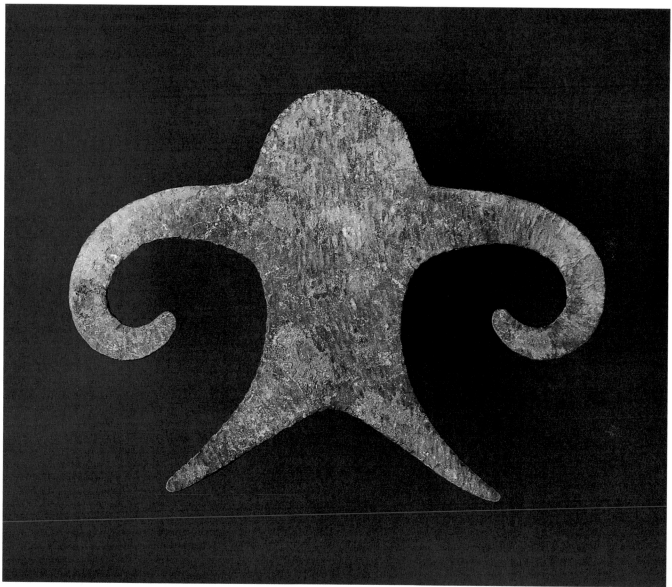

Anthropomorph (a)

The three anthropomorphs in the collection are also said to have been found in Uttar Pradesh. These enigmatic objects are undoubtedly of major religious significance, though nothing is known of their usage. That they should indeed be understood to be anthropomorphic is confirmed by a similar bronze object, clearly male, in the Patna Museum.[5]

The common denominator for the anthropomorphs is a domical "head," large, outstretched arms curving inward, and splayed, fishtail-shaped legs terminating in points. Although the proportions of the known anthropomorphs vary, little about them suggests the possibility of establishing a chronological sequence because anthropomorphs of different proportions have been found together. Two of the Kronos anthropomorphs are noticeably thicker along the top of the head, a common feature of these cast and then hammered copper objects.

Most of the published anthropomorphs have been found in Uttar Pradesh, not very far from Mathura, at the ancient sites of Bisauli, Fatehgarh, and Seorajpur.[6] The

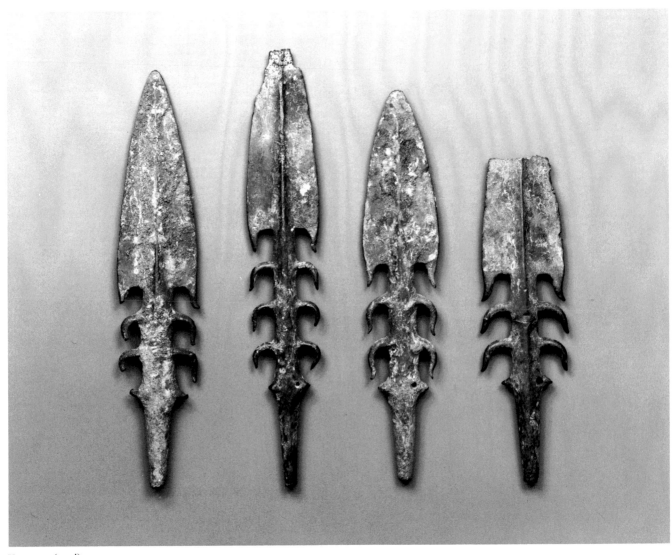

Harpoons (a–d)

three in the Kronos Collections are purported to have been recovered around Mathura; the two smaller anthropomorphs were found with the harpoon with three pairs of barbs and the one with the missing point, the larger anthropomorph with the other two harpoons.

Seven years ago, P. K. Agrawala stated that at least a dozen anthropomorphs were known.[7] It would be more realistic to say that probably fewer than fifty are known. In all events, it is quite clear that they are very rare and that they must have been, like the other copper imple-ments, costly and prestigious objects in comparison to clay figures.

[1] Lal 1951, p. 31.
[2] Ibid., pp. 35–39.
[3] Lal 1971–72, pp. 46–49.
[4] Ibid., p. 49.
[5] Agrawala 1967–68, pp. 96–98.
[6] Gordon 1958, p. 137.
[7] Agrawala 1977, p. 37.

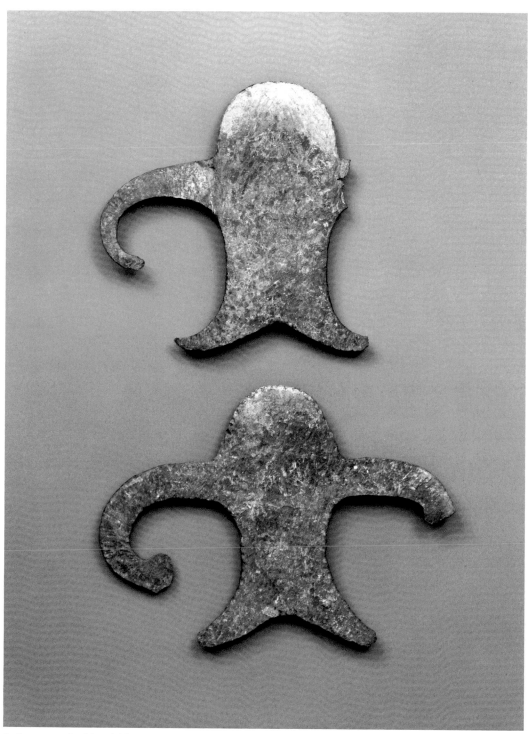

Anthropomorphs (b) and (c)

2 PAIR OF ROYAL EARRINGS
India, perhaps Andhra Pradesh, ca. 1st century B.C.
Gold; (a) H. 1⁵/₁₆ in. (3.4 cm), W. 3⅛ in. (7.9 cm),
D. 1½ in. (3.8 cm); (b) H. 1½ in. (3.8 cm), W. 3 in.
(7.6 cm), D. 1⁹/₁₆ in. (3.9 cm)
Gift of The Kronos Collections, 1981 (1981.398.3, 4)

Students of Indian art have long been fascinated by the extraordinary jewelry worn by both male and female figures in early Indian sculpture. Earrings, in particular, being the most three-dimensional and complex in shape, are depicted in sizes and forms that seem at times to go beyond the bounds of credibility.

The corpus of extant early Indian jewelry, ranging from material found at Mohenjo-Daro and Harappa to jewelry often of classical and Iranian inspiration recovered from various Gandharan sites, is relatively meager. While some Shunga gold jewelry has survived,[1] nothing extant has to date provided sufficient justification for the acceptance of all depictions of jewelry on sculpture as literal.

Extensive early textual references to jewelry and the probable codification of types and shapes make clear, however, that, aside from its intrinsic value, jewelry was considered a major art form. Body adornment in India was not merely self-embellishment, but had very real social and religious significance—a good basis for the verifiability of these depictions despite the lack of external evidence. This spectacular pair of earrings, a recent gift to the Museum, not only will rewrite the history of jewelry and goldworking in ancient India, but also provides the first tangible evidence for the accuracy of jewelry representation on early Indian sculpture.

These earrings, henceforth to be known as the Kronos earrings, are designed as conceptualized organic motifs. Each is composed of two rectangular budlike forms growing outward from a central double-stemmed tendril. The tendril is decorated with tripartite diagonal bands of raised granulation alternating with circular rosettes, forming a chevron pattern.

The tendril terminates at each end in a calyx richly ornamented with larger rosettes and a two-layered petal motif. The four-sided bud, its edges highlighted by a double row of large granulated beads, swells forth from under the calyx and ends in a convex square. Its unadorned surfaces are relieved by decoration on only two sides. The underside of each bud is decorated with a classical early Indian palmette motif worked in repoussé with several grades of applied granulation. (One of the few differences between the earrings is in the decoration of these fronds—one has the circular motif, the other a diagonal veining.) The front bud of each earring is decorated with a winged lion and the back bud with an elephant. These two royal animals are placed so that the lions would face each other across the wearer's neck while the elephants would face outward. The animals are of repoussé gold, completely covered in granulation and then intricately detailed with granules, snippets of wire and sheet, and individually forged and hammered pieces of gold. Fanciful necklaces adorn the lions' necks, and full harnesses with blanket covers decorated with swastikas, an ancient solar symbol, are worn by the elephants.

A careful examination of earring shapes and decoration on early sculpture reveals that broad regional styles do exist. The Kronos earrings have some parallels at Bharhut and Sanchi and on the early sculpture at Mathura. It is particularly fascinating, however, that a pair of earrings of considerable size and very similar shape—clearly showing a convex end—are worn by the famous *Chakravartin* (Universal Ruler) from the stupa at Jaggayapeta, datable to the first century B.C.[2] To my knowledge, this is the closest parallel to the Kronos earrings. The Jaggayapeta relief clearly illustrates that the weight of such earrings and the distension of the earlobe resulting from the habitual wearing of such heavy ornaments caused them to rest on the shoulders.

That the Kronos earrings are the most superb example of Indian jewelry known is incontrovertible. Their size and weight, their consummate craftsmanship, the royal emblems, and the fact that similar earrings are being worn by the *Chakravartin* at Jaggayapeta leave little doubt that they were royal commissions—a claim no other extant Indian jewelry can so clearly make. Of perhaps even greater significance, both the conception and execution of these earrings prove that ancient Indian goldworking was on a level at least as high as that of other major goldworking cultures. They thus open a whole new chapter on the ancient art of India.

Published: Lerner 1982c, pp. 69–70.

[1] In the collection of The Cleveland Museum of Art there are three elaborate repoussé gold objects—a bead and two pendants (acq. nos. 73.66–68; *Bulletin of The Cleveland Museum of Art* 1974, p. 58, cat. no. 180).

[2] Zimmer 1955, pl. 37, and Loth 1972, pl. 3, fig. 6.

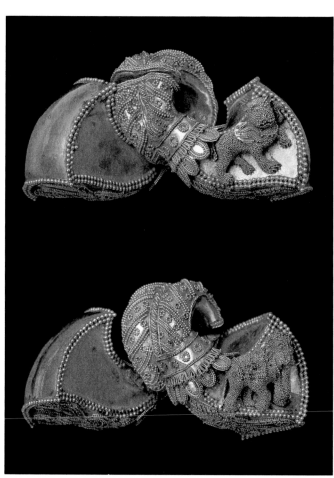

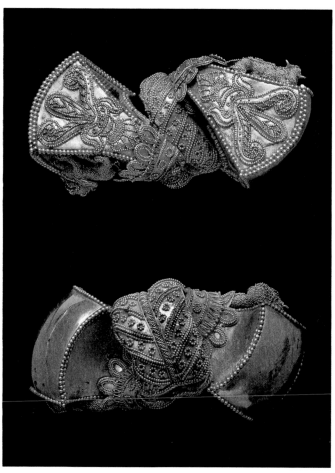

Inner (above) and outer surfaces of left earring (a) Above: top of right earring (b) Below: underside of left earring (a)

3 RONDEL WITH SEATED HARITI
Pakistan, Gandhara, Kushan period, 1st–2nd century
Silver with gold foil, Diam. 3½ in. (8.9 cm)
Gift of The Kronos Collections, 1981 (1981.460.2)

After the death of the famed Macedonian general Alexander the Great around 323 B.C., the vast empire he assembled through conquest began to disintegrate. However, a legacy of strong links to the classical world was left in the ancient region of Gandhara, within the borders of what is today Pakistan and Afghanistan.

Strategically situated at the crossroads to northern India, the Mediterranean, ancient Bactria, and far-off China via Central Asia, Gandhara was a great melting pot. Seleucids, Scythians, Indians, Bactrians, Romans, Parthians, and Sasanians all, in varying degrees, left their cultural imprint on the region. It was under the Kushans, however, a people originally of Scythian origin, that Gandhara achieved its greatest glory. The most important of the Kushan rulers, Kanishka, who probably acceded to the throne sometime between A.D. 78 and 144, was one of Buddhism's greatest patrons.

Alexander's classical legacy and Gandhara's contacts with the Mediterranean world under the Kushans led to the development in Gandharan Buddhist art of a style markedly dependent upon Hellenistic and Roman prototypes. Although other influences contributed to this style, the classical flavor of Gandharan sculpture is strong and unmistakable. The hybrid style (employed almost exclusively in the service of Buddhism) and extensive patronage resulted in a vast body of architecture, sculpture, and minor decorative arts, which served as one of the major stylistic and iconographic sources for the development of Buddhist art in other countries.

The first of the Gandharan objects in the Kronos Collections is a silver rondel of great rarity depicting the goddess Hariti. Hariti is a fascinating minor deity who evolved into a goddess of fertility particularly associated with children. It was believed that in a former incarnation Hariti was an ogress who devoured infants; she was also associated with the infantile disease, smallpox. She was eventually tamed and converted by the Buddha and became a tutelary goddess charged with the protection of infants. In the art of Gandhara, she is usually depicted with children around her.

Hariti is seated on a chair whose back and side panels are decorated with a wavy line and dot pattern. Two birds are perched on the chair back, and the bottom element of the visible chair leg is in the shape of an inverted lotus. The goddess cups her right breast with her left hand, and her right hand supports the head of the child lying across her lap. She is fully clothed and wears a profusion of elaborate jewelry: armbands, bracelets, decorated anklets, and a broad collarlike necklace. Her elaborate coiffure is enhanced by a diadem and by the rosettes on each side of her face. Gold foil has been applied over her face, hair, and necklace. Two lotuses, one still in bud, flank her chair. She is surrounded by an egg-and-dart border, and the outer perimeter of the rondel has a design of stylized lotus petals of the sort found on Gandharan stone cosmetic trays. There are two pairs of loops, probably for fastening to a fabric (or perhaps to the cockade of a turban) on the reverse of the rondel: one pair at the top, the other at the bottom.

Kushan sumptuary objects of gold and silver are quite rare. Only three other silver rondels of this sort are known to me, all in the collection of the British Museum and acquired in 1922 in Rawalpindi, Pakistan.[1] One of the three is quite close to the Kronos Collections example: it shows a goddess seated on a chair, but there is no child on her lap; it also does not have gold foil and is in a less complete state.[2]

Quite a few Gandharan stone images of Hariti are known, but none, to my knowledge, is similar to this rondel. Stylistically, the goddess is closer to the terracotta sculptures of the Shunga period than to the later Kushan sculptures of the Gandhara school, suggesting that a dating to the first or the early part of the second century is not likely to be far off. This could then be one of the earliest known depictions of Hariti.

[1] Dalton 1926, pl. XXVIII.
[2] Ibid., no. 198; British Museum acq. no. 1937.3-19.4 (I do not know why the registration number begins with 1937).

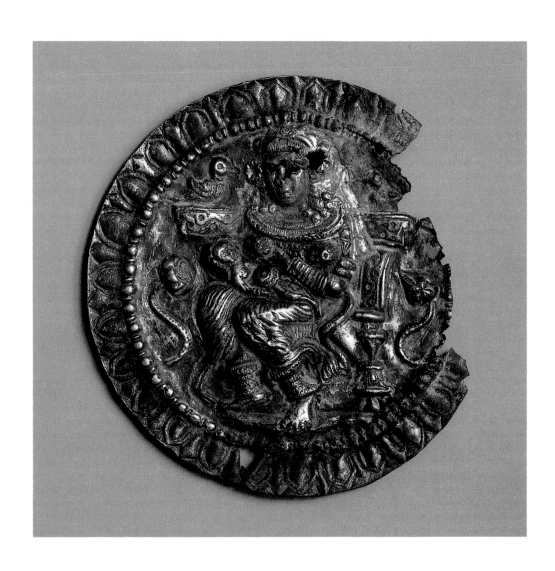

4 FEMALE DEITY
 Pakistan, Gandhara, Kushan period,
 ca. 2nd – 3rd century
 Stone, greatest Diam. 3³⁄₁₆ in. (8.1 cm)

This stone rondel depicts an unidentified female divinity whose ultimate iconographic origins reside in the classical world. Objects such as this, displaying a mixture of Hellenistic, Parthian, and Bactrian stylistic and iconographic elements, contributed heavily to the hybrid nature of Gandharan art (see No. 3). An interesting stylistic comparison can be made with another sculpture of a female deity recovered from Sirkap and now in the National Museum, Karachi.[1]

The winged deity wears a band across her forehead and over the top of her head that divides her hair into two segments. The serpentine locks of hair are arranged like rays in a halo, perhaps meant to suggest her solar affiliation.

Its original setting has been lost, but this rondel may have been set into a stone surround.

[1] Marshall 1951, pl. 211, no. 3a.

24

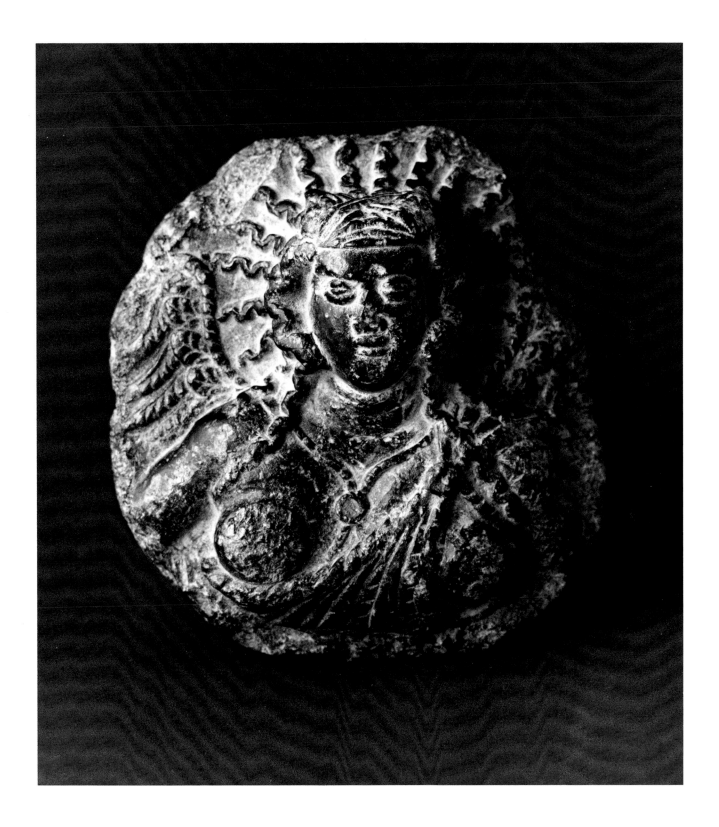

5 CHALICE
India, Kushan or early Gupta period,
2nd – 4th century
Said to have been excavated at Sarnath in 1848
Bronze, H. 3⅝ in. (9.2 cm), Diam. 4¼ in. (10.8 cm)

This bronze chalice stands on a hollow, flaring foot that is slightly convex toward the edge. There are two incised lines at the edge of the foot, another further inward, and additional lines near the bottom of the cup where it joins the foot; a circular banding appears again around the rim. A seven-character inscription in Kharoshthi, not yet deciphered, is incised on the cup.

Ritual and utilitarian objects of this sort have rarely attracted the scholarly attention they deserve. Consequently, little is known about their dates and provenances. This chalice may be an exception. The inscription on it gives us a much firmer basis for dating, as the use of Kharoshthi in northern India seems to have ended around the fifth century. In addition, we have at least a suggested provenance. The chalice is purported to have had an old tag reading, "Excavated by Major-General Alexander Cunningham at Sarnath in 1848."[1]

Unfortunately, the circumstances surrounding the tag are confusing. According to the *Archaeological Survey of India* for the years 1861–62, Sir Alexander Cunningham, the first Director General of Archaeology in India, excavated at Sarnath from December 1834 to January 1836.[2] Although he returned to the site between 1836 and 1861, he did not, so far as I can determine, conduct additional excavations. In the same *Survey*, Cunningham and others claim that the excavations at Sarnath were resumed in 1851 under the direction of Major Markham Kittoe.[3] In the *Survey* for 1904–1905, however, Sir John Marshall says that Kittoe's excavations began in 1848.[4] (Both sources agree that they continued until 1852.) Other excavators followed Kittoe at the site. Therefore, even though it is possible that Cunningham excavated the chalice at Sarnath, or that he obtained it from Kittoe or one of the later excavators, the provenance is by no means certain.

[1] According to the previous owner, Cunningham gave the chalice to the journalist Sir Percival Landon in the late 1890s. It was then presented to another man in whose family's possession it remained until it was placed at auction in London in 1980.
[2] *Archaeological Survey of India: Reports,* vol. 1 [Report of 1861–62], 1871, p. 107.
[3] Ibid., p. 106.
[4] *Archaeological Survey of India: Annual Report, 1904–1905,* 1908, p. 62.

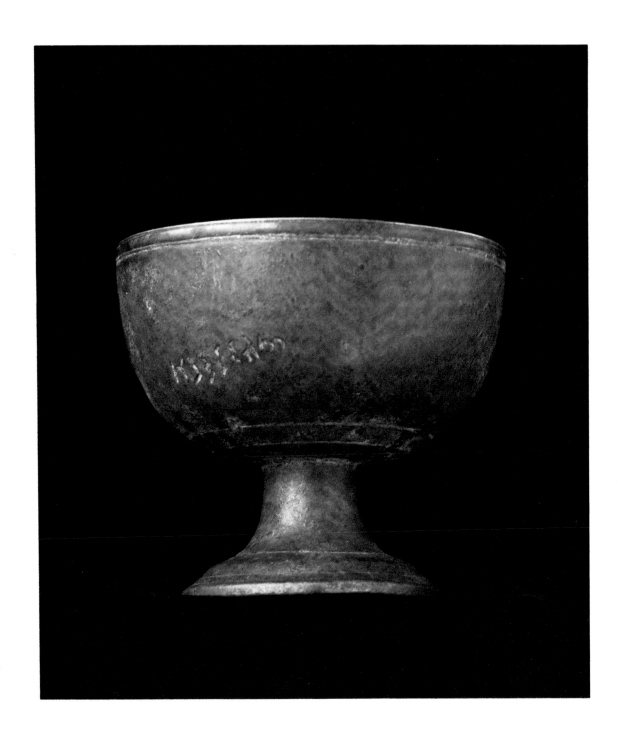

6 EARRING(?) WITH MALE HEAD
Pakistan, Gandhara, ca. 4th century
Ivory, Diam. 1 in. (2.5 cm)

Despite a literature rich in references to ivory carving and the once ready availability of the tusks of the Asian elephant, surprisingly few early Indian ivory carvings are known. Other than the famous Begram ivories found in Afghanistan, and perhaps the group of circa eighth-century Kashmiri-style ivories, there has not been a body of sufficiently analogous material to establish other "schools" of early ivory carving. This paucity of material makes any new addition to the corpus of early ivories of particular interest, even if it is outside the mainstream of the major styles of the great subcontinent.

The small ivory rondel (unfortunately incomplete) in the Kronos Collections is said to have been recovered from the area in northern Pakistan that was once part of the ancient region of Gandhara. It preserves the head of a youthful male with long tresses, encircled by a pearl-like border. An undecorated area surrounds the border, and the outer perimeter is decorated with a stylized wreath. At the bottom are four pendant elements with holes; traces of a fifth can be seen on the reverse.

The rondel is clearly of classical inspiration, but it is difficult to determine if a specific Greco-Roman proto-type existed, or if the type underwent any Bactrian modifications along the way to Gandhara. It is not unlikely, however, that it was carved in Gandhara by a local artist.

Undoubtedly an object of sumptuary art, this rondel is probably from a pair of earrings, or perhaps part of a necklace. Jewels or gold beads were most likely suspended by gold wire from the lower projecting elements, and there may have been additional embellishments. Terracotta rondels with heads have been recovered from Taxila,[1] but for the closest approximation of the type one must look to the gold earrings of Gandhara, even though they have central floral medallions.[2]

[1] Marshall 1951, pls. 135gg, 138h and i.
[2] Ibid., pls. 190d and f.

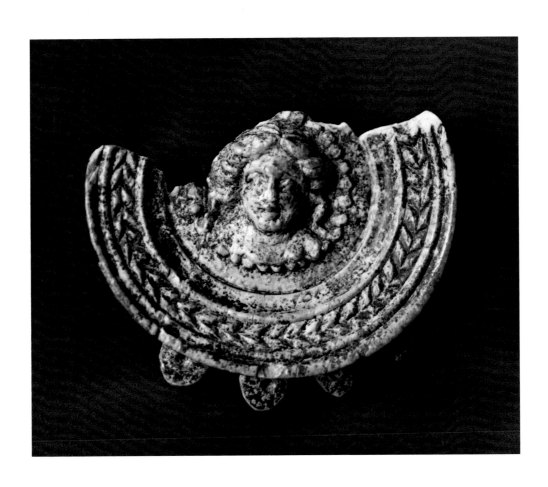

7 THE BODHISATTVA AVALOKITESHVARA
 SEATED IN MEDITATION
 India, Mathura, Kushan period, 2nd century
 Mottled red sandstone, H. 26 %16 in. (67.4 cm),
 W. 14⅛ in. (35.9 cm)

Of the many superb sculptures in the Kronos Collections, perhaps none is of greater significance to the iconography of Buddhist art than this extraordinary seated Bodhisattva. In the art of India, China, Japan, Korea, and other Asian countries, there is a specific iconographic type that has been generically referred to as "the Meditating Bodhisattva." This image usually takes the form of a seated deity whose right leg crosses the pendant left leg, the right ankle resting on the left knee. The figure's right elbow rests on the right knee and one or more fingers of the right hand touch or point to the right cheek, a distinctive gesture that is usually identified as one of meditation and pensiveness. Often the head of the Meditating Bodhisattva is tilted slightly toward the raised right hand.

So important is this enigmatic deity that he appears in a number of different contexts in various countries at different times. In early Chinese sculpture he can be identified, both by inscriptions and through the proximity of Siddhartha's horse, as Siddhartha before attaining enlightenment.[1] He is also associated with the messianic Bodhisattva Maitreya, who meditates and waits to become the Buddha of the next *kalpa* (great world age). Maitreya can therefore be considered to be in a state of anticipatory meditation. It has also been argued that some of these Chinese sculptures must represent the historical Buddha Shakyamuni.[2] In early Japanese and Korean art, this popular form is usually described simply as the meditating or pensive Bodhisattva. It is generally accepted, however, that the prototype for the Meditating Bodhisattva comes from India.

The Kronos Bodhisattva, seated on a raised pedestal, is in the standard attitude of the Meditating Bodhisattva, although the left hand makes an unusual gesture of bending four fingers back on the palm. The figure is richly adorned with the jewelries of a princely bodhisattva, and wears many bracelets, armbands, a torque, earrings, a diagonal cord with two amulet cases, and a complex, decorated turban.[3] The turban has a large frontal medallion with a diminutive representation of a seated Buddha at its center; the Buddha's hands rest in his lap in the gesture of meditation. Heraldic beaked lions appear on either side of the medallion, and on the armbands and the left earring.[4] The figure is nude from

the waist up and wears a dhoti, the lower hemline clearly visible above the ankles. An accumulation of cloth—part of the shawl draped behind the Bodhisattva—is suspended from the left wrist. A sandal is worn on the left foot, and the empty right sandal rests next to it on the decorated footstool. The pedestal is quite weathered, but one can make out the outlines of wickerwork and, at the bottom, on either side of the footstool, the lower part of a group of standing figures. To the left of the footstool are two figures in Kushan dress and a smaller figure whose hands seem to be clasped in adoration, or perhaps holding an object. On the right side are the remains of what appear to be two figures wearing monastic garments and a smaller figure in the same attitude as the figure on the left. The two small figures may represent donors. A portion of a halo survives behind the Bodhisattva's shoulders.

The Kushan period sculptures made at the ancient sacred city of Mathura in Uttar Pradesh are one of the glories of Indian art, or, for that matter, the art of the world. The literature is rich in praise for the astonishing aesthetic level attained by the best of these sculptures, as well as for the iconographic richness of the school. This body of sculpture covers a period of approximately 225 years, from the beginning of the first century to some time early in the third, when the Kushan empire started to collapse. It does not misstate the facts to claim that the Buddhist art of Mathura during the Kushan period is one of the two legs serving as the foundation for the body of all subsequent Buddhist art throughout Asia—the other leg being the Kushan period sculpture from Gandhara, to the northwest in what is now Pakistan and Afghanistan (see No. 3).

The dating of Kushan period sculpture at Mathura is based primarily on coins and on the dated inscriptions that appear on the pedestals of many sculptures. These dates are regnal (dependent upon the knowledge of when a specific ruler first acceded to the throne), the ruler of prime importance being the emperor Kanishka. As there is still no unanimity regarding the crucial date of the first year of Kanishka's reign, there is more than one possible system for dating Kushan sculptures. Alternate systems of dating Mathura sculpture could place our figure as late as the early part of the third century. But if

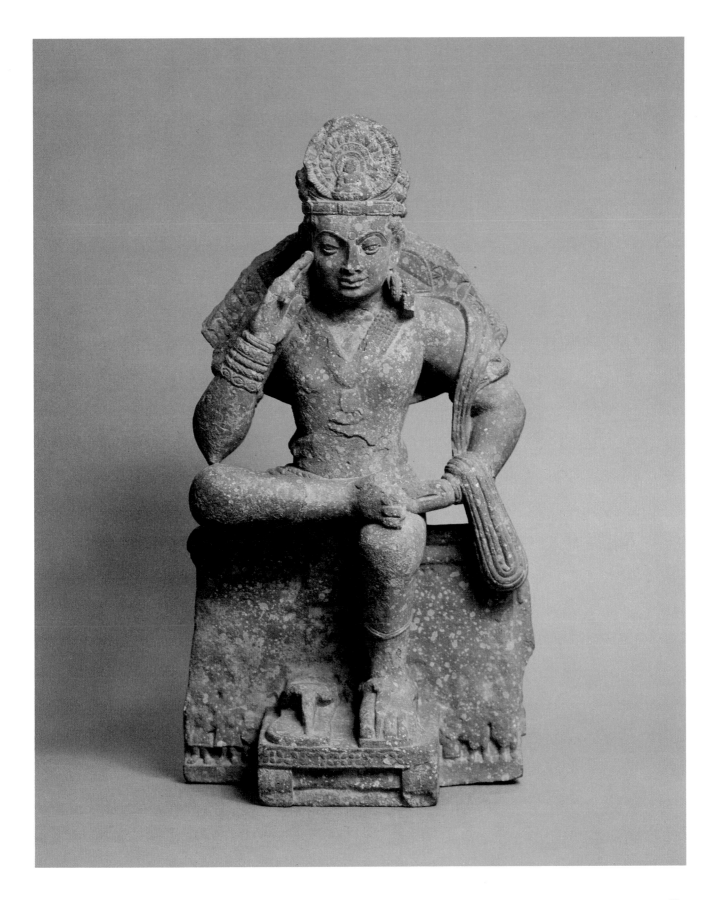

traditional Indian dating, particularly as employed at the Government Museum at Mathura, is followed, the first year of Kanishka's reign would be A.D. 78 and the Kronos Bodhisattva, by stylistic comparison to other sculptures, should be dated to the early part of the second century, which seems reasonable.

That the prototype for the iconographic form of the Meditating Bodhisattva must be sought in India, particularly in the ancient region of Gandhara, has been acknowledged by most scholars in the field, although Soper has suggested that at least the hand-to-cheek gesture may have appeared in Gandharan art as a borrowing from the Mediterranean world.[5] Pal has written, "It is generally admitted that the iconographic type of the pensive figure was derived from Gandhara. . . ."[6] I have stated that "the contemplative Bodhisattva in 'pensive mood' . . . can be traced directly from Gandharan stone sculpture, where he appears first as an attendant figure and later alone."[7] Others have made approximately the same claim. The Kronos Bodhisattva, however, introduces new evidence that slightly complicates the accepted hypothesis.

Until the appearance of the Kronos Bodhisattva, the Meditating Bodhisattva so popular in Gandharan art was almost unknown elsewhere in Indian art. In 1967, Pal could state, "It is somewhat curious that despite the popularity of this type of figure with the Gandhara artists, in no other Indian center of Buddhism, whether Mahayana or Hinayana, was he known to have been represented."[8] At the time this was written the assertion was only partially accurate, however, for at least two incomplete sculptures from Mathura that were unlikely to be anything other than fragments from a Meditating Bodhisattva were known. The first, in the Government Museum at Mathura, is a well-published fragment of a large figure seated on an elaborate wicker seat.[9] The only part of the figure that has survived intact is the left lower leg and foot, which wears a sandal and rests on a footstool. An empty right sandal is placed next to it. The lower right leg and foot are completely gone but the nature of the break at the left knee would suggest that the missing leg would have been placed laterally so that the foot would have touched the left knee. Nothing else aside from a pendant, elaborately pleated section of cloth has survived from what must at one time have been a most

imposing sculpture of the Meditating Bodhisattva. The other Mathura figure, on exhibition at the Indian Museum, Calcutta (acq. no. A25031, old no. N.S.3747), is a small, unpublished, mutilated, Kushan period seated Bodhisattva. Both legs are missing, but two sandals rest on the small projecting ledge that serves as the footstool, and the left foot is still clearly visible in the left sandal; the right sandal is empty. It is very probable that this is another example of the Meditating Bodhisattva.

These two fragments, along with the Kronos figure (and other examples may still come to light), show clearly that the Meditating Bodhisattva was indeed a part of the iconographic repertory of the Mathura sculptors, even though it was not as popular as at Gandhara.

Virtually all of the Gandharan examples of the Meditating Bodhisattva known to me, whether individual icons or parts of larger compositions, are assignable on stylistic grounds to the third century or later. We have suggested a second-century date for the Kronos Meditating Bodhisattva, and since it is a fully developed icon, with no indication of tentativeness or experimentation in iconography, composition, or general sculptural treatment, there must have been earlier examples from Mathura ateliers. A suggestion of part of the pose can also be found earlier, in the second-century B.C. sculpture of Bharhut, although these examples seem to be of figures resting their heads on their hands, a pose too mundane and universal to be accepted as a true prototype, and the legs are not in the requisite position.[10]

On the basis of this evidence, it might seem plausible, rather than crediting the prototype for the pose to the ancient Gandhara region in the far northwest, or even, as suggested by Soper, to the Mediterranean world, to cite the Kronos sculpture as the earliest fully developed example of the Meditating Bodhisattva, and to suggest that we look to Mathura for the origin of the iconographic type. There is, however, external evidence that weakens this hypothesis: bodhisattvas almost never wear sandals in the sculpture of Mathura while in Gandharan art they are almost always shown with them. The prominent and carefully placed sandals on the Kronos Bodhisattva, and on the other two Mathura examples, are so clearly a standard feature of Gandharan Meditating Bodhisattvas[11] that they represent a foreign intrusion that can only have been imported from Gandhara. Even

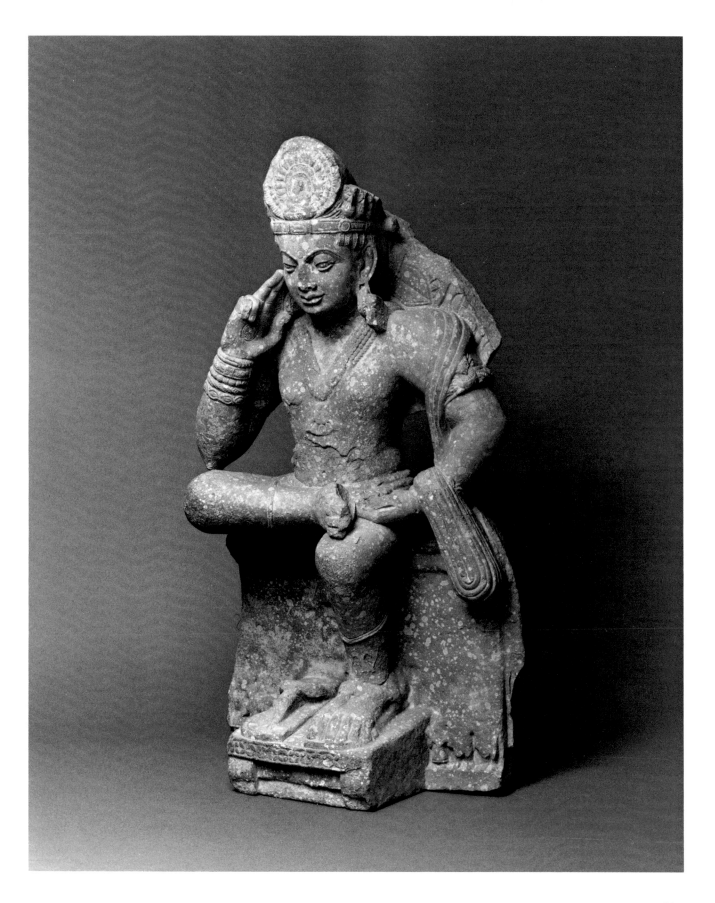

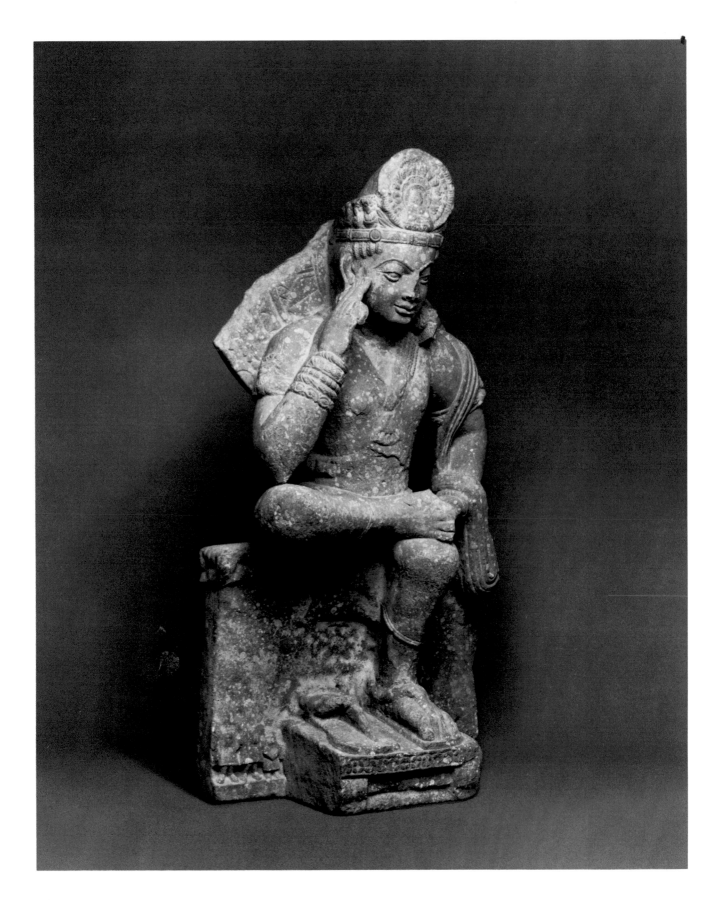

34

though no Gandharan prototype of an earlier date than the Kronos Bodhisattva now exists, we can presume that eventually, one will be discovered.

The iconographic importance of the Kronos Bodhisattva is not limited to the pose of the figure. Equally, if not more important is the fact that through it we can now definitely identify the Meditating Bodhisattva — at least in a Kushan period Mathura context. As stated earlier, included in the central medallion of the turban is a diminutive representation of a seated Buddha whose hands rest in his lap in the gesture of meditation. In Buddhist iconography, the Bodhisattva Avalokiteshvara, the Lord of Infinite Compassion, is usually identifiable through the inclusion of a small Buddha in the deity's headdress or hairdo. The Buddha is Amitabha, the "spiritual father" of Avalokiteshvara. The Kronos Bodhisattva may be the earliest example of the appearance of Amitabha in conjunction with Avalokiteshvara. (I know of only four other examples of Kushan period sculptures from Mathura that have Buddhas in the central part of their headdresses.)[12] The appearance of Amitabha at such an early date is corroborated by the important find in 1977 of an inscribed pedestal at Mathura, dated A.D. 106, which mentions the name of the Buddha Amitabha for the first time.[13]

I am not sure if, on the strength of the evidence of the Kronos Bodhisattva, all otherwise unidentifiable examples of the Meditating Bodhisattva in Gandharan art should be thought of as meditating Avalokiteshvaras. The problem is complicated by the fact that on some sculptures one finds two bodhisattvas seated in this position. A particularly interesting example in the Indian Museum, Calcutta, shows one deity, probably representing Manjushri, the Bodhisattva of Transcendental Wisdom, holding a manuscript and the other, likely to be Avalokiteshvara, holding a lotus.[14] However, when they are separate icons, most of the Gandharan examples hold lotuses, and can therefore be identified as Padmapani, the lotus-bearing form of Avalokiteshvara.[15] Later Kashmiri and Swat valley examples of the Meditating Bodhisattva are clearly representations of Avalokiteshvara, containing Amitabhas in their hairdos and holding lotus flowers in their left hands.[16]

The alert, staring gaze of this Bodhisattva, not suggestive of a pensive or meditative mood, might cause us to question whether it should be identified as a Meditating Bodhisattva at all. (And if not, exactly what does the hand-to-cheek gesture signify?) We may have here an example of the Bodhisattva prior to his association with a contemplative mood.

It is important that our lengthy discussion of the iconography and origin of the Kronos Meditating Bodhisattva not overshadow the fact that it is a glorious sculpture. Beautifully modeled, with subtle, flowing transitions of volumes and harmonious relationships of forms, this dignified and majestic image is a major contribution to the corpus of Kushan period sculptures from Mathura.

[1] Soper 1959, pp. 225–26.
[2] Ibid.
[3] For Kushan sculptures with very similar treatment of bracelets, see Sharma 1976a, figs. 45, 47, 48 (all published elsewhere in better illustrations), and Bachhofer 1929, pl. 85 (right). For comparable examples of torques, see Bachhofer 1929, pl. 85 (left and right), and Vogel 1930, pl. xxxiv-a. In addition, two fine Kushan sculptures from Mathura in private collections in Chicago and New York wear very similar torques.
[4] The curious treatment of the muzzle of the lions as a "beak" has caused similar examples to be confused with birds, but that they are composite, mainly leonine creatures can be seen from examples of lion thrones (see Vogel 1930, pl. xxvii-b). Beaked lions also appear in the headdresses of the two sculptures in private collections mentioned in note 3, as well as on a famous head of a bodhisattva in the Lucknow Museum (Pal 1979, figs. 12, 13).
[5] Soper 1959, p. 226.
[6] Pal 1967–68, p. 44.
[7] Lerner 1975a, cat. no. 4.
[8] Pal 1967–68, p. 45.
[9] Vogel 1930, pl. xxxiv-b.
[10] Pal 1967–68, n. 21.
[11] For a good example, see *Mayuyama, Seventy Years,* 1976, pl. 621.
[12] One is a late Kushan example cited in the *Annual Bibliography of Indian Archaeology for the Year 1934,* pl. iv-c. The second, also in the Government Museum, Mathura (acc. no. 34.2367), survives as just a narrow section of the forehead and the headdress. The third example, the only surviving sculpture that, to my knowledge, can rival the Kronos Bodhisattva as the earliest complete example of Avalokiteshvara with a seated Buddha in the headdress, is now in the collection of the Lucknow Museum — surprisingly, this figure holds a vase (Coomaraswamy 1965, fig. 78). The fourth sculpture is illustrated in Mallmann 1948, pl. iib. A few other Kushan sculptures from Mathura have rows of diminutive Buddhas flanking the central medallion of the turban (see Pal 1979, p. 213, and the sculpture in a New York private collection cited in notes 3 and 4).
[13] Sharma 1976a, pp. 9, 10.
[14] Foucher 1918, fig. 408.
[15] See *Mayuyama, Seventy Years,* 1976, pl. 621.
[16] Lerner 1975a, cover and pl. 4.

35

8 STANDING *YAKSHI*
 India, Mathura, Kushan period, 2nd – 3rd century
 Mottled red sandstone, H. 32 in. (81.3 cm)

In Indian art, certain beautiful young women are as-
signed a variety of closely related functions concerned
with fertility. It is sometimes difficult to isolate the
specific generative aspect intended, particularly when
the deity is incomplete and has been removed from her
architectural context, as is the case here, and it has
become convenient to call these otherwise unidentifiable
females *yakshis,* a kind of generic term for fertility
goddesses.

The corpus of Kushan period sculptures from
Mathura forms a virtual encyclopedia of the different
nature goddesses, as well as of early Indian concepts of
feminine beauty. By the second century, the basic female
sculptural type had long been established: narrow waist
and shoulders, full hips, breasts, and thighs, the obvious
voluptuousness emphasizing fecundity and potential
motherhood. The Kronos Collections *yakshi* clearly re-
flects this idealization.

The *yakshi* stands with legs apart in a pronounced
tribhanga (thrice bent) stance, which causes a compres-
sion of the flesh at her waist, a naturalistic touch often
found on figures of this school and period. She wears a
necklace, bracelets, a large bangle around her left ankle,
and an elaborate girdle with an ornate, finely decorated
clasp. Her long skirt, of fine, transparent material, is
secured around the hips by a fabric belt decorated with
rosettes, the knot depicted in a logical, convincing man-
ner. The skirt adheres so tightly to her body that the only
indications of its existence are just above the belt and
below the bangle on her left ankle. The placement of the
suspended ends of the belt, which fall over the pubic area
and down the inside of her left thigh, reinforces the
sensual nature of this deity. The pendant cloth at her
right side is probably an accumulation of the fabric of her
skirt, as is often seen on more complete images.

Typical of the Kushan style at Mathura, the juxta-
position of jewelry and garments to large areas of
smooth skin establishes a system of visual and tactile
rhythms that play over the surface of the stone, and the
contrast of surface decoration to sensual plasticity con-
siderably enhances the total effect. The quality of the
modeling of this figure compares favorably with the very
best of the Kushan period sculptures from Mathura. The
volumes of the individual parts of the body are exquisite-
ly rendered to create a voluptuous, idealized conception
of a female that could serve as the paradigm for all Indian
nature goddesses associated with fertility.

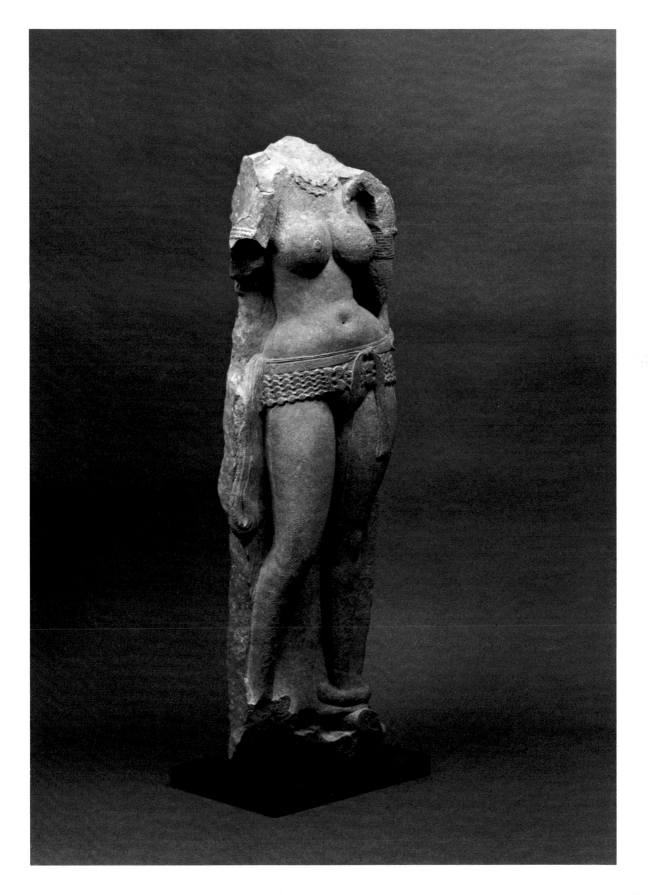

9 THREE HEADS
Pakistan, Gandhara, 4th – 5th century
Terracotta; (a) Male with Mustache (4th – 5th
century): H. 7⅝ in. (19.3 cm), (b) Patron Goddess
of a City (?) (4th – 5th century): H. 9½ in. (24.1 cm),
(c) Central Asian Female (ca. 5th century): H. 8 in.
(20.3 cm)

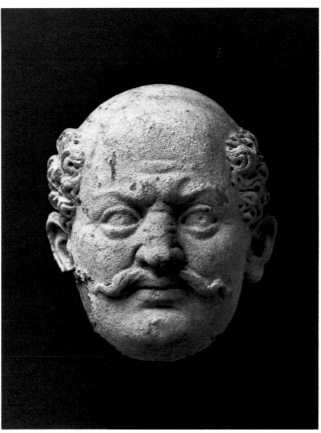

Male with mustache (a)

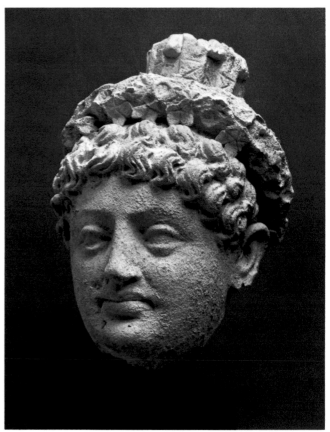

Patron goddess of a city (b)

These three terracotta heads, each in its own way a
reminder of the remarkably high aesthetic level periodi-
cally attained by the sculptors of Gandhara, once deco-
rated a Buddhist temple or monastery. The exact site is
unknown, but judging from the quality of these heads it
must have been a Buddhist complex of major impor-
tance. Two other heads, probably from the same site,
have been published previously.[1]

Distinct facial types, some clearly portraits, appear
throughout Gandharan art. Reminiscent of Roman por-
trait sculpture, perhaps modified by Bactrian inter-
mediaries, these heads visually confirm the great variety
of Gandharan culture. The range of facial types attests to
the cosmopolitan nature of the area and to the fact that it
was an obvious melting pot of foreign inhabitants —
monks, merchants, soldiers, and others.

The first of the heads portrays a bald male with a

mustache, furrowed brow, and slightly wrinkled nose. As
with the finest examples of Gandharan portraiture in
stucco and, less often, terracotta, there is an immediacy
and psychological intensity here that is not often found
in portraits in stone. The pliable material, easier to work
than stone and more responsive to particularly fine
modeling, also called for a different approach to the
sculpting of volumes and details. Rather than being
stereotyped and repetitive like some stone examples,
these well-observed depictions in terracotta and stucco
have a lively spontaneity and verve. It is also true that,
freed from the iconographic confines of depicting a
Buddha or other major deity, the sculptors could follow a
more individualistic approach.

The second head, whose physiognomy is suggestive
of a Westerner, presents an interesting problem of
identification in that it appears rather androgynous, and

38

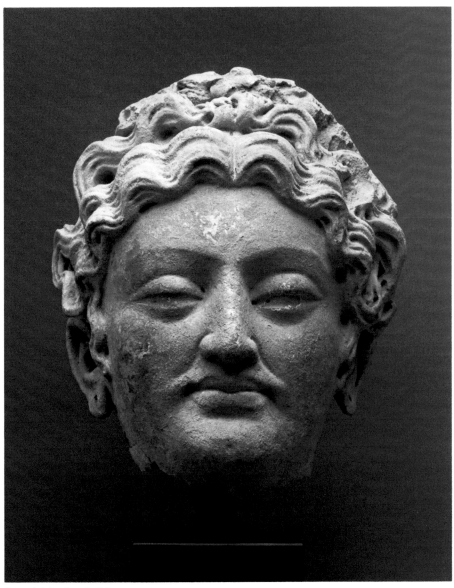

Central Asian female (c)

we have encountered no unanimity as to whether it is male or female. As with the first head, the quality of modeling is very sensitive and revealing, again suggesting portraiture rather than an idealization, though the latter is present in sufficient degree to cause the confusion regarding gender.

One very tangible piece of evidence weighs the scale toward the feminine side. The hairdo has two rows of curved locks covering the upper forehead, then a floral wreath. On top, there is a miniature representation of a fortified city, which usually identifies the patron goddess of a city and is thus less likely to appear on males.[2] This iconography derives from Hellenistic-Bactrian prototypes. A thick, hard, white burial crust has developed over the surface of these first two heads.

The third head was acquired with the first two, but may be from a different site. The material, clearly terra-cotta, seems to be of a different composition, and the surface has a different kind of skin. This female head has a physiognomy that is much closer to Central Asian types, though the lips are wider and more sensual than normally encountered at sites there. Although this must be a depiction of a Central Asian woman, it is less specific than the previous heads and not likely to be a portrait. The hair, arranged in two tiers, is parted at the center into sections of undulating waves that are pulled toward the sides, over the ears, and up to where the ends are knotted above the part. The remains of a wreath are still visible.

[1] Lerner 1980, p. 65; 1981, p. 75.
[2] Taddei 1970, pl. 90.

10 SECTION OF A PORTABLE SHRINE WITH SCENES
 FROM THE LIFE OF THE BUDDHA
 Pakistan, Gandhara, ca. 5th – 6th century
 Stone with the remains of metal pins; H. 4⅜ in.
 (11.1 cm), W. (front) 1½ in. (3.8 cm), W. (side) 1¼ in.
 (3.2 cm), D. 1½ in. (3.8 cm)

Front of shrine

This three-sided section of a portable shrine in triptych form can well serve as the paradigm for a small group of portable shrine fragments whose importance far exceeds their miniature size. Because the dissemination of Buddhist doctrine, styles, and iconography throughout Asia and the Far East was largely effected through portable icons and religious texts, these objects serve as an important body of documentation. Many of these "pocket shrines" must have been carried home by monks and disciples returning from perilous pilgrimages and periods of study. Merchants and traders also carried them along the silk routes. They surely found their way to China and other parts of the Far East as well as Southeast Asia. At least three fragments of stone portable shrines are known to have been found in Central Asia.[1]

The arrangement of most of the individual scenes on this sculpture follows orthodox Gandharan iconography. On one side, the upper register shows the miraculous conception of Prince Siddhartha; below that, the taming of the maddened elephant Nalagiri is shown; and the bottom compartment depicts the fasting Siddhartha. The second side has an unidentified scene on top, then Siddhartha wrestling, and, below, the Buddha's first sermon at Benares (Varanasi). The outer portion of the shrine has Buddha, the head missing, seated in meditation, then a larger image of a standing Bodhisattva Maitreya, and, finally, a damaged representation of a standing Buddha and bodhisattva.

While continuing in the tradition of Gandharan carved friezes, the portable shrine fragments known to me cannot date to the period of greatest sculptural activity in the area, namely, the second to the fourth century. Nor do they belong to the late seventh and eighth centuries, as has been suggested by Barrett.[2] On the basis of style, they fit very comfortably into the fifth and sixth centuries and thus serve as a bridge between Gandharan and Kashmiri sculptural traditions.

Sections of portable shrines are quite rare, and the majority of those known seem to be part of diptychs. The only other section from a triptych that I know of is in the Peshawar Museum, Pakistan.[3]

Exhibited: "Along the Ancient Silk Routes," The Metropolitan Museum of Art, New York, 1982 (not in catalogue).

[1] Lerner 1982a, pp. 61 – 62.
[2] Barrett 1967, p. 13.
[3] Allchin 1972, pl. IX.

40

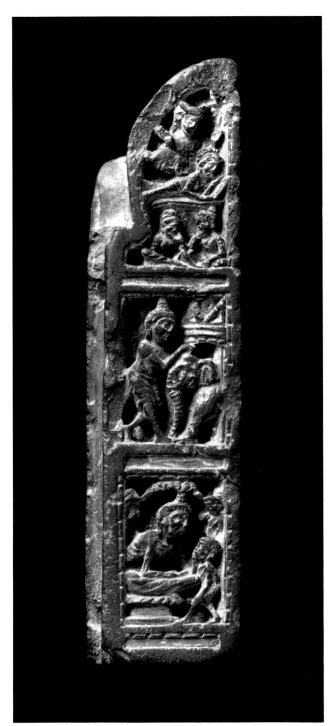

Side

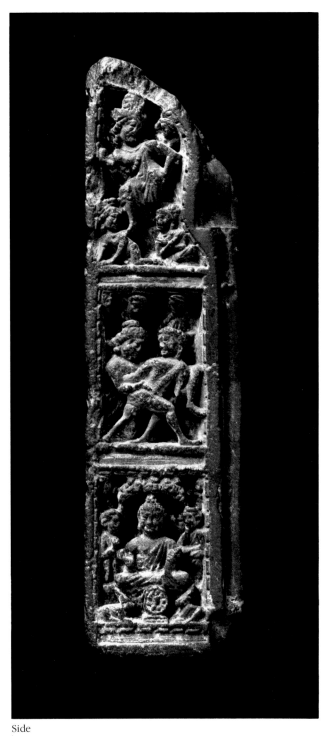

Side

41

11 HEAD OF A BODHISATTVA(?)
India, Andhra Pradesh, Nagarjunakonda,
ca. second half of 3rd – early 4th century
Limestone, H. about 6⅞ in. (17.5 cm)

To the south of the areas ruled by the Kushans, in what is today the state of Andhra Pradesh, major dynasties were established by the Satavahanas and Ikshvakus. Under the patronage of the former, the great gates at Sanchi and the stupas at Amaravati were erected. Ikshvaku patronage was responsible for the later Buddhist and Brahmanical sites at Nagarjunakonda, from which this fine head comes. The art styles and iconography of Andhra had far-reaching influences — apparent in the sculpture of countries as widespread as Sri Lanka (Ceylon) and Afghanistan.

This compelling head, probably of a bodhisattva, is distinctively within the stylistic range of the Nagarjunakonda sites. Carved from a greenish-tinged limestone, the long, slightly ovoid face has the flat nose, small pursed lips, and open eyes typical of the styles of the later stupas at Nagarjunakonda. The complex turban, drawn to the rear of the head and knotted, is one of the many variants found on both relief sculpture and sculptures in the round from these sites.

In comparison with the sculptures of Gandhara and Mathura, which are well represented in the United States, examples of the Andhra style, particularly sculptures in the round, are quite rare.

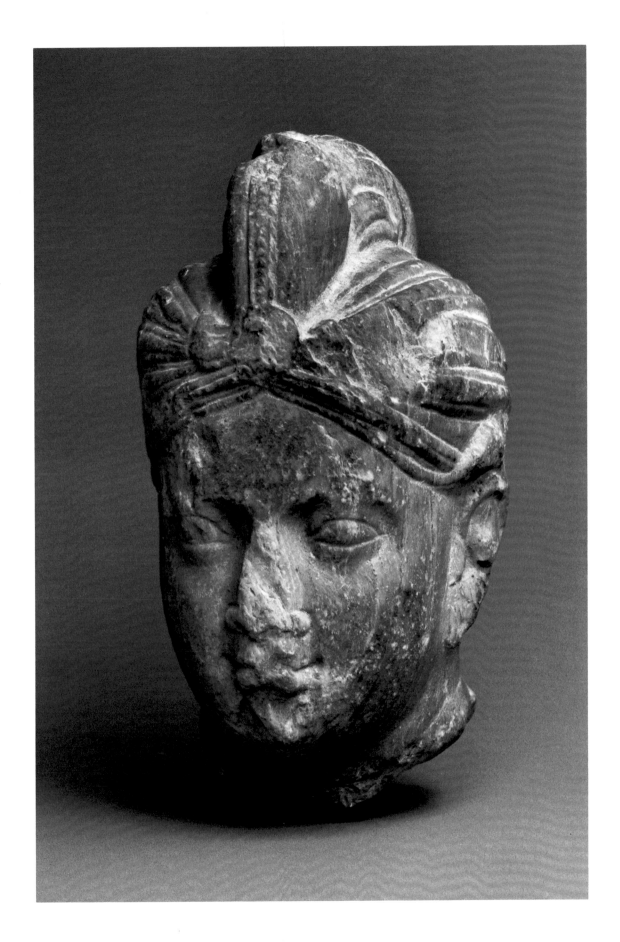

12 HEAD OF BUDDHA
Sri Lanka, Anuradhapura style, ca. 5th century
Bronze, H. 2½ in. (6.3 cm)

The chronology and stylistic sequences of the art of the island-nation of Sri Lanka (formerly Ceylon) are very difficult to chart. The conservative nature of Sinhalese art and the lack of dated monuments or individual sculptures make the task a particularly frustrating one. Even among Sinhalese scholars there is little unanimity regarding stylistic chronologies, although they do agree that the art of the small nation was at times clearly responsive to stylistic changes occurring in India. As a result of the somewhat free-ranging, idiosyncratic interpretation of stylistic sequences, it is not at all unusual to find the same important sculpture assigned dates as much as four or five hundred years apart. A case in point is the famous bronze seated Buddha from Badulla now in the National Museum, Colombo, which has been given five different dates ranging from the third to the eighth century.[1] Other examples could easily be cited. Rather than being discouraged by such a chaotic situation, one is forced to be even more careful than usual in suggesting approximate dates.

The dating of this rare bronze head of Buddha is especially taxing because its body, and the evidence it would have provided, has been lost. Discussing the head in the context of Indian art, rather than indicating cognate Sinhalese examples, may be more informative. During the early periods (from about the second to the fourth century) of sculptural production in Sri Lanka, there was a close dependence on the styles of southern India, particularly Andhra Pradesh. At times it is difficult to determine, on the basis of style alone, whether a sculpture was created in Andhra Pradesh or Sri Lanka.

An interesting feature of this head is the hairline. Instead of being the simple single or double curve found on many later sculptures, this hairline curves four times as it crosses the forehead—over each temple and again on the sides in front of the ears. This unusual treatment seems to be indicative of a relatively early date, as it is a direct borrowing from representations of the Buddha of the Ikshvaku and late Satavahana periods (second to third century) from Andhra Pradesh.[2]

One of the main clues that allows us to assign this fine head to Sri Lanka rather than Andhra Pradesh is the lack of an *urna*, or round mark between the eyebrows, sometimes depicted as a circular wisp of hair. The *urna* is

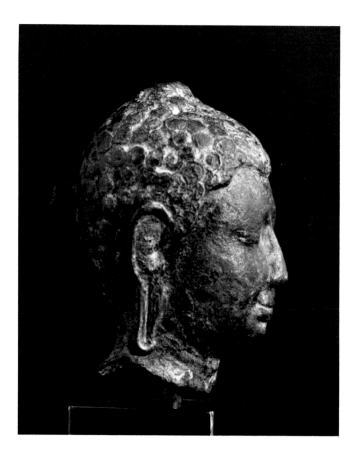

a special kind of "beauty mark" and one of the suprahuman markings or physical attributes *(lakshanas)* of the Buddha. Although quite prominent in Andhra sculpture,[3] this *lakshana* was usually omitted by Sinhalese sculptors.

The nose of the Buddha is partially reconstructed.

[1] Sivaramamurti (1963, pl. ɪd) assigned it to the third century; de Silva (1976, p. 37) to the fifth; Snellgrove (1978, p. 144) to the fifth through the sixth; Wijesekera (1962, p. 247) to the seventh; and Dohanian (1977, p. 93) to the early eighth.
[2] Visitors to the 1982 Hayward Gallery exhibition of Indian art in London could have seen this feature on a standing Buddha from Andhra Pradesh dated to the second or third century (*In the Image of Man,* 1982, no. 329, p. 190).
[3] *Rarities of the Musée Guimet,* 1975, p. 37.

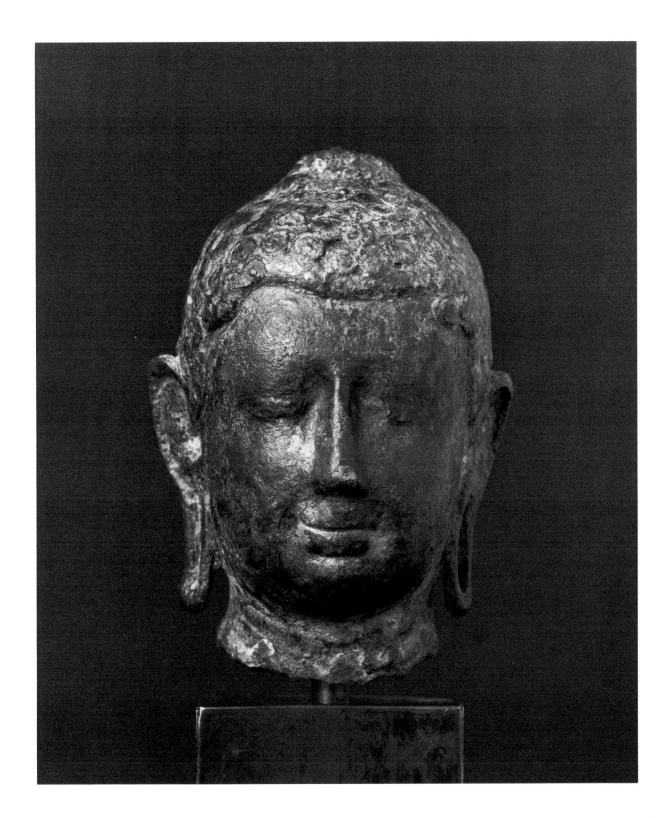

13 SEATED BUDDHA

Sri Lanka, Anuradhapura style, ca. 7th century
Bronze with traces of gilding, H. 3½ in. (8.9 cm)

Although Anuradhapura was pillaged by the Pandya armies of southern India during the ninth century and the Chola armies during the tenth, it remained the Sinhalese capital from ancient times until 1070 when, for strategic purposes, the capital was moved to Polonnaruva. The finest Sinhalese art dates to the Anuradhapura period. Unfortunately, relatively few bronze sculptures from this period have survived, and those extant must be considered precious evidence of a once glorious past.

This small Buddha from the Anuradhapura period sits in the half-lotus posture *(virasana)*, his right leg over his left. His hands rest on his lap in the attitude of meditation *(dhyanamudra)*. The monastic garments are arranged so as to leave the right shoulder bare, and the drapery folds are indicated by precise incised lines. The neck has the *trivali* markings (the three auspicious beauty folds) and the hair, arranged in small curls, covers a high *ushnisha* (cranial protuberance symbolizing transcendent wisdom). In all ways, this seated Buddha is represented in the manner usual for Sri Lanka, though it is clearly among the most aesthetically satisfying of all Sinhalese bronzes.

The masterful combining of smoothly flowing volumes and beautifully proportioned, superbly articulated forms is impressive. The chest swells upward to the gently sloping yet powerful shoulders. The proportions of the legs and the wide angle of the spread knees suggest that the legs are extraordinarily long, but in perfect harmony with the rest of the body. The shape of the head is different from that of the earlier example in No. 12; it is longer and slightly ovoid. The hairline is also different, and lacks the additional curved section at the temples.

The expression on the face is quite remarkable, and seems to suggest a sense of transcendent assuredness almost empyrean in its totality. Neither stern nor welcoming but, rather, impersonal and devoid of emotion, it is the expression of a being who has reached a higher plane of cosmic consciousness. Aside from its obvious great dignity, this Buddha image has a compelling, almost hypnotic, presence. The artist behind this masterpiece has translated a spiritual conceptualization of the Buddha into a tangible reality that approaches perfection.

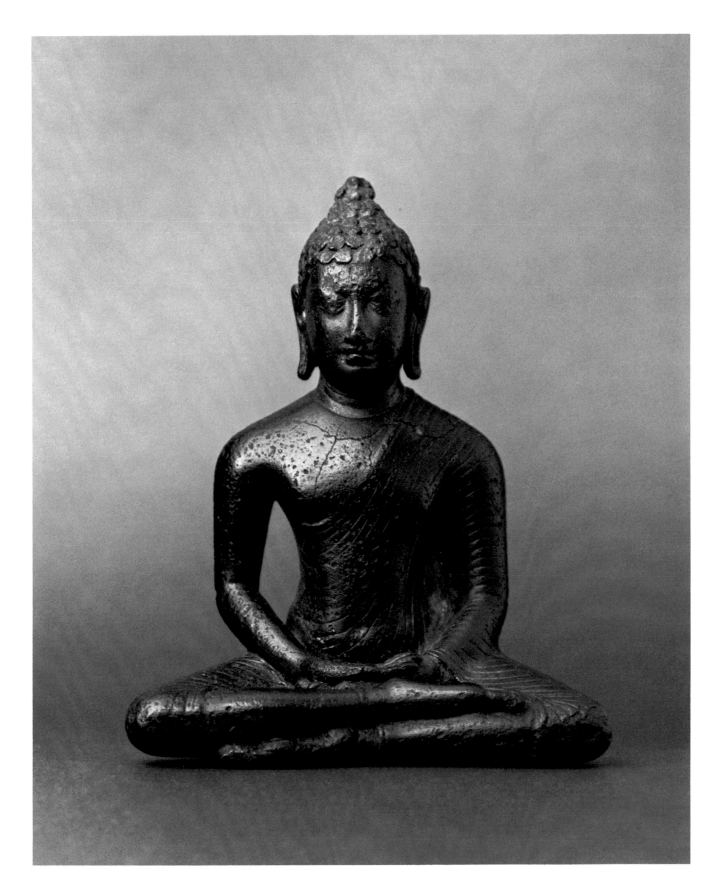

14 *NAGARAJA* AND *NAGINI*
(SERPENT KING AND CONSORT)
India, Madhya Pradesh, Gupta period,
ca. second quarter of 5th century
Stone; *Nagaraja:* H. 38⅞ in. (98.7 cm),
Nagini: H. 34½ in. (87.6 cm)

The animistic worship of serpents *(nagas)* on the Indian subcontinent is considerably more ancient than the worship of the Brahmanical deities or the Buddha and may go back to the dawn of civilization. The regenerative aspect of snakes, along with their other distinctions, has disturbed and captured the popular imagination of many cultures, and snake worship is encountered in one form or another in areas geographically quite distant.

In India, the *nagas* are associated with water, which is considered holy. Ancient sites were sometimes associated with *nagas,* and temples were dedicated to *naga* worship. Following the Indian tradition of erecting temples on ground already considered sacred, there seems to be evidence for Buddhist monuments having been constructed over earlier *naga* temples.[1] Attesting to the popularity of *naga* worship in the Mathura region is the existence of many anthropomorphic statues of *Nagarajas* (Serpent Kings), which usually take the form of a standing figure set against the flattened coils of a snake and canopied by its large, outspread hood. The cobra normally has seven heads for a *Nagaraja* and five for a *Nagini* (Serpent Queen, or the consort of a *Nagaraja*).

It is not surprising that these popular tutelary deities were eventually enlisted into the service of the major religions. *Nagas* figure prominently in both Hindu and Buddhist legend. They are important minor players in the drama of Buddhism in the Gandhara region, in spite of the lack of evidence of great cults of *naga* worship that would have prompted the dedication of large single images like those found at Mathura and in other parts of India.

This Serpent King stands with both feet firmly and uniformly positioned on the ground, in the *samabhanga* stance. His lowered left hand holds a flask, and between the thumb and forefinger of his raised right hand he holds the stem of a lotus whose flower is missing. The deity wears a necklace, bracelets, and earrings, and a turban in which there appears to be the suggestion of a leonine face spewing pearls. He is dressed in a short dhoti secured by a sash knotted at the left side, and between his legs there appears to be a panel of cloth that descends to his ankles. A long scarf encircles his body. It falls over his left shoulder and crosses his left forearm and knees before disappearing behind the right hip. The scarf is looped over the left wrist, and the two ends are suspended down the left side. The *Nagaraja* is framed by the heavy coils of the serpent—three at each side. Although only a portion of the septenary cobra hood has survived, enough is present to establish the relationship of scale between human figure and *naga.*

The *Nagini* stands in the same manner as her consort and is similarly framed by the coils and hoods of the *naga.* Her raised right hand holds a lotus flower, and her left hand is placed on her left hip. She wears a tightly adhering transparent garment and a thick scarf, of which only the section falling down her left side has survived. Her forearm is covered by bangles and she wears the usual necklace and earrings, as well as coiled anklets of uneven thickness. Above the waist, she wears a fine *suvarnavaikakshaka,* a kind of thin belt crossing from shoulders to hips. Her hair is arranged in a Gupta style, and in the center of her hairdo, above her forehead, is a large jeweled medallion (*lalatika* or *chatulatilaka*).

The stocky, powerful proportions of the *Nagaraja* are reminiscent of the sculptural styles of Madhya Pradesh during the first half of the fifth century, particularly as seen at Udayagiri.[2] The *Nagini* shows the beginnings of the trend toward a taller, more elegantly proportioned figure seen on some sculptures from Sanchi that are stylistically datable to around the second quarter of the fifth century.[3] Because the Kronos Collections *Nagaraja* and *Nagini* are closer in style to the Sanchi sculptures, they should be assigned a similar date.

The somewhat eroded condition of these sculptures does not detract from their power or grandeur. Despite the more refined and elegant proportions, their lithic qualities are reminiscent of the iconic monumentality associated with pre-Gupta period sculptures. The resolute gazes of both figures enhance their authority and presence, though the effect is tempered by the sensual beauty of their faces.

Both figures are carved in the round, the intertwined coils of the *naga* clearly defined on the backs in low relief. Their frontal orientation suggests that they were originally placed against a temple wall.

Gupta period representations of *Nagarajas* are relatively rare, particularly when compared to the number of surviving Kushan period examples. Gupta examples of *Naginis* are even rarer. The Kronos Collections pair are therefore of major importance, and must be considered a significant link in the chain of Gupta sculpture studies.

[1] Vogel 1912, pp. 159–60.
[2] Harle 1974, pls. 8, 10, 11.
[3] Ibid., pls. 40, 41.

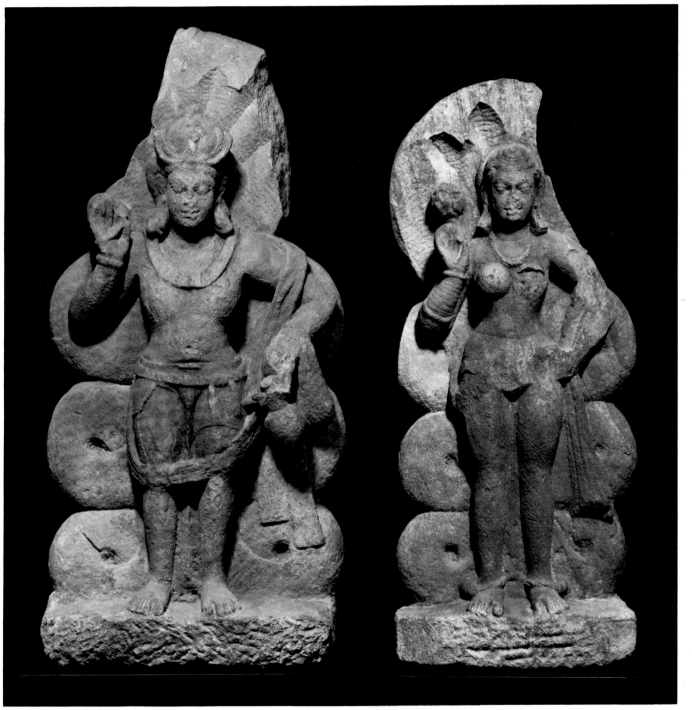

Nagaraja *Nagini*

49

15 STANDING FOUR-ARMED VISHNU
India, Kashmir, late 7th century
Stone, H. 18¾ in (47.5 cm)
Gift of The Kronos Collections, 1982 (1982.462.9)

In Indian sculpture it is usual for the body to be conceived of as a container or vessel for the sacred breath, which expands from within, making the skin so taut that the musculature is concealed. Kashmiri sculpture, on the other hand, follows Gandharan traditions, which stem from Hellenistic-Roman prototypes. The usual Gandharan rendition of a standing bodhisattva shows the figure with a full, well-muscled chest, and this powerful representation of a four-armed Vishnu standing in a slightly hipshot posture clearly continues that tradition.

Vishnu wears a three-lobed tiara, with two pleated ribbons falling from a knot at the back of the head. The deity is richly adorned with an elaborate torque, a necklace, earrings, a jeweled belt, and armbands. He wears a dhoti, a scarf around his hips, knotted in front with the ends doubling back, the sacred thread across his chest from his left shoulder to the right side of his waist, and the standard floral garland *(vanamala).* Vishnu's auspicious symbol, in the form of a slightly raised lozenge, appears on his chest. All this rich surface decoration is in marked contrast to the rippling muscles of the chest and the other areas of bare flesh.

More complete examples of Kashmiri Vishnus permit a reliable reconstruction of the original appearance of this sculpture. Both front arms would have projected outward, the raised right hand holding a lotus, the left, a conch. The two back arms would have been lowered, the hands resting on the personified attributes of Vishnu: Chakrapurusha, the dwarf personification of his war discus, on the left, and Gadanari (or Gadadevi), the female personification of his mace, on the right. Between the feet of Vishnu, rising out of the pedestal supporting the group, the earth goddess Bhudevi would have appeared.

Quite a few unusual details on this Vishnu seem to corroborate a dating to the late seventh or early eighth century. On Kashmiri sculpture of the second half of the eighth century and later, the floral garland is almost always longer than the one seen here, usually falling well below the knees, while post-Gupta sculptures of the sixth and seventh centuries often have the shorter *vanamala.* The wide, elaborate torque with two *makaras* (mythological creatures; see No. 47) is almost never encountered on Kashmiri sculptures after the middle of the eighth century, but is not uncommon on earlier sculpture. I know of no other instances where the sash around the hips is knotted between the thighs, with the ends going back around the figure; the only Kashmiri comparison, and at that still rather dissimilar, appears on a well-known bronze Chakrapurusha datable to the late sixth or the seventh century.[1] Vishnu's hair is arranged in cylindrical curls in the fourth- to sixth-century Gupta fashion that became the standard in Kashmir from around the sixth or seventh century. Within the context of Kashmiri sculpture, it is rather unusual to find the ubiquitous dagger at the right side missing, and it is also unusual, but not unique, that there is no halo behind the head.

The majestic presence of this image is enhanced by the sense of inner spiritual strength it radiates, something not often found in Kashmiri stone sculpture of the ninth century. There is also none of the pudgy roundness associated with ninth-century sculptures, particularly those assigned to the reign of Avantivarman. Rather, the dynamic tautness in the modeling of the body is reminiscent both of Gandharan bodhisattvas of the third and fourth centuries and of the sculpture of the Gupta period (fourth to sixth century). This Vishnu's great sculptural power is heightened by the position of the raised front arms, elbows pointing outward — on most Kashmiri sculpture the front arms are closer to the body. This unusual posture appears earlier on a Gupta period (ca. 400) relief sculpture of Vishnu outside Cave 6 at Udayagiri.[2] A fine early Kashmiri sculpture of the god Karttikeya, not likely to date later than the sixth century, now in the Sri Pratap Singh Museum, Srinagar, exhibits many interesting similarities to this figure, including the powerful proportions of the body.[3]

Our Vishnu seems, therefore, to be transitional: he retains the sculptural vigor of the earlier styles while foreshadowing the fully developed Kashmiri styles of the second half of the eighth century. This sculpture is not only one of the earliest Kashmiri stone examples in Western collections, it is also one of the finest.

[1] Pal 1975a, pl. 14.
[2] Harle 1974, pl. 8.
[3] Kak 1923, p. 66.

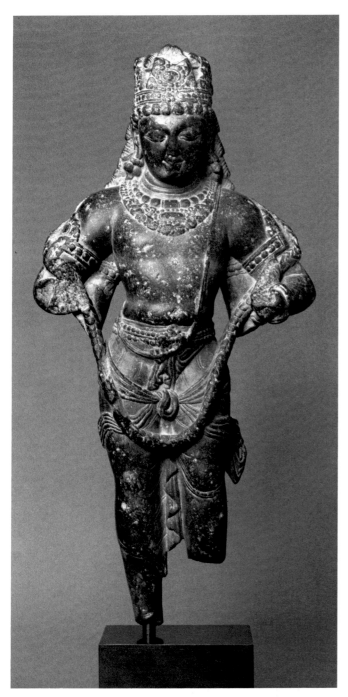 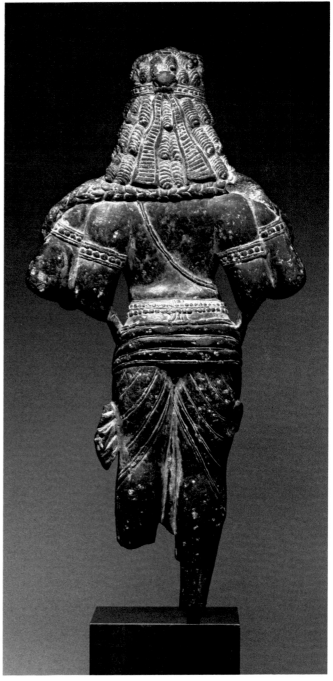

16 STANDING BODHISATTVA VAJRAPANI
Nepal, Licchavi period, 6th – 7th century
Bronze(?), H. 8¹⁄₁₆ in. (20.5 cm)

The early Buddhist and Hindu sculpture of Nepal, a major tradition within the field of Asian art, is represented in the Kronos Collections by three sculptures. The earliest of the three is not only a major addition to the literature, but a sculpture of stunning quality.

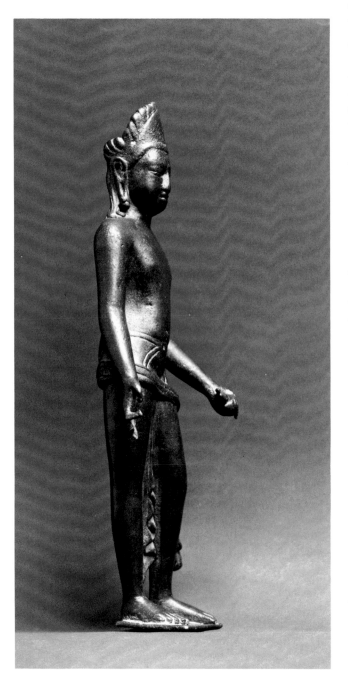

A male deity, nude from the waist up, stands in the most graceful hipshot position, the weight of his body shifted to the rigid right leg, the left leg slightly bent. His lowered left hand holds a thunderbolt (vajra), and his right hand, with thumb and index finger curved toward each other, is in the gesture of holding a small round object, perhaps a fruit or a lotus bud. He wears a dhoti secured at the waist by a plain knotted belt. Gathered between his legs is a panel of cloth with gently undulating folds. Remarkably, there are no other indications of the dhoti; the lower hemline is not shown, nor is the cloth patterned. A sash, or long scarf, is worn diagonally across the hips and knotted at the left side, the two ends descending gracefully in pleated folds terminating in two finely arranged flares.

The deity wears a plain, miter-shaped tiara backed with a stiff, pleated cloth. Three fine strands of hair curve onto each shoulder in the fashion often seen on northern Indian sculptures. Except for the discreet earrings, the three auspicious beauty folds (trivali) at the front of the neck, and a small mark in the center of the right palm, the deity is otherwise unadorned.

This figure, quite simply, is a very strong candidate for being the most beautiful early Nepali metal sculpture in existence. Slim and elegant, with gently swelling body forms, modeled with refinement and sensitivity, it can be placed at the very apex of Nepali sculpture. The almost total lack of surface decoration emphasizes not only the exquisite modeling, but also the subtle stance with its slight twists of the body and positioning of arms and legs on different planes. The almost stern composure of the face is compelling, and even the feet are modeled with extraordinary care. There is a nobility of bearing and an astonishing sense of regal presence. Perhaps, in summary, one can suggest that there is an aesthetic purity at work here that has resulted in a sculpture that clearly transcends all its known peers.

The approximate date of this masterpiece can be established by comparing it to three well-published sculptures. Perhaps the most useful starting point for a stylistic analysis is the Dvakha Baha stone chaitya in Kathmandu.[1] This seventh-century (Licchavi period) four-sided monument is one of the cornerstones of the study of early Nepali sculptural styles. Two of the sides have representations of Buddhas, the other two have images of the bodhisattvas Padmapani (Avalokiteshvara) and Vajrapani (the thunderbolt bearer). These bodhisattvas establish the type of dress and ornamentation that will be found on virtually all Nepali metal images from the seventh through the tenth century. Each wears a dhoti with incised decoration, a portion bunched between the

legs, secured by a jeweled belt, and a sash across the hips, knotted at one side with the pleated balance falling into two flaring ends. The standard jewelries — necklace, earrings, bracelets, and armbands, as well as the appropriate crowns — are also worn. In addition, Padmapani wears the sacred thread *(yajnopavita),* which will be seen on almost every other Nepali male figure from the seventh century onward; three notable exceptions are the standing Vajrapani on the Dvakha Baha chaitya, a standing copper Vajrapani[2] (or Indra[3]) in the Los Angeles County

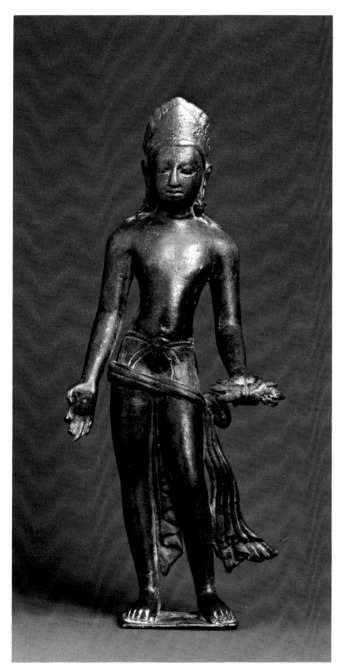

Museum of Art, and this standing figure from the Kronos Collections.

The metal sculptures most useful for comparison are two eighth-century Vajrapanis, the one in Los Angeles and another now at The Cleveland Museum of Art.[4] Both are in the fully developed Nepali style and wear dhotis, with the usual incised decorations, secured by jeweled belts with central jeweled medallions. A necklace and bracelets are worn by both figures, and the one in Cleveland also has armbands and the long sacred thread, worn diagonally from left shoulder to right knee.

The eighth-century Cleveland Vajrapani exhibits the standard treatment of the dhoti and type of jewelries worn by male deities established as early as the seventh century by the Dvakha Baha bodhisattvas. The absence of armbands and the sacred thread on the Los Angeles Vajrapani, as well as some stylistic nuances, suggests that a late seventh-century date may be preferable to the early eighth-century date most recently assigned to it.[5] Not only is the Kronos Collections Vajrapani free from these standardized motifs of dress and adornment, but its facial type also seems to be in a style anterior to the fully developed Nepali facial features found on the Dvakha Baha chaitya. It is entirely possible that it predates not only the Los Angeles Vajrapani but the Dvakha Baha chaitya as well.

Because the Kronos Vajrapani clearly represents an early stage of development of the Nepali style, and is without the stylizations characteristic of the seventh and eighth centuries, it brings the Nepali tradition, at least in metal sculpture, backward one step closer to Gupta prototypes. The mode of dress (or lack of it) seems to have been inspired by the fifth- and sixth-century Gupta period aesthetic of Sarnath, where the pronounced preference for tightly adhering garments without drapery folds emphasized the plasticity of the body.[6] Although additional Gupta period sites such as the early sixth-century temples of Nachna Kuthara[7] provide informative precedents, I would not suggest a specific Gupta school for an immediate prototype. Rather, there is no doubt that the general system of aesthetics developed under the Gupta empire clearly carried over to the creation of this sculpture.

A metal analysis has not yet been done, but this sculpture is not of the high-copper-content alloy normal for early Nepali metal statues. It may indeed be bronze rather than copper. There are no traces of gilding.

[1] Pal 1974, pls. 13 – 16.
[2] Ibid., pl. 202.
[3] After examining this sculpture, von Schroeder seems to have spotted a horizontal third eye. This, combined with the miter-shaped crown, has prompted him to identify the deity as Indra rather than Vajrapani. See von Schroeder 1981, pl. 75D.
[4] Pal 1974, pl. 203.
[5] Pal 1978b, p. 120.
[6] Pal 1974, pl. 22.
[7] Harle 1974, pl. 107.

17 STANDING FOUR-ARMED VISHNU
Nepal, 10th century
Gilded copper, H. 8⅜ in. (21.3 cm)

In Nepal, the sculptural representations of Vishnu most often encountered show him four-armed and standing in a rigid symmetrical posture. In his raised left hand he holds the war mace *(gada),* in his raised right hand the war discus *(chakra).* His lowered left hand holds the conch *(shanka),* a kind of battle trumpet, and his lowered right, a round object probably meant to be a lotus bud *(padma).* The particular arrangement of these four attributes identifies this form of Vishnu as the *shridhara* type, one of the twenty-four forms of Vishnu, the most famous example of which is probably the tenth-century stone Vishnu at Changu Narayan.[1]

The implication of Vishnu's battle implements should not go unnoticed. Hindu theology systematically allows divinities to assume various forms to accomplish specific tasks. Vishnu, in his special role of preserver and protector of the universe, is periodically called upon to save the universe from some great calamity. This he does in the guises of his special avatars, which represent specific descents from his heaven to combat the forces of destruction and evil. In this context, Vishnu must be understood to be a martial deity, and accordingly holds war instruments. The seemingly contradictory lotus is an almost generic symbol of divinity.

Vishnu stands on a stepped pedestal with a scrolling floral decoration. He is dressed in a dhoti, with a portion bunched between his legs. A jeweled belt, bracelets, armbands, a necklace, earrings, and the sacred thread are all present. He wears a three-lobed crown, the central panel of which contains the leonine "face of glory" *(kirtimukha).* His head is framed by a nimbus with a design of pearls and stylized flames. He also wears a sash around his waist, the two falling ends swerving symmetrically outward. Only the raised mace disrupts the otherwise hieratic symmetry of the figure.

A much greater sense of bulk and solidity is evident with this figure than with the preceding Vajrapani (No. 16). The proportions of the elaborate aureole (which has survived on very few early Vishnus) not only seem to emphasize the powerful form of the deity, but also impart a visual richness unusual for such images.

Published: Pal 1975b, no. 78, p. 131.

[1] Pal 1974, pl. 117.

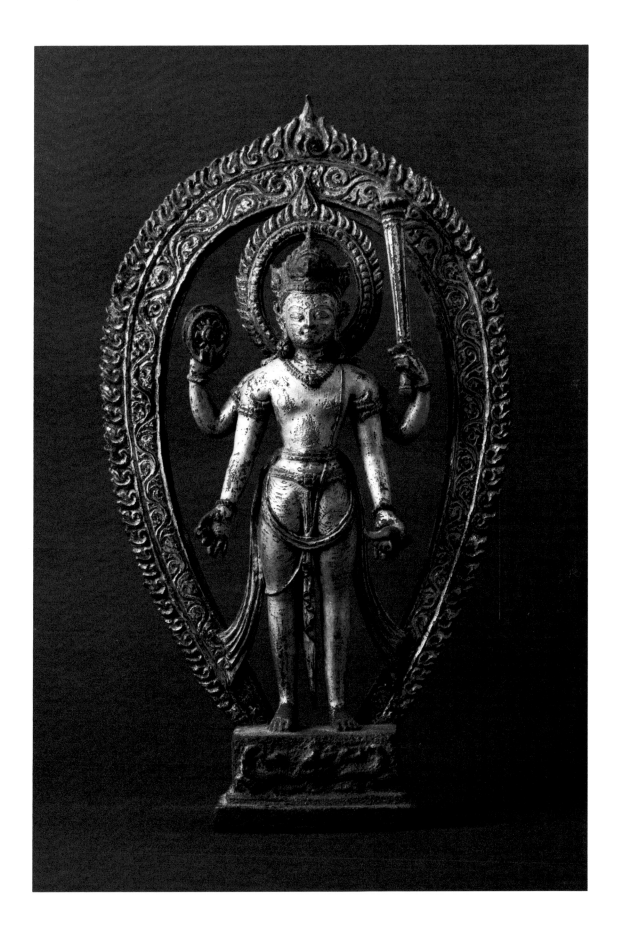

Nepal, ca. 11th century
Gilded copper, H. 4⁵/₁₆ in. (11 cm)

That the Kronos Collections abound not only in sculptures of remarkably high quality but also in iconographic types not often encountered will by now be quite apparent, and is exemplified by this Nepali representation of Garuda, the half-avian, half-human vehicle of Vishnu.

Except for his large, elaborate wings, arranged almost like a feathered cape, this kneeling Garuda is shown in human form. His dress, including the sacred thread, is of the type often worn by Nepali deities. Garuda's serpent-shaped armbands and necklace are a reminder of the ancient antagonism between the great birds and serpents *(nagas).* He wears two different types of earrings, as is usual, and a three-lobed tiara. His hair is piled high in a bun in a manner reminiscent of Gupta styles. Viewed from the rear, the arrangement of feathers and falling locks of hair is handled in a very skillful manner.

Up to this point, everything about the image is treated in orthodox iconographic fashion. The objects held in the hands and the position of the arms, however, are anything but orthodox for such an early date. In his right hand, Garuda holds the flaming *chakra,* an attribute borrowed from his master, Vishnu. In his left hand, he holds a vase containing what appear to be thin, curling leaf forms. A vase is sometimes held by Vishnu when he is shown with more than four arms, but it must be considered a rare attribute. In the context of this early example, the vase held by Garuda should be understood to represent either a "vase of plenty" *(purna-ghata),*[1] or the vase containing the elixir of immortality *(amrita)* recovered by the gods during the churning of the Ocean of Milk[2] (see No. 46).

Equally surprising is the position of Garuda's arms. In virtually all early images of Garuda familiar to me, there are only three types of arm positions: (1) when Garuda is shown supporting Vishnu on his back, his wings and arms are usually symmetrically outstretched[3] (or, on rare occasion, while his wings are outstretched, his hands support the feet of Vishnu);[4] (2) when Garuda is part of a larger stone composition, either standing or flying, his hands are joined together in *anjalimudra*[5] *(namaskaramudra),* the gesture of adoration; and (3) when Garuda is a separate icon, he is often depicted kneeling, again with his hands clasped in the attitude of adoration.[6]

An immediate prototype for this very unusual example of Garuda, with outspread arms holding a *chakra* and a vase, is not known to me, but Indian precedents probably exist. A considerably later Nepali kneeling Garuda of this form seems to be one of the very few published examples; its pedestal may also preserve the look of the original pedestal for the Kronos Collections Garuda.[7]

Until the discovery of an older example, this Garuda seems to have the distinction of being the earliest known representative of a most unusual iconographic variant of the vehicle of Vishnu.

[1] It is interesting that the *purna-ghata* appears on the pedestal of the Changu Narayan Vishnu (see No. 17, note 1).

[2] P. Pal has written that the pot and a parasol, according to the texts, are the prescribed attributes for Garuda. I am unaware, however, of any particularly early examples of this type. See Pal 1970, p. 121 and fig. 108.

[3] Pal 1974, pls. 30, 97, 109–12.

[4] Ibid., pl. 108.

[5] Ibid., pls. 2–4.

[6] Ibid., pls. 98, 101–104, 106.

[7] von Schroeder 1981, pl. 104c.

19 SEATED BUDDHA
India, Nalanda style, Pala period,
ca. first half of 8th century
Bronze, H. 2¾ in. (7 cm)
Gift of The Kronos Collections, 1982 (1982.462.3)

This small seated Buddha, acquired in Java by a previous owner, is an example of the sort of easily portable Indian icons that significantly influenced the formulation of styles in Southeast Asia. Indeed, these Indian models, particularly the bronze sculptures of the Pala period, were sometimes followed so closely that occasionally it is difficult to determine if one is dealing with an Indian original or a Southeast Asian copy (see No. 24). This lovely image was in fact previously thought to be a Javanese sculpture, a not altogether impossible assumption.

Probably more than any others, the bronze sculptures of the eighth through the tenth century from the Pala period (particularly those associated with the styles created at the great university and monastic center of Nalanda, in the Patna District of Bihar State) played an enormous role in the dissemination of eastern Indian styles. Their impact is most apparent in the art of Nepal and Tibet, Burma, and the Indonesian kingdoms.

This image of the Buddha is seated on the remains of a lotus pedestal; only the long stamens have been preserved. Part of the mandorla—a portion of the beading motif on the outer perimeter, a single stylized flame, and a strut with one blossom—is still intact. This type of mandorla, seen in complete form on No. 20, is usually associated with Pala styles. The Buddha sits in the cross-legged yogic position, with his left hand, holding a strip of cloth from the robe, resting on his lap in the gesture of meditation *(dhyanamudra)*. His lowered right hand is in the attitude of *bhumisparshamudra* (calling the earth goddess to witness). The monastic garments are arranged to leave the right shoulder bare, and the individual hemlines of the various garments are clearly indicated.

Although preserving much of the Gupta tradition, the proportions of this Buddha have been altered to reflect Pala period preferences. The transition from the full shoulders to the very narrow waist is quite dramatic and is echoed in the face, where the wide forehead descends to a narrow chin. The well-outlined, open eyes and the thin, long neck often appear on Nalanda-style images.

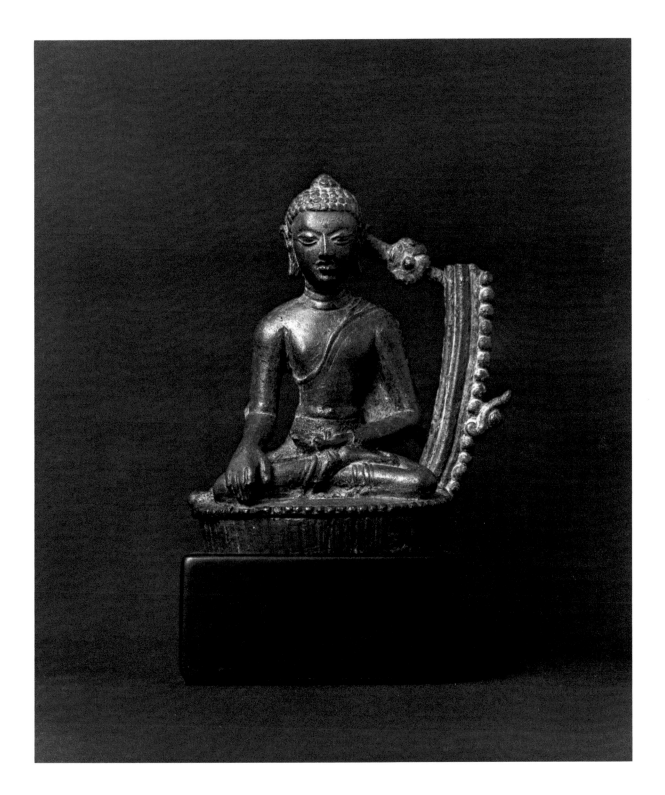

20 SEATED TARA
Bangladesh, Comilla District, or India, Bihar,
Pala period, ca. second half of 8th century
Bronze, H. 6⅝ in. (16.9 cm)
Gift of The Kronos Collections, 1979 (1979.510.3)

Tara, the most revered goddess of the Buddhist pan-
theon, is seated here on a pedestal composed of a row of
stamens emerging from a single row of lotus petals. Her
left leg rests on top of the pedestal; her pendant right leg
is supported by a small lotus attached to the lower part of
the pedestal. Behind her is a mandorla, its struts embel-
lished with blossoms, with an outer perimeter of beads
and stylized flames. In her raised left hand the goddess
holds the stem of the *utpala* (blue lotus or water lily)
whose blossom can be seen attached to the lower right
strut of the mandorla. In the palm of her right hand is a
small round object perhaps representing a lotus bud or a
fruit. Tara wears a long skirt, a sash across her breasts,
and a necklace, armbands, bracelets, and anklets. Her
hair is arranged in a bun with a jeweled medallion at the
front.

As the individual styles of the Pala period in eastern
India are still being sorted out, we are uncertain whether
this imposing sculpture was made in what is today
Bangladesh or should be assigned a Bihari provenance.

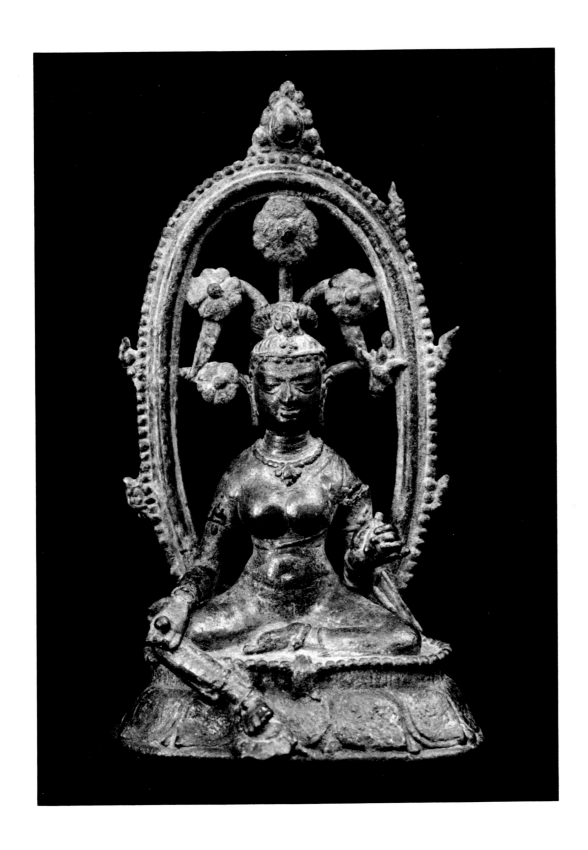

21 THE BUDDHA AKSHOBHYA
Bangladesh, probably Comilla District,
8th century or later
Bronze, H. 8 in. (20.2 cm)

The Buddha Akshobhya is identifiable through the small stylized thunderbolt *(vajra)* placed in front of him and the position of his lowered right hand (the gesture of calling the earth goddess to serve as witness). He is seated in a cross-legged yogic position on an elaborate pedestal composed of a stepped base from which emerges a lotus stalk with two large scrolling leaves supporting a double-lotus throne.

Akshobhya wears the traditional monastic garments, which leave the right shoulder bare. His left hand, resting on his lap in the gesture of meditation, holds a tasseled string that is attached to his robe. Flanking the double-lotus throne is the lower portion of a very unusual halo decorated with rather crudely modeled figures and animals.

Bronze sculptures with similar elaborate pedestals have been recovered from the Salban Vihara at Mainamati, in Comilla District, Bangladesh,[1] though at least one (perhaps originally from Bangladesh) has been found at Kurkihar in Bihar.[2] Another comparable example of this type, from a Buddhist temple-monastery at Chittagong and attributed to the tenth century, has recently been published.[3] In Burma, only slightly to the east of Comilla District, this kind of pedestal, with lotus stems flanked by large leaves and supporting a double-lotus throne, became common during the eleventh and twelfth centuries.[4]

[1] Asher 1980, pls. 248, 250.
[2] Shere 1956, fig. 4.
[3] Mitra 1982, ill. 84.
[4] Luce 1969–70, vol. 3, pls. 400–405.

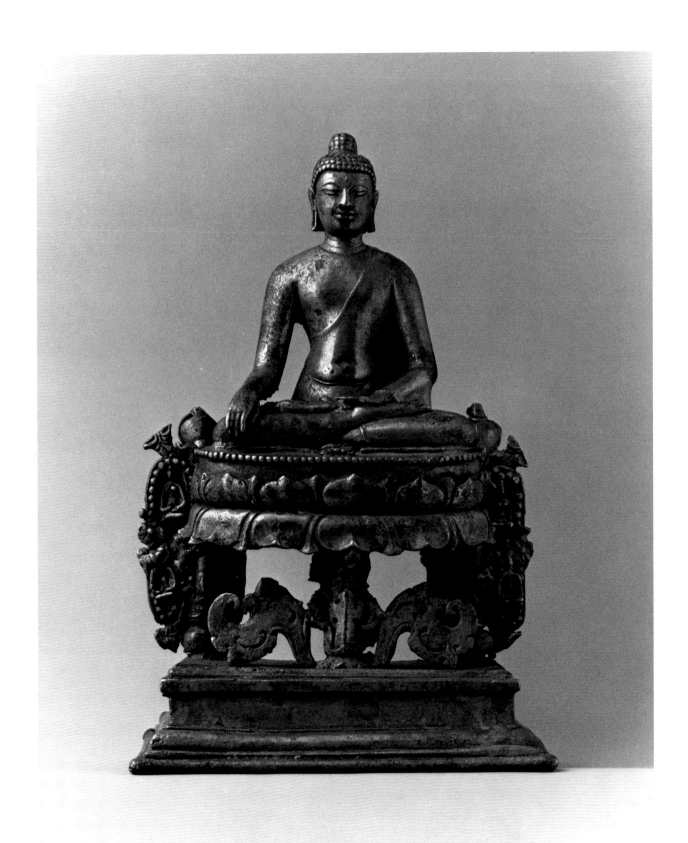

22 CHALICE AND BANGLE
India, Bihar, Pala period,
9th – 10th century or earlier
Bronze; chalice: H. 4 $^{11}/_{16}$ in. (12 cm),
bangle: Diam. 2 $^{15}/_{16}$ in. (7.5 cm)
Gift of The Kronos Collections, 1979 (1979.509.1, 2)

In June 1978, The Metropolitan Museum of Art purchased at auction in London a superb Pala period bronze Shiva seated with Parvati (*Uma-Maheshvara*) group.[1] At the same auction, a bronze chalice and small bangle were sold as separate lots.[2] The auction catalogue stated that all three bronze objects "were discovered in Behar [*sic*] when the river Gogra, a tributary of the Ganges, changed course about seventy years ago."[3] The chalice and bangle were given to the Museum in 1979 as a gift of the Kronos Collections.

On stylistic grounds, the *Uma-Maheshvara* sculpture is datable to the late ninth or the early tenth century. If found alone, the chalice and bangle would have been very difficult to place, both chronologically and geographically. As it is, their dates remain tentative.

The chalice has a deep bowl, with a flanged rim, on a stepped and waisted, flaring circular base. Concentric lines are incised on the interior of the bowl, a conch and fish on the exterior beneath the rim. As mentioned in our description of the earlier bronze chalice purportedly found at Sarnath (No. 5), objects of this sort have not been adequately studied and are not easily dated. The nature of the discovery of this chalice probably permits a Bihari attribution. The method for assigning the date, based entirely on the dating of the sculpture the chalice was found with, rather than on any systematic, morphological analysis, may turn out to be inadequate.

The bangle, basically a split ring with eight rounded bosses, is even more difficult to date than the chalice, as it provides no stylistic clues to assist in establishing its chronological parameters. It may very well be earlier than the chalice, but by how much we do not know. Its small size suggests that if it was intended to be an anklet, it could only have been worn by a small child. The possibility exists that this object had an entirely different use — the auction catalogue described it as an "open ring weight."[4]

Published: Lerner 1982b, pl. xx, fig. 3.

[1] Lerner 1982b, pl. xx, fig. 2.
[2] Ibid., pl. xx, fig. 3.
[3] Sale cat., Christie's, London, June 7, 1978, p. 23.
[4] Ibid.

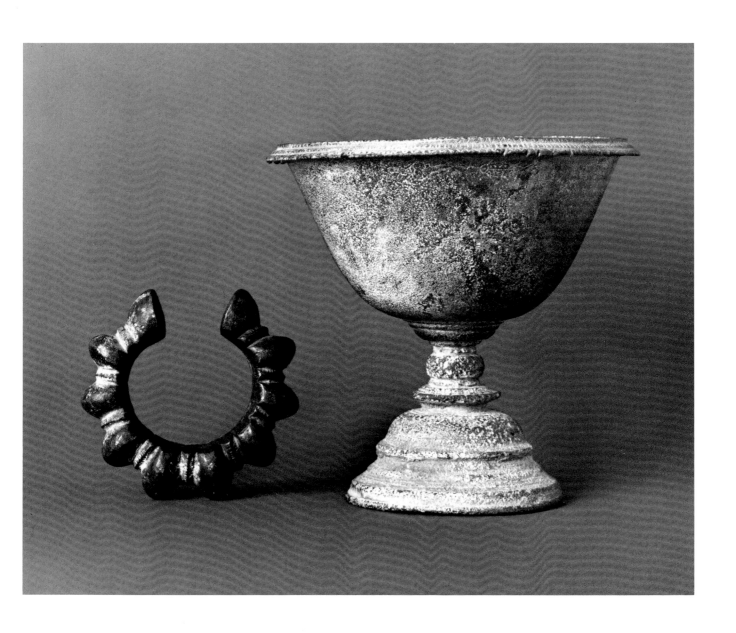

23 STANDING FEMALE DEITY, PERHAPS TARA
India, Bihar(?), Pala period,
second half of 11th century
Stone (Basalt?), H. 24¾ in. (62.9 cm)

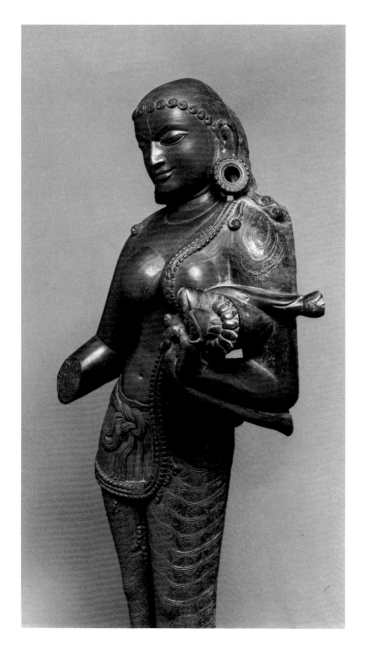

The Indian delight in visual metaphors based on literature, poetry, and nature is clearly evidenced in the injunctions set down in various manuals on how to fashion images. Because the shapes of the individual parts of the bodies of divine images should transcend mundane human references, a different vocabulary of forms is required. Consequently, one finds imagery such as "lips full like the ripe mango fruit," "eyes shaped like lotus petals," and so on. The idealization of the body forms can be seen clearly in the sculptural treatment of this female deity from eastern India.

Standing in a pronounced *tribhanga* (thrice bent) posture, the goddess is shown as a youthful beauty of flawless perfection — no suggestion of the realities of the natural aging processes are permitted to intrude here. Her melon-shaped breasts are perfect hemispheres; her skin is taut and unblemished. The polished surface, the quality of the stone, and the extraordinary precision of carving, of both the larger volumes and the exquisite surface decoration, give the figure the appearance of a sculpture in metal.

The identification of the deity poses a problem. In her present condition one cannot tell with complete certainty if she is a main deity or one of the flanking attendant figures from a large stele. It is rather surprising that she wears no crown, and neither necklaces nor armbands, but these omissions are not sufficiently telling to clarify her identity.

It seems unlikely that she represents one of the consorts of Vishnu. Sarasvati, who appears on Vishnu's left side, almost always holds a musical instrument.[1] Lakshmi, who stands to his right, usually holds a lotus (as here), but her left hip is bent in toward Vishnu, exactly the opposite of our deity's stance. The Buddhist deity Tara, if attendant upon a larger Avalokiteshvara, would also stand on the right side with her left hip inclined. It appears, therefore, that unless we have here an unusual variant, this figure was probably not part of a trinity. The next most likely suggestion is to identify her as an image of Tara that was the central icon of a larger composition.[2]

[1] Banerji 1933, pls. xliv(a) and (c).
[2] For some stylistically and iconographically cognate examples, see Ghosh 1980, pls. 29, 50, and Banerji 1933, pls. iv(b), xvii(c), xxxix(c).

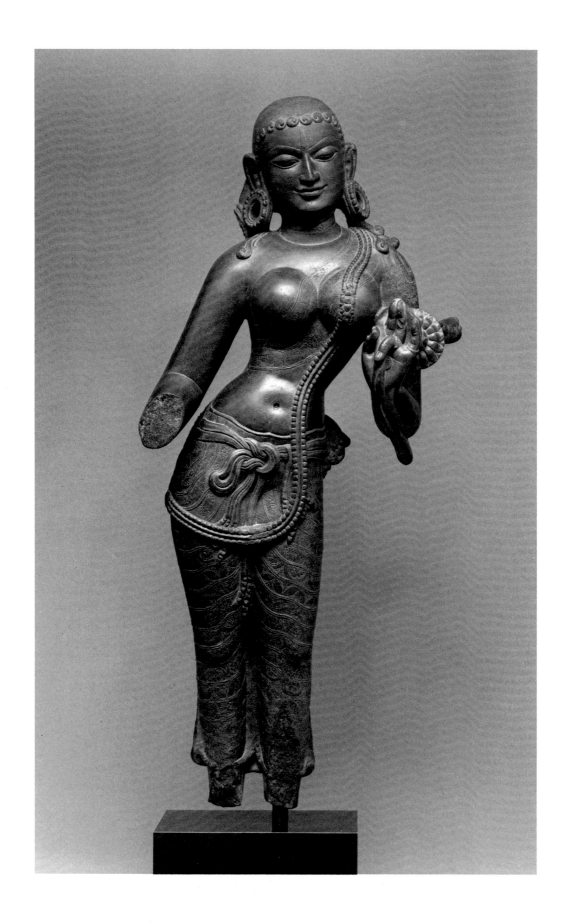

24 SEATED BUDDHA
Burma or northeast India, 11th – early 12th century
Bronze with partial gilding and traces of cold gold
and blue polychrome, H. 5³/₁₆ in. (13.1 cm)

In the West, the study of early Burmese sculpture can be regarded as being either chaotic or simply in a rudimentary stage. This is partly due to the inaccessibility of the material, but other reasons are more germane: very little has been published (G. H. Luce's magnum opus notwithstanding);[1] general interest in Burmese art has lagged (certainly when compared to interest in the art of Cambodia or Thailand); and very few pre-twelfth-century sculptures have survived. The formidable task of establishing chronological and stylistic sequences for the sculpture of this period still remains.

The geography of Burma has always made it susceptible to stylistic impulses emanating from its more powerful neighbors. India to the west and China to the northeast were clearly the most potent centers of artistic activity, but Nepal, Tibet, and then Thailand to the southeast have all contributed in some degree to the various Burmese styles. The variety of ethnic groups in Burma also affected art styles.

With the accession of a new king at the capital of Pagan in 1044, a period of relative stability began and, over the next two or three centuries, styles developed that established the artistic traditions we think of as being characteristically Burmese. After the twelfth century, one can indeed speak of a mainstream of Burmese art based primarily on what has survived at Pagan.

But, along the way, sculptures were created that are almost indistinguishable from those of Burma's neighbors — particularly those of India during the Pala period. To complicate the matter, the influences from northeast India during the Pala period penetrated to other receptive centers such as Tibet, and occasionally one is confronted with a sculpture of unknown origin that could be either a Pala original or a Tibetan or Burmese sculpture so closely following Pala prototypes that it is difficult to assign a provenance with any degree of confidence. To further confuse stylistic analysis, portable Burmese sculptures migrated to Tibet. That this seated Buddha, wherever it was made, was at one time worshiped in Tibet is apparent from the traces of cold gold on the neck, ears, and parts of the face, as well as from the blue pigment still visible in parts of the hair.

The Buddha sits on a raised double-lotus throne in the cross-legged posture of *vajrasana* (the diamond or adamantine posture). His left hand rests on his lap and his lowered right hand makes the gesture of calling the earth goddess to witness, which is associated with that crucial event prior to his enlightenment at Bodhgaya (Gaya): the temptation of Siddhartha by the personification of evil, Mara.

Assembled along the very fine line dividing some Burmese sculptures of the eleventh and twelfth centuries from those of northeast India are stylistic criteria both amorphous and concrete. On the Burmese side, I would place the squat proportions of the body, the heaviness of the upper arms, and the shape of the face and head of this Buddha. The application of gold to the exposed parts of the body (as separate from the later application of cold gold during the sculpture's tenure in Tibet) is a technique of surface embellishment usually associated (correctly or not) with Burma.

If this is not an Indian sculpture, then northeast India must be credited with its immediate prototype. On the Indian side, I would cite the proportions and arrangement of the lotus petals, which closely follow Bihari bronze sculptures.[2] The color of the ungilded metal is very similar to many Pala period sculptures, and the treatment of the flap of garment on the left shoulder, although found on some Burmese sculptures, is more Indian than Burmese. The very small curls on the head appear on both Indian and Burmese sculpture.

The uncertainty regarding this sculpture's origin is indicative of the existence of a true international style during this period and reminds us of the great need for additional research on early Burmese metal sculptures.

[1] Luce 1969 – 70.
[2] Sharma 1979, figs. 1, 2.

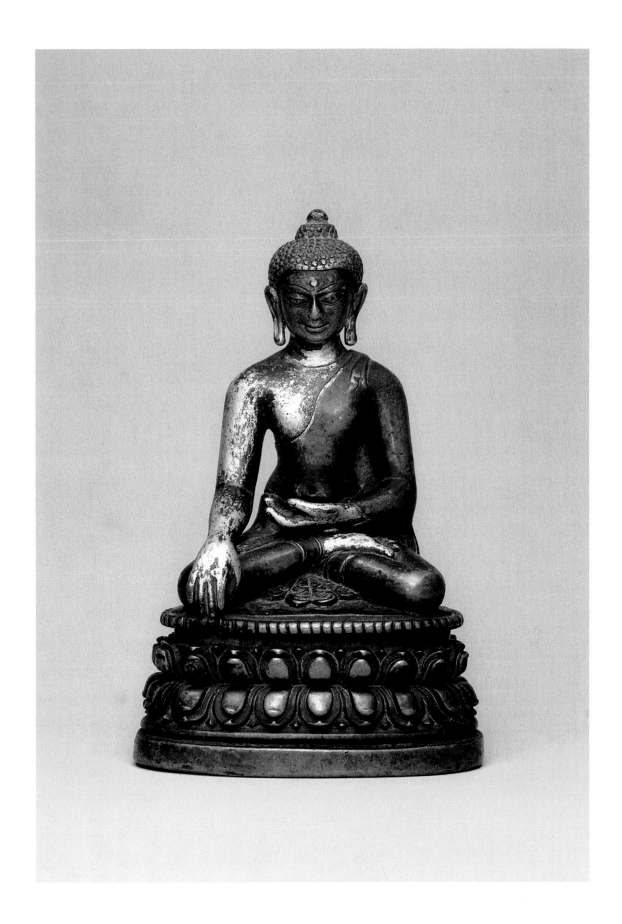

25 SEATED AMITAYUS,
THE BUDDHA OF ETERNAL LIFE
Northern Burma(?), ca. 11th – 12th century
Bronze, H. 9⁵/₁₆ in. (23.8 cm)

A comparison between the preceding seated Buddha (No. 24) and this remarkable sculpture, stylistically so dissimilar, makes clear the astonishing variety one encounters in early Burmese sculpture. Rather than reflecting Indian influences, this sculpture seems to owe its stylistic allegiances to the arts of Nepal, Tibet, and probably China. If we are correct in our suggested provenance, this rare and extraordinary sculpture can serve as the ultimate example of Burma's receptivity to outside influences and ability to transform these influences in a unique fashion. We suggest that northern Burma is a most likely provenance for this bronze because, although there is a strong mixture of Nepali-Tibetan-Chinese elements present, it is improbable, on the basis of style, that the sculpture was made in any of those countries.

Amitayus, the Buddha of Eternal Life, is identifiable through the ambrosia vase he holds in his hands, which are placed on his lap in the gesture of meditation. He wears a high, tripartite crown of the type seen most often on Nepali sculptures of the eighth through the eleventh century[1] and in western or southern Tibet in the eleventh and twelfth centuries.[2] The diamond- or lozenge-shaped earrings and the three long, twisted strands of hair on each shoulder are also common motifs in the art of Nepal and Tibet. The shape of the face and the physiognomy are reminiscent of some Chinese bronze sculptures of the tenth through the twelfth century. The restrained use of simple jewelries of unusual form may be a feature indicative of an early date, as may the sense of restraint and serene spirituality radiating from this Amitayus.[3] The figure is seated in the full lotus posture *(padmasana)*.[4] A portion of the outer garment falls onto the top of the pedestal; the lower hems curve gracefully as they fall, and between them the folds of a section of cloth resting on the pedestal are arranged in a beautiful abstract pattern beneath the crossed ankles. I would consider the treatment of these motifs — particularly the abstract patterning of the cloth — a distinctively Burmese contribution.

Although Amitayus is most often shown wearing the rich regalia associated with bodhisattvas, he can be considered either a crowned and jeweled Buddha or a bodhisattva. Because the art of Burma at this time was primarily devoted to Theravada Buddhism and to depictions of the historical Buddha Shakyamuni, a representation of the Mahayana Buddhist deity Amitayus should also be considered a foreign intrusion, probably from the north.

The compressed double row of lotus petals, beautifully shaped and proportioned, is another very unusual feature. Of particular interest are the exceptionally large underpetals. Perhaps the closest one can come to cognate examples are the lotus petals on some Shrivijaya bronze sculptures from Indonesia.

The very thin casting is not something one normally associates with Burma's northern neighbors, nor is it a usual quality of Pala bronzes; the Shrivijaya kingdom or Thailand may be the source for such metalworking techniques. The lovely soft green patination is of a sort often encountered in Southeast Asia.

[1] von Schroeder 1981, pls. 76D, 78D, 79C, 81C, 85C, and many others. This type of crown originates in India and also is to be found on sculptures from Kashmir.

[2] Ibid., pls. 30I, 31G.

[3] Perhaps the prototype for the Kronos Collections sculpture served as inspiration for sculptures such as the western Tibetan Akshobhya illustrated by von Schroeder (1981, pl. 33B).

[4] *Padmasana* is usually thought of as a slightly more relaxed version of *vajrasana.* There is, however, little consistency in the depiction of this *asana,* and even less in how it is described. (See No. 24.)

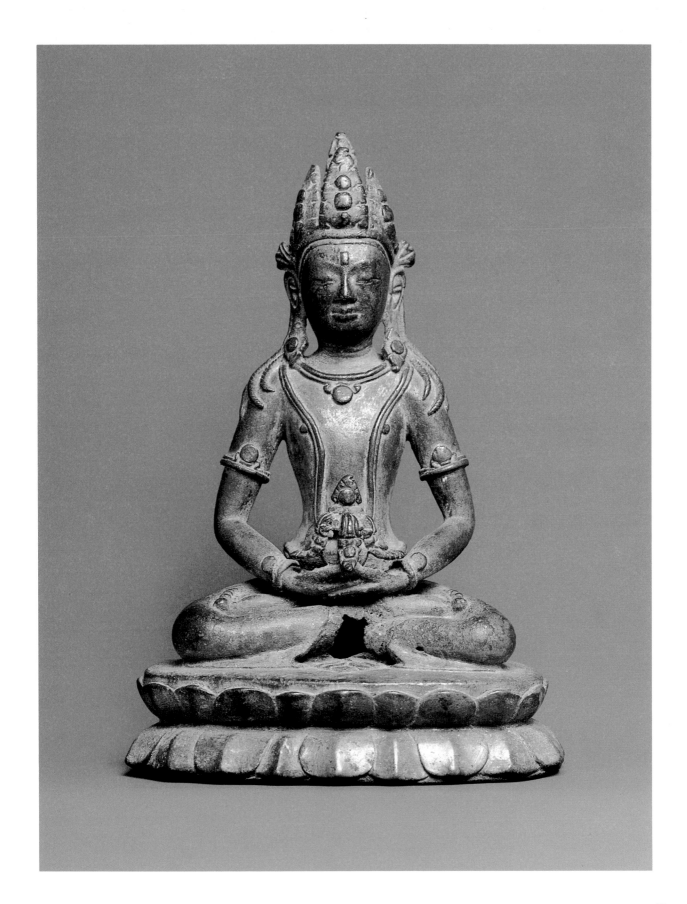

26 RELIQUARY(?) WITH SCENES FROM THE
LIFE OF THE BUDDHA
India or Pakistan, Kashmir region,
late 9th – 10th century
Bone with traces of polychrome and cold gold,
H. 5⅜ in. (13.6 cm), W. 4⅜ in. (11.1 cm)

Among the rarest and most beautiful ivory carvings from any culture are the famous examples, probably numbering less than three dozen, from Kashmir.[1] Datable on stylistic grounds to around the eighth century, these carvings are clearly the products of extraordinarily sophisticated and technically skilled ivory-carving workshops. None of the later products of these workshops seemed to have survived, and because there was no tangible evidence of their existence after the eighth century, it had been thought that, for unknown reasons, the collective skills of the workshops may have disappeared during the ninth century.[2] The recent discovery, however, of this remarkable bone carving, dating no earlier than the ninth century, testifies to the continuation of these skills and extends the tradition by at least a century.

Carved from an approximately triangular section of elephant(?) bone, this object was probably part of a reliquary. Three scenes are depicted. The first shows the miraculous birth of Siddhartha, later to become the Buddha, emerging from the right side of his mother, Queen Maya. Maya's raised right arm grasps the branch of a tree while her sister, Mahaprajapati, supports her left arm. The orthodox iconography of the scene is disturbed by the substitution of another woman to receive the emerging baby. The Brahmanical deity Indra is normally accorded this honor (see No. 30). Another tradition, rarely depicted, has Indra assuming the appearance of an old woman and it is perhaps this variant that appears here. Maya is richly adorned with the jewelries appropriate for royalty and has an elaborate asymmetrical hairdo of Gupta period type. The hairdo, arranged at the left side of her face, is common to many female deities from the western Himalayan regions and the Swat valley of the ninth and tenth centuries[3] and is on occasion also found on Kashmiri sculptures.[4]

The second scene depicts the temptation of Siddhartha as he meditated at Bodhgaya immediately prior to attaining enlightenment and becoming the Buddha. This great scene usually shows the Buddha making, as he is here, the gesture of *bhumisparshamudra,* his right hand touching the ground to call the earth goddess to testify that through the merit accumulated in earlier existences,

Siddhartha has the right to become the Buddha. The evil Mara, symbolizing the world of passions and desire, tried to prevent Siddhartha's becoming "the enlightened one" by tempting him with the wealth of the universe (and with Mara's daughters, who are seen here flanking the Buddha),[5] by arguing that he was unworthy to become the Buddha, and by threatening him. Temptations, intellectual disputation, and threats proved to no avail. In desperation, Mara unleashed the forces of darkness — the final, futile act before his defeat.

Artists of all periods have delighted in portraying the grotesque and sometimes comical members of Mara's army. Within an otherwise strict and conservative iconographic tradition, these personifications of passions and evil impulses presented a rare opportunity for artists to allow their imaginations free reign. Kashmiri ivory carvers, in particular, excelled at these depictions.[6]

The third scene, which seems to be by a different hand, is allocated more space than the other two, and is clearly the main scene of the carving. It shows a rare representation of the seated crowned and jeweled Buddha. As I have written elsewhere, "The Buddha is normally depicted wearing the simple garments of a monastic. A special form, however, developed, which permitted him to be portrayed wearing rich jewelry and a crown, perhaps meant to symbolize and isolate that great moment when Siddhartha attained enlightenment and became 'The Buddha.' Alternately, Professor Rowland has suggested that the crowned Buddha symbolizes the special form of the transfigured Buddha splendidly revealing himself to the Bodhisattvas (the Buddha in *sambhogakaya*)."[7]

The Buddha is seated in a cross-legged yogic posture on a lion throne. His hands display the preaching gesture *(dharmachakrapravartanamudra)* of setting the wheel of law into motion that is associated with his first sermon at the Deer Park at Sarnath. He wears a distinctive short pointed cape decorated with tassels, and on each shoulder there is a device consisting of a crescent encircling another form.

Two seated four-armed figures flank the Buddha. Because the attributes they hold are either incomplete or unclear, I would not hazard a guess as to their identity

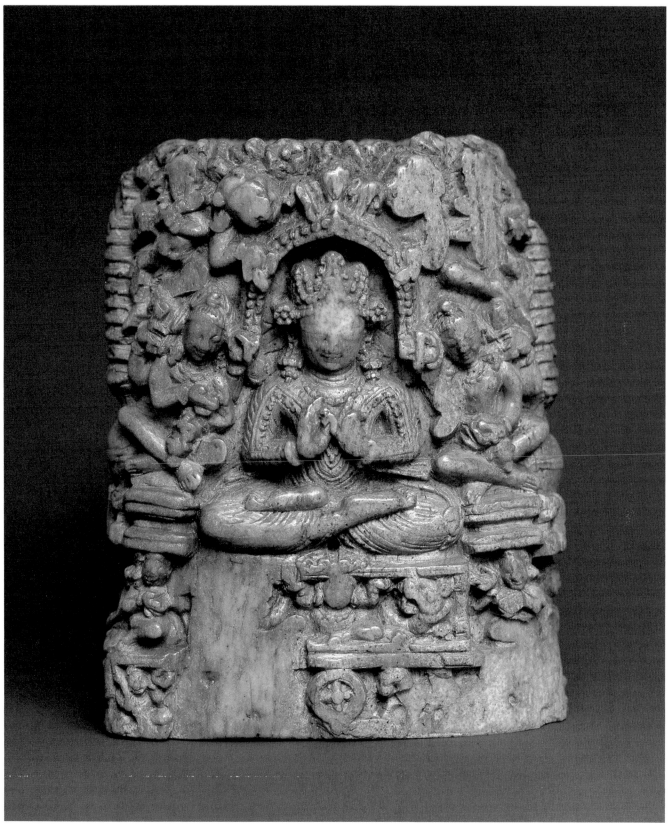

The crowned and jeweled Buddha

The miraculous birth of Siddhartha

other than to suggest that it would be appropriate for either the bodhisattvas Maitreya and Avalokiteshvara or the Brahmanical deities Indra and Brahma to be depicted. No matter who is represented, Rowland's suggestion that the crowned and jeweled Buddha represents a special cosmic episode, a kind of apotheosis of the Buddha preaching to the major deities, would be quite plausible in this context.

Recently, however, Deborah Klimburg-Salter has suggested a more probable explanation for the crowned and jeweled Buddha. Her suggestion is based on the later portions (ca. fourth century) of the *Mahavastu*,[8] where it is stated that the career of the Buddha begins, not with his miraculous birth from the side of Queen Maya, but rather while he is still residing in *Tushita* (Joyful) Heaven. When the Bodhisattva (the Buddha-to-be, or he who will become the historical Buddha Shakyamuni) decides the time has come to be born on earth in order to become the Buddha, the heavenly hosts rejoice and rays of light miraculously issue from those assembled to fall on the head of the Bodhisattva, consecrating him. To represent the special nature and enormity of the Bodhisattva's decision and the ritual cosmic consecration *(abhisheka),* a separate form of the Buddha image was devised: a crowned and jeweled seated Buddha wearing a pointed cape with tassels and what Klimburg-Salter calls "shoulder effulgences" (like the devices on this Buddha) and making the gesture of setting the wheel of law into motion. If Klimburg-Salter's interpretation is correct, then the main scene on this bone reliquary should be called "the *abhisheka* of Shakyamuni in the *Tushita* Heaven."[9] It would be chronologically the earliest, and the scenes of the miraculous birth and the temptation of Mara would follow in logical sequence. In fact, the placement of the scenes on this icon fits neatly with her hypothesis. One would "walk" clockwise around the carving to view the scenes as a kind of continuous narrative of events in a manner corresponding to the circumambulation of a stupa.

Klimburg-Salter's identification of this scene and her interpretation of the significance of the crowned and jeweled Buddha are very convincing, but her suggestions regarding the special costume worn by the Buddha, particularly the pointed cape and the shoulder effulgences, are more problematic. She cites the area around the Hindu Kush in northeast Afghanistan as the source for Kashmiri versions of the cape and shoulder effulgences. Her hypothesis relies heavily on the art of Bamiyan and Fondukistan, a burden these undeniably important sites seem unable to carry, for whether Bamiyan was the iconographic and stylistic cornucopia she would have it be is open to question. Her theory is also weakened by evidence indicating that these two

elements of the Buddha's costume appeared in Kashmiri art before they were known in Afghanistan, and that they seem to have been borrowed from other sources.

The pointed cape appears considerably earlier than most researchers have recognized. In 1975, I drew attention to Kushan period examples:

> The short, three-pointed garment with jeweled pendants covering the shoulders and upper part of the chest is not uncommon on Kashmiri representations of the crowned Buddha. Undoubtedly a foreign borrowing, its significance and origins are a bit obscure. It may have been borrowed from one of India's western neighbors, entering the North Indian repertory during the Kushan period, around the third century. In the sculpture of both Gandhara and Mathura, foreigners, probably of Indo-Scythic origin, wear this curious garment, seemingly comprised of mail-plate armor.[10]

I would now revise this slightly by suggesting that the pointed cape probably appears in India as early as the second century; that at Mathura it does not appear to be an armored piece of apparel; and, finally, that it is more accurately called a four-pointed cape because a fourth point frequently appears on the backs of images in the round. The evidence presently available therefore indicates that this enigmatic cape first appeared in the repertory of Indian costume. Because it then reappears in Kashmir, embellished with fringes or tassels and jewels,[11] before there is any evidence of it at Hindu Kush sites (Pal places the cape's appearance in Kashmir as early as the sixth century),[12] there is as yet no justification for claiming the Hindu Kush as its source.

The shoulder devices that sometimes appear on the seated Buddha in conjunction with the four-pointed cape (as on this carving) comprise a crescent encircling either a ball, a fleur-de-lis, or a rosette. According to Klimburg-Salter, these shoulder effulgences are one of the necessary ingredients in the *abhisheka* of Shakyamuni theme: they symbolize the supernatural aspects of the Buddha and his consecration by divine light.[13] Although it may be that the textual descriptions served as a catalyst for the use of these devices, their appearance on Kashmiri sculpture in the context of the crowned and jeweled Buddha may also be more related to symbols of royalty, as found, for example, on crowns in Sasanian art, than to the *abhisheka* ritual. (The crescent encircling a disk or ball also appears as a motif on Kashmiri crowns; see No. 27.)

Although Klimburg-Salter also suggests northeast Afghanistan as the source for the use of the shoulder effulgences in Kashmiri art, it is possible that their appearance on Buddha images in Kashmir is more linked to China, albeit in a circuitous way.

On sixth-century (and perhaps even slightly earlier) Chinese sculptures, one often finds large raised disks on the shoulders so placed that at times it is easy to interpret them as earrings or part of a necklace. But a careful examination very often makes clear that they represent something else (though just what that is is usually not discussed in the literature). These disks do not, to my knowledge, appear on images of the Buddha, but rather are restricted to bodhisattvas and guardian figures. Their appearance on the bare shoulders of guardian figures strongly points to their being a kind of shoulder effulgence.[14] The ambiguous way in which the Chinese used these disks suggests that they were never comfortable with the device, and they seem to have abandoned it during the T'ang period.[15] Gandharan images of the Buddha with flames emanating from the shoulders and ancient Iranian "light-emitting" icons must have been China's sources for this motif. But if these are indeed a kind of shoulder effulgence, then China may be a more likely source than Afghanistan for their later appearance on Kashmiri-style sculpture, especially given the extensive contacts between China and Kashmir. Furthermore, this motif is so very common in sixth-century Chinese sculpture and so very rare in Afghani art of this date, if it appears at all, that it seems cumbersome to argue that Afghanistan is its source.

The bottom register of the crowned and jeweled Buddha scene is unfortunately only partly preserved, though one can still make out a wheel, part of a horse, and a seated figure holding a weapon. The presence of the horse and figure is most unusual and provocative. Their proportions suggest that there were originally seven representations along the register, which then strongly suggests an iconographic feature that is, in my experience, unique on Kashmiri or Kashmiri-style sculptures: the *saptaratna*, or seven jewels, of a *Chakravartin*.

At his birth, Siddhartha had the choice of becoming either a ruler of the temporal world *(Chakravartin)* or a spiritual ruler of the universe. He chose the latter, and became the Buddha Shakyamuni. The concept of the *Chakravartin*, which predates Buddhism, was absorbed into Buddhist theology so that Shakyamuni could be considered the spiritual counterpart of the "world monarch." The seven jewels of a *Chakravartin* are the sacred wheel, the white elephant of state, the perfect horse, the wish-fulfilling gem, the perfect minister (sometimes minister of state, sometimes of finance), the perfect wife, and the perfect general. The wheel, the general, and the horse are all that survive on this carving.

The prototypes for the depiction of the seven jewels of the universal monarch in the art of Kashmir and the

The temptation of Siddhartha

western Himalayas are surely northeast Indian early Pala period representations. A review of Pala period Buddhist sculptures in stone and metal reveals many examples depicting the *saptaratna*, usually on the lowest register of scenes with the crowned Buddha.[16] (These crowned Buddhas can sometimes be identified as Akshobhya by a *vajra* on the pedestal.) Burma borrowed the theme from the same source; the *Chakravartin's* seven jewels are almost invariably encountered on the lowermost registers of the many existing small plaques from Burma that represent the eight great events in the life of the Buddha.[17]

At two of the edges of our triangular carving are two tall, multitiered stupas placed above small meditating Buddhas. Although other precedents for the stupas exist, a crucial Kashmiri icon in the Rockefeller Collection at the Asia Society in New York definitively links them to the seated crowned Buddha scene and proves that they are meant to be flanking elements for that composition. Judicious caution is required in explaining the appearance of these twin stupas. They commonly appear on Pala period sculptures,[18] often on steles representing a preaching crowned and jeweled Buddha,[19] and they are also found in other contexts, such as wall paintings in Central Asia and Afghanistan. To my knowledge, however, they are never so prominent a part of the composition as they are both on this carving and on the Rockefeller Collection Kashmiri icon that serves as its precedent. Whether the ultimate prototypes are the large, complex steles of Gandhara, where one often finds, in the upper registers, pairs of small seated Buddhas (and bodhisattvas) in domed enclosures suggestive of stupas,[20] or some other source, is not certain. But it is clear that no great intellectual or religious breakthrough was required for the transition from representations of pairs of small stupas, like those in early Pala sculpture, to larger stupas. If early Pala sculptures of northeast India might be considered one iconographic source for pairs of small stupas, then the tall, attenuated type seen on this carving derives from northwest Indian prototypes. In fact, earlier bronze stupas from Gandhara of approximately the same proportions as the stupas on this carving are known.[21]

The iconographic explanation for the paired stupas may also defy speculation, for many possibilities exist. They may represent the two other "bodies" of Buddhahood, which with *sambhogakaya* (the Buddha revealing himself to the Bodhisattvas) form the *trikaya,* or triple nature of the Buddha.[22] Two stupas with an image of the Buddha could also represent some other philosophical trinity, such as the early Buddhist concept of the *triratna,* which is the Buddha, his teachings or universal laws, and his monastic community. Or the two stupas could symbolize the Buddhas of the past and of the future.

The existence of Kashmiri prototypes for the style, composition, and almost all of the unusual iconographic features found on this carving leaves little doubt as to its approximate provenance. Kashmiri ivory carvings — particularly the superb examples in the collections of the Prince of Wales Museum, Bombay; the British Museum; the Kanoria Collection, Patna; and The Cleveland Museum of Art[23] — are the source for the very crowded figural arrangements packed with celestial musicians, grotesques, flying attendants with wreaths, and others, and provide the basic background and context in which this bone reliquary can be examined. A few Kashmiri metal sculptures, most notably the famous seated crowned and jeweled Buddha in the Rockefeller Collection,[24] provide the iconographic precedents for the "*abhisheka* of Shakyamuni in the *Tushita* Heaven" scene. The Rockefeller Collection sculpture, the closest precedent for our seated crowned and jeweled Buddha, wears the four-pointed short cape with shoulder effulgences and makes the gesture of setting the wheel of law into motion. This extraordinarily rich and complex sculpture is also the source for the tall twin stupas. Another seated Buddha in a private collection in New York,[25] although less grandiose, is of the same type and wears the four-pointed short cape with shoulder effulgences. His hand positions are different, however, and he sits, as on our bone carving, on a throne with two lions flanking an atlantid-*yaksha*. Curiously, this type of throne, which is so common on Kashmiri stone and metal sculptures, does not appear on the ivories.

Stylistically, this bone reliquary cannot date to the eighth century, and even though a late ninth-century date is possible, assigning it to the tenth century is the most judicious position to take. It is interesting that at least two important iconographic features seem to have been misunderstood by the artist: the pointed, tasseled cape, shown properly on the chest, is misrepresented as it descends the upper arms; and the meditating Buddhas on the edges, rather than being incorporated into the drums of the stupas, as they are on the Rockefeller Collection icon, have been placed under them. This bone carving's stylistic allegiances and iconographic programming place it very comfortably within the Kashmiri artistic orbit, but whether it was in fact carved in Kashmir or in an adjacent area is not known.

Determining the function of this extraordinary object is also problematic. Given the penchant for reliquaries of all sorts in the Gandhara region, Kashmir, and the western Himalayas, however, the carving could easily have been capped at the top and bottom to serve as a relic container. A clear interior recess at the top suggests that something was once inset there.

Although stained and colored ivory or bone carvings can be found in many different parts of the world, the nature of the traces of polychrome and cold gold on this object indicate that it was once worshiped in Tibet.

[1] Most of the famous Kashmiri ivories appear in Dwivedi 1976, pls. 74–87.

[2] There is good reason to suggest that the "Kashmiri" ivory in the John D. Rockefeller 3rd Collection, Asia Society, New York, is the latest in the sequence of Kashmiri ivories and is unlikely to date earlier than the ninth or perhaps even the tenth century. It would therefore appear to be the single known example extending the ivory carving tradition. But since the Rockefeller Collection example seems either to closely follow or to be a later copy (how much later I do not know) of the example in the Kanoria Collection in Patna (ibid., pls. 81, 82), it is difficult to assess its relative position in a discussion of the Kashmiri ivories. A good possibility also exists that it was not carved in Kashmir at all but rather at some not too distant atelier (Lee 1975, p. 10).

[3] Asymmetrical hairdos with locks of hair falling down one side of the face or arranged in large buns appear on pls. 9G and 12B and on the flanking attendants of pls. 12E, 12G, 24A, and 24D in von Schroeder (1981) and on many unpublished examples.

[4] Ibid., pl. 23A. Close parallels can also be found on the Avantisvamin Temple at Avantipur in Kashmir.

[5] The immediate precedent for the composition of Mara's daughters is a superb Kashmiri ivory, now in The Cleveland Museum of Art, depicting the attack of Mara (Dwivedi 1976, pl. 85).

[6] Ibid.

[7] Lerner 1975a, entry 5.

[8] I am indebted to Deborah Klimburg-Salter for graciously sending me copies of parts of the text from her forthcoming study, *The Kingdom of Bamiyan*, a major contribution that will undoubtedly be of great value to all scholars interested in this area.

[9] Klimburg-Salter's description.

[10] Lerner 1975a, entry 5. It should also be noted that James Harle, in a personal communication, cites a Gandharan stucco example at Jaulian, Taxila.

[11] Pal 1975a, pls. 16, 29, 30, 32, 36, and many others.

[12] Ibid., pl. 16.

[13] Klimburg-Salter, in press, and 1982, p. 95, pl. 9.

[14] See, for example, the south wall of Cave XIII at Lung-men (Tokiwa and Sekino 1925–26, pl. 76).

[15] They can, however, continue to be found on archaistic sculptures.

[16] Dani 1959, pl. 30; Banerji 1933, pl. XIV(e), and perhaps XIX(b) and (c). Because the seven jewels are usually depicted in miniature on the lowermost register of stone sculptures, they are often damaged or otherwise unrecognizable because of their size or because the illustration has been cropped.

[17] Lee 1975, cover and p. 25. See also Luce 1969–70, vol. 3, pls. 400–405.

[18] Kramrisch 1929, figs. 10, 14, 16. Earlier Pala period examples exist.

[19] Ibid., fig. 14.

[20] Lyons and Ingholt 1957, pls. 254–57.

[21] Franz 1978, p. 38, figs. 42, 43 (spires missing). See also Klimburg-Salter 1982, fig. 9. Another, unpublished, fine example is in the National Museum of Oriental Art, Rome.

[22] Rowland 1963, p. 8.

[23] Dwivedi 1976, pls. 74, 79–82, 85.

[24] Pal 1975a, pl. 30.

[25] Ibid., pl. 32.

27 DIADEM WITH *KINNARIS*
India or Pakistan, probably Kashmir,
9th – 10th century
Gold inset with garnet, greatest H. of central panel
(excluding pendants) 2⅛ in. (5.4 cm), L. (including
two side loops) 11⅞ in. (30.2 cm)

This three-piece gold diadem, like No. 2, is an important addition to the literature on Indian jewelry. Nothing similar, so far as I am aware, has previously been reported.

The diadem is of repoussé goldwork. Nineteen pendants are attached to its lower edge, five on each side and nine on the central panel — the longer pendant in the center ends in a leaf-shaped form, the others in smaller concave disks. The curves on the top edge of the diadem are surmounted by rounded budlike forms, five on each panel. Both the pendants and the buds are reminiscent of gold jewelry from the ancient Gandhara region. At the top outer edges of the central panel are two crescents encircling disks, a motif referring to the moon and sun that is frequently encountered in Kashmiri sculpture, either on the tops of mandorlas or as a finial on a stupa. This device also appears on the shoulders of crowned and jeweled Buddhas (see No. 26).

The four *kinnaris*, however, dominate the design. There are two of these half-avian, half-female celestial creatures flanking the garnet in the center, and another on each side panel, their birds' tails abstracted into complex scrolling forms. Each of the *kinnaris* holds a thin, jeweled chain, and the pair on the central panel also hold between them what seems to be a crown. The garnet is a sumptuous but discreet embellishment.

Although this diadem could have been made further west in northern Pakistan, Kashmir provides the strongest parallels. The style of the human portion of the *kinnaris* is closer to Kashmiri styles than anything else, and the hairdo is a Kashmiri continuation of a type seen often on Gupta period sculptures. *Kinnaris* rank rather low on any scale of importance for deities and are normally to be found in a minor context on the decoration of temples. On the *kinnaris* perched on the broken pediments of the eighth-century temple of Martand, the avian half is treated in a somewhat naturalistic fashion. We come closer to the *kinnaris* on the diadem on the ninth-century temple of Avantisvamin at Avantipur, where there are *kinnaris* holding garlands and, on the lower frieze of an interior facade, a *kinnari* with a fancifully scrolling tail that is the closest Kashmiri parallel known to me.[1] The style and iconography of the diadem raise some interesting questions. The ubiquitous crowns, diadems, and tiaras of the art of Kashmir are almost always high and tripartite or triple-lobed. I know of no others shaped like this one, nor am I aware of any others

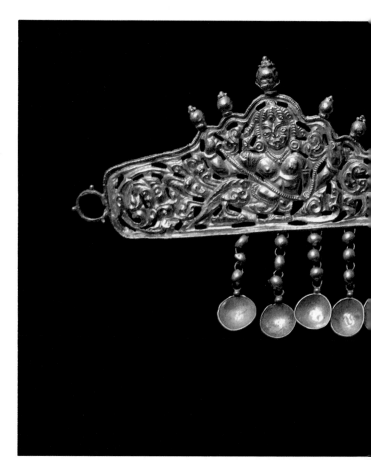

decorated with *kinnaris*. In the corpus of known Kashmiri sculpture, therefore, the Kronos Collections diadem may be unique.

Although it is impossible to insist that this diadem was created in Kashmir — at least one common Kashmiri motif, rosettes above the ears, is missing — it clearly belongs within the Kashmiri stylistic orbit. It could date to as early as the second half of the ninth century, but a more conservative dating to the tenth century is probably more accurate.

[1] The frieze is shown in Mitra 1977, pl. VIII-B, but the *kinnari* is not clear in this illustration. The scrolling tail forms can be seen more clearly on certain representations of *makaras;* see Paul 1979, pp. 416, fig. 6; 418, fig. 9.

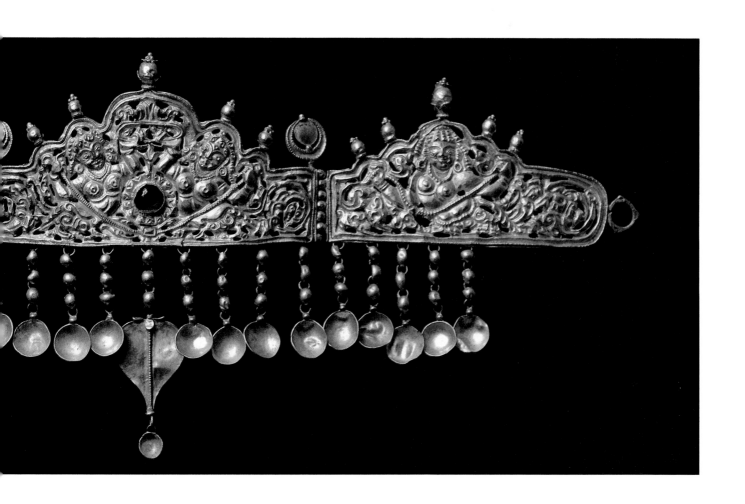

28 STANDING EIGHT-ARMED
ASHTAMAHABHAYA TARA
India, Himachal Pradesh or Jammu and Kashmir,
10th – 11th century
Wood with gilded bronze ring on reverse, H. 17¾ in.
(45.1 cm), W. 8⅝ in. (21.9 cm)

In the northernmost Indian states of Himachal Pradesh and Jammu and Kashmir, the ancient heritage of wood temple architecture can still be seen to advantage. Although much has been lost, the few surviving temples, whose elaborately carved facades and interiors seem to be mostly original, give testimony to a very rich wood carving tradition.[1] Almost nothing of this tradition has been preserved in the West;[2] this carving from the Kronos Collections, to my knowledge, is unique in American collections.

Set within a deeply carved architectural framework, an originally eight-armed female deity stands gracefully on a lotus pedestal. She represents the Buddhist goddess Tara. Unfortunately, the only one of her attributes to have survived is a long-stemmed *utpala* (blue lotus or water lily).

This Tara is similar in quite a few ways to the Queen Maya carved on the bone sculpture of No. 26. Except for the anklets worn by the Tara, their costumes and jewelries are identical. The main difference is in the proportions of the body—the Tara being clearly more slender and elongated. The adjustment from a fuller figure to a more elegantly attenuated one or, in the case of male figures, from a powerful, muscular body (as seen on No. 15) to the taller and slimmer figure usually encountered in the tenth and eleventh centuries, is easily charted. The famous standing Buddha in the collection of The Cleveland Museum of Art could well serve as the paradigm for the elongated type.[3] As with most stylistic progressions, this line of development is not without side excursions, and consequently must be viewed as a general tendency rather than as a fixed, measurable rule. If the two well-known inscribed brass sculptures from Chamba—the standing Durga and "Shakti Devi"[4]—do indeed belong to the eighth century (which has always seemed questionable to me, since on the basis of style they can hardly be earlier than the ninth century), perhaps this tendency toward elongation originated in Himachal Pradesh rather than Kashmir.

To the right of the standing Tara, a small figure in monastic garb, perhaps the donor, stands in adoration. Carved on the columns flanking the goddess are eight mutilated figural groupings, most of them showing small figures turned toward her. Despite their condition, these almost definitely identify the specific form of Tara represented on this plaque as Ashtamahabhaya Tara, protectress against the eight great perils.[5] Most of the eight scenes on the panel are damaged, so one cannot with total confidence insist on this identification, but two of the perils—elephants and fire—are still clearly visible behind the small figures at Tara's lower right side. (The eight great perils are collectively referred to as the *ashtamahabhayas;*[6] the other six are lions, snakes, water, demons, thieves, and fetters.)

The treatment of the architectural motifs, including the two pairs of damaged birds, comes directly from the great eighth-century stone temples of Kashmir.[7] The bottom register, following Kashmiri prototypes, has three seated figures: the one in the center, with both arms raised, serves as an atlantid; the pair on the sides seem to be holding flywhisks.

Over the centuries, a rich, dark patina has developed on this sculpture. I cannot tell if the sculpture was originally set into a wall—a gilt bronze ring (to permit hanging) and some slight incised decoration on the back suggest that it may always have been an individual votive tablet.

While it may not be possible to assign this wood carving to a specific site, the treatment of the female deity fits easily into what we know of the tenth- and eleventh-century styles of Kashmir, Ladakh, and western Tibet. The elegant attenuation and proportioning of the body, the large *utpala* flower, and the jewelries and high crown, along with the distinctive asymmetrical hair arrangement, clearly belong to western Himalayan traditions of that date.

In 1909, at the monastery of Tabo (Ta-pho) at Spiti, in northern Himachal Pradesh near the Jammu and Kashmir border, A. H. Francke discovered two wood carvings of standing Buddhas set into architectural frameworks not unlike this one.[8] On one of them, which has a border, the incised decorations are quite similar to those on our Tara. Although such a suggestion would only be conjecture, it would not be impossible for the Kronos Collections wood carving to have come from Tabo as well.

[1] See Francke 1914, pls. xxx-b, xxxvii-a, xxxix-a, xliii-a and b; Goetz 1955; Tucci 1973, pls. 133–39; Snellgrove and Skorupski 1977, pls. 24, 25, 29, color pl. iii.
[2] Tucci 1973, pls. 131, 144, and 150 are in the Bonardi Collection in Italy.
[3] Ibid., pp. 100–101.
[4] Goetz 1955, pls. vi, vii.
[5] Ghosh 1980, pp. 38–47.
[6] Ibid., p. 40.
[7] The trefoil arch enclosed by a triangular pediment can be seen on many Kashmiri temples, including Martand, Buniar, and Avantisvamin.
[8] Francke 1914, pl. xviii.

29 THREE CARVED CONCH SHELLS
Northern India
Shell; (a) ca. 11th century or earlier, L. 6⁵⁄₁₆ in. (16 cm),
(b) ca. 11th century or earlier, L. 7¼ in. (18.4 cm),
(c) ca. 11th–12th century, L. 8 in. (20.3 cm) with
silver addition

Conch shells have had a place in Asian ritual since ancient times. Whether as the battle trumpet of Vishnu or as objects used for ritual libation or any one of a number of other purposes, they are encountered in a variety of contexts.[1] Perhaps most familiar to those acquainted with the art of the Himalayas are the many surviving ritual trumpets of Tibet, where the conch is used mainly as the body of the instrument, with elaborate metalwork mouthpieces and coverings added.[2]

Until recently, no other conch, from either the Buddhist or Brahmanical repertory of ritual objects, with such elaborate carved decoration as appears on the first two of these conches was known to have survived. A poll of people experienced in many fields of Asian art had produced no information leading to a secure attribution. The very recent discovery of the third carved conch, however, provides answers to many of the questions raised by the original pair. We will discuss them first.

It is clear from the openwork carving on the first two shells that they could not have been used as trumpets. More likely, they were used for the ritual pouring of some liquid, probably holy water. Both shells are elaborately carved with many registers of different designs: bands of stylized lotus petals, floral and scrolling leaf forms, pearling motifs, lozenge-shaped patterns, and other minor decorations. A *kirtimukha* (the leonine "face of glory" that symbolizes prosperity, among other things, and was so popular in early Indian art) appears on each shell with a large openwork rondel above it. A rampant lion appears inside the rondel on the first shell; the rondel on the second shell is very damaged and confusing—it may originally have encircled a storklike bird.

The repertory of decorations on both conches is so similar that they are clearly the products of the same area. Nevertheless, some interesting differences can be noted. The quality of both carving and conception is clearly superior on the second shell, the one with the birdlike

Fronts of shells (a) and (b)

image. Incorporated into the decor, below the central band of lozenges, there seem to be representations of perhaps five animals, with a figure holding a bow behind them. The spout end of this shell is also completely decorated with elongated lotus petals. On the conch with the lion, the spout area has been carved away, clearly indicating that a spout of another material was originally attached. (The vendor was told that it was gold and had been melted down.)

The similarity of some of the decoration to Sinhalese Buddhist architectural "moonstones" (the stepping stones at the bottoms of flights of steps),[3] as well as to other relief decorations on Sri Lankan sculpture, and the inclusion of paired *hamsas* (geese), so commonly found in the art of that island-nation, initially suggested a fruitful avenue for further investigation. On the other hand, so much of what appears on these shells evolves out of a vocabulary of traditional decoration drawn upon

by artists in widely disparate geographic locations that it was apparent that a more detailed analysis was required. For instance, the rampant lion seemed to be in a style associated with Orissa in eastern India, while other decorations suggested the ivory carvings of southern India. The easy portability of these shells confounded the problem, as both were reported to have come from the north: the one with the missing spout from Nepal or Tibet, the other from the region of Ghazni, south of Kabul in Afghanistan. The newly discovered third conch supports this assumption, for although it is sufficiently different in design and iconography to suggest that it is probably later in date than the first two, it is similar enough in conception to suggest northern India as a common provenance.

The iconography of the third conch is clearly Vaishnavite. The main band of carving illustrates the *Lakshmi-Narayana* theme. Narayana is one of the twenty-four

83

Backs of shells (a) and (b)

forms of Vishnu, and Lakshmi, his favorite consort, is the goddess of beauty and fortune who was rescued from the primordial Ocean of Milk when it was being churned to obtain ambrosia for the gods. Together, this divine couple protect the universe. As usual, they are supported by Garuda. A pair of adoring donors appears at their right.

The band continues with depictions of the ten avatars of Vishnu (the *dashavataras*) supported on a panel of stylized lotus petals. Closest to Vishnu and Lakshmi is Kalki, the tenth and messianic avatar, who, a bit akin to a knight in shining armor, is shown, as is usual, riding a white horse and brandishing a sword. It is believed that Kalki will appear at the end of the present dark age *(kali yuga)* to overcome the forces of evil. The rest of the avatars are shown in descending order, in normal sequence until Kurma and Matsya, who are in reverse order (a not unusual occurrence). Matsya (see No. 63) has been damaged, and what would have been

the depiction of Kurma, the tortoise avatar, has not survived. The conch is also decorated with carved bands of a scrolling foliate design, beading, and, at the top, attenuated lotus leaves.

The style of the figures and the architectural framework of the *Lakshmi-Narayana* panel on this conch strongly suggests a northern Indian provenance, probably Bihar or Himachal Pradesh, and a dating to around the eleventh or twelfth century. Some time later, this ritual pouring vessel was carried to Tibet, where the very fine silver mount showing a dragon amid stylized clouds was added, both as embellishment and to cover the damaged portion of the conch.

[1] For two unusual northeast Indian examples, see Banerji 1933, pl. LXIIE.
[2] Pal 1969, p. 126.
[3] Paranavitana 1971, pls. 37–42.

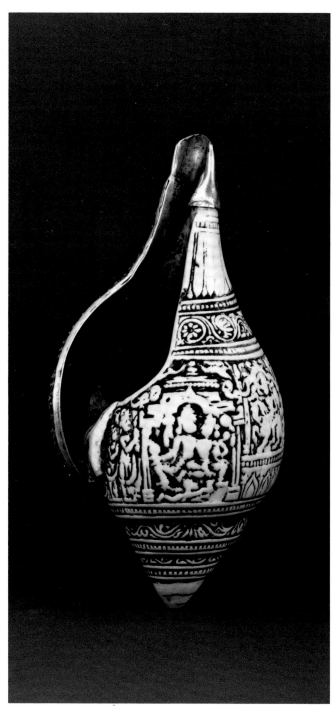

Front of shell (c), with the *Lakshmi-Narayana* panel

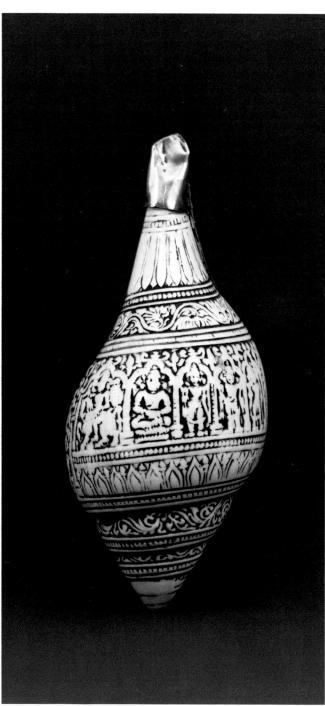

Back of shell (c), with the avatars of Vishnu

30 MANUSCRIPT COVER WITH SCENES FROM THE LIFE OF THE BUDDHA

India, Pala period, 9th century
Ink and colors on wood with metal insets,
H. 2¼ in. (5.7 cm), L. 22⅜ in. (56.8 cm)
Gift of The Kronos Collections and
Mr. and Mrs. Peter Findlay, 1979 (1979.511)

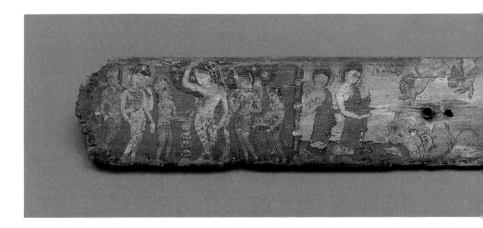

It has long been accepted that the genesis of the eastern Indian Pala school of painting and of its slightly later offshoot, the Nepali style, seen on palm-leaf manuscripts and their protective wooden covers must be sought in the cave paintings of western India, particularly at Ajanta, Bagh, and Ellora. Unfortunately, until now there has been no painting that might serve as the bridge linking these two traditions. A chronological hiatus of approximately 150 years exists between the terminal styles of painting at Ellora and the Pala painting tradition, whose earliest dated illuminated manuscripts belong to the last quarter of the tenth century. The gap has been a major obstacle both to the confirmation of the theory regarding the origin of the Pala style and to an understanding of the early development of portable painting. This single painted wooden manuscript cover from the Kronos Collections seems to be the missing link, the first tangible evidence confirming the theory. After such a long period of searching, its discovery is indeed very exciting, and of the greatest significance to Indian painting scholarship.

The question of where this cover was painted is obviously fundamental. It is said to have come from a library in western India many years ago, but the palette employed allies it with eastern traditions, and the format and iconography relate it to eleventh-century Pala-Nepali manuscript paintings. The style of painting on the cover, however, is considerably earlier, and more closely allied to the western cave painting tradition than anything previously known.

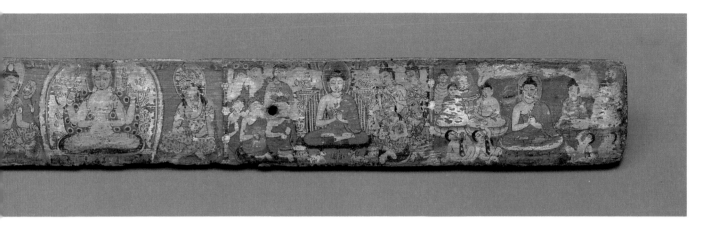

Despite the many Ajantaesque elements present, charting a direct connection between our manuscript cover and the fifth- and sixth-century Ajanta wall paintings is difficult, and though the ninth-century wall paintings at Ellora bring us a bit closer, we still cannot point to exact parallels with any degree of authority. Our cover, however, is closer in style to these western cave paintings than any other known portable painting. It probably dates to around the second half of the ninth but no later than the first half of the tenth century, and may therefore be the earliest Indian portable painting in existence (barring a few paintings from the Kashmir-Gilgit area that are more related to Central Asian than to Ajanta traditions). The cover is of seminal importance to the history of the development of Indian painting.

The Kronos manuscript cover is a long horizontal section of wood with two holes, inset with metal, that would have aligned with holes in the palm-leaf manuscript and the second cover (both now lost) to permit cords to pass through. As with many manuscript covers, the outer surface is completely encrusted with saffron, vermilion, sandalwood paste, and other organic matter ritually applied when the manuscript was both in worship and in use. Whatever decoration existed on this surface is irretrievably lost.

Four of the five scenes painted on the inside of the cover depict half (the lost companion cover presumably had the other four) of the eight great events in the life of the Buddha, though not in chronological order. The fifth scene, on the central panel, depicts the seated Prajnaparamita, the Buddhist goddess of transcendent wisdom, flanked by bodhisattvas. The presence of this scene indicates that the palm-leaf manuscript once protected by this cover was almost certainly the *Ashtasahasrika Prajnaparamita Sutra (The Perfection of Wisdom in Eight Thousand Verses),* one of the most important Buddhist texts of the period. The use of columns segmented by lotus forms to separate the scenes is very unusual, and probably another bit of evidence for an early date.

The first of the four scenes from the life of the Buddha is of his miraculous birth in the Lumbini Grove. In orthodox fashion, the baby is shown emerging from the right side of his mother, Queen Maya, who holds on to a branch of a spreading *ashoka* tree. The Brahmanical gods Indra and Brahma are normally present at the birth, and here Indra is shown receiving the baby in a cloth while Brahma stands behind.

The second scene depicts the subjugation of the maddened elephant Nalagiri, who was set loose by the Buddha's wicked cousin Devadatta. As the elephant drew near, all who had been with the Buddha deserted him except his disciple Ananda. Nalagiri, drawn most beautifully, is shown bowing in submission before the Buddha and Ananda. The two lions with billowing manes above Nalagiri are normally not present in Gupta period or earlier depictions of this event. Their appearance on this manuscript cover marks the first occurrence of a convention we will encounter with some degree of consistency

The miraculous birth of the Buddha

on later covers. Stella Kramrisch, describing a mid-eleventh-century Nepali painted cover now in the collection of the Los Angeles County Museum of Art, writes, "The lions above the subdued elephant in rut are of particular interest. The lions symbolize the power of Buddha, the Lion of the Shakya clan."[1] Earlier, when writing about a Pala period stone sculpture of Buddha subduing Nalagiri, Kramrisch suggested much the same meaning for the appearance of the lions.[2] Another explanation for the lions says that the Buddha raised "his right hand and from his fingers issued five lions, who attacked the elephant and saved the life of the Buddha."[3] It is this later tradition of five lions that one invariably encounters from the eleventh century onward. On the cover of a famous manuscript in the Bodleian Library, Oxford (Ms. Sansk. a.7 [R]), two of the five small lions that seem to have sprung from the Buddha's hand are actually biting Nalagiri's head.

The scene to the right of the central panel shows the Buddha preaching to a group of bodhisattvas and monks. The two small deer flanking a wheel in front of the Buddha's throne identify the scene as the Buddha's first sermon at the Deer Park at Sarnath, often referred to as his setting the wheel of law into motion.

The final scene again shows a Buddha, seated this time on a lotus pedestal, surrounded by eight seated Buddhas, with a ninth, perhaps the messianic Bodhisattva Maitreya, floating overhead. This scene represents the great miracle at Shravasti, where the Buddha caused a multiplicity of Buddhas to appear. Many Buddhist miracle scenes incorporate into the narrative a group of non-believers who are so awed by the powers of the Buddha they become immediate converts. Often these figures are represented as being rather childlike, with hands clasped in adoration in spontaneous response to the magnitude of the miracle just witnessed. They are found in Cave IX at Ajanta[4] and on Gupta period reliefs from Sarnath, where one specific corpulant ascetic often appears in the audience to the Shravasti miracle.[5] Each of the four awe-inspired figures on this cover has one hand raised reverentially above his head. In the version of the Shravasti miracle on the mid-eleventh-century cover in Los Angeles, two of the three quite prominent figures also have one raised hand; the third is standing on one hand.[6] These figures should also be interpreted as being overwhelmed by the miracle they have witnessed. The figures on both covers wear sashes of either animal skin or foliage draped over the left shoulder, suggesting they are ascetics who live in the wild forests.

At the earlier western cave sites, particularly at Ajanta and Bagh, the style is a painterly one with modeling effected through the manipulation of color tonalities and the emphasis on plasticity further enhanced by the varying thicknesses of the line. Although the

Prajnaparamita flanked by bodhisattvas

Kronos cover is in a predominantly linear style, very
skillfully executed and at times quite animated, there are
clear instances of attempts to increase the illusion of
volume through the use of color. In combination with the
beautiful flowing line, which is sometimes both thicker
and richer to accentuate the rounded curves, the contrast
of deep vibrant colors emphasizes volume. The tech-
nique of outlining forms in darker tones to suggest
volume is found throughout the cave paintings; on this
cover the same technique is visible on the arms of Queen
Maya, the lowered arm of the Buddha subduing the
elephant, the garment of the Buddha delivering his first
sermon, and other less preserved sections. Highlighting
with different colors to create three-dimensionality ap-
pears on the lotus-decorated columns as well as the
cushions and lotuses upon which various deities sit.
The brilliant colors provide an overall luminosity that
heightens the visual impact of the painting.

Published: Lerner 1980, pp. 66–67.

[1] Kramrisch 1964, p. 143.
[2] Kramrisch 1929, fig. 10; see also fig. 20.
[3] Saunders 1960, p. 58; see also p. 59 and nn. 25–29.
[4] Yazdani 1930, pl. xv(b). The diminutive figures flank the lotus sup-
porting the seated Buddha's feet.
[5] Williams 1975, p. 183.
[6] Kramrisch 1964, p. 143.

31 MANUSCRIPT COVER WITH SCENES FROM
KALIDASA'S PLAY, *SHAKUNTALA*
Nepal, 12th century
Ink and colors on wood, H. 2 in. (5.1 cm),
L. 7¹⁵⁄₁₆ in. (20.2 cm)

Early painted manuscript covers from eastern India and Nepal from the ninth through the thirteenth century, although relatively rare, are sufficiently plentiful to provide a good sense of both the styles and iconography of the period. In the past, some confusion regarding style has arisen because wooden covers and palm-leaf manuscripts were mismatched. Manuscripts painted in India sometimes lost their original covers and were provided with new ones — eleventh-century Pala period manuscripts with twelfth-century Nepali protective covers are not unknown.[1]

Among the best-known and most admired of the Pala period and early Nepali painted wooden manuscript covers is one belonging to the private collection of Suresh Neotia in Calcutta.[2] The cover has become known for its exquisite coloring, delicate drawing, and lively composition — in short, for its superb quality. In addition, it seems to be the only surviving manuscript cover illustrating an entirely secular story, recently identified as the play *Shakuntala* by Kalidasa, the great Gupta period Indian classical poet.[3] Some scholars had reservations about this identification, but the recent serendipitous and exciting discovery of this lost mate to the Neotia cover completes the pair and helps to corroborate the identification.[4] As all of the surviving early illustrated palm leaves and painted covers depict religious subject matter, and no other known illustrated example survives as testament to the rich body of secular literature,[5] the importance of the Neotia-Kronos manuscript covers is inestimable.

Kalidasa's great romantic play *Shakuntala* tells the story of King Dushyanta's encounter in the forest with the beautiful Shakuntala, their marriage, their temporary separation because of a curse, and finally, their reunion. The scenes depicted on the Neotia and Kronos covers are taken from the first two or three acts of the seven-act play.

Each cover has two scenes separated by a tree. The Neotia cover shows King Dushyanta, royally attired like a bodhisattva, in the forest with his buck-toothed jester Madhavya. The second scene depicts Shakuntala and two female companions seated on a stone bench.

The Kronos cover shows King Dushyanta and Shakuntala seated on a decorated cushion. Dushyanta seems to be holding a tiny object between the thumb and index finger of his raised right hand, and he grasps Shakuntala's hand as if to place a ring on her finger. It is almost definite that this scene illustrates the gift of the ring through which the curse is dispelled and the lovers are reunited. The second scene, again on the stone bench, shows the King, his hand raised to his chin, apparently listening with rapt attention to the animated conversation of his jester.

Further confirmation of the secular nature of the subject, and of the accuracy of its identification as Kalidasa's play, is the emphasis — unusual for the period — on the pictorial metaphor of scrolling, flowering creepers wrapping around the trees, a well-known romantic allusion to the love of man and woman. This imagery is beautifully expressed throughout the play; one repeatedly finds passages describing the creeper twining around a mango tree. One of the heroine's companions tells her, "Shakuntala, this is the jasmine creeper who chose the mango tree in marriage . . . " and Shakuntala comments, "The creeper and the tree are twined together in perfect harmony."[6] The pairs of small antelopes on both manuscript covers are also allusions to marital fidelity.

Attempts at indicating the plasticity of the figures, inherited from the Ajanta tradition and seen on No. 30, have been replaced here by two-dimensional patterning and a greater emphasis on the fine wiry line. Recession into the depth of the picture plane seems not to have been a significant concern of the artist. The narrative details of the story, the arrangement of the floral forms, and the juxtaposition of the lush colors were clearly of prime importance. The degree to which the artist was successful clearly places this picture at the forefront of early Nepali painting.

[1] Many examples of such mismatching exist, but among the most important manuscripts that have palm leaves in the Indian style of the Pala period and protective wooden covers painted in a slightly later Nepali style are one in the Bodleian Library, Oxford (Ms. Sansk. a.7 [R]) and two in the University Library, Cambridge (Add. 1464, 1643). The covers on Add. 1643 were even painted by two different artists.

[2] Pal 1978a, pls. 173–75 (described as "Cover depicting scene from a secular story, 13th century").

[3] *In the Image of Man,* 1982, pp. 144, 145, cat. no. 182 (described as "Indian, Pala period, 12th century").

[4] I am grateful to Barbara Stoler Miller for having provided a copy of the text of her translation of *Shakuntala,* scheduled for publication in 1984 (Stoler Miller, in press).

[5] Although it should be noted that even the secular material has considerable religious overtones.

[6] Stoler Miller, in press, Act I.

The Kronos manuscript cover

The Neotia manuscript cover

32 FIVE-PANELED RITUAL CROWN
 Nepal, late 14th – early 15th century
 Opaque watercolor on cloth mounted on board;
 average size of each panel including cloth band:
 H. 7½ in. (19 cm), greatest W. 4⅜ in. (11.2 cm)

This crown would have been worn by a Buddhist priest during the performance of certain rituals.[1] Each of its five panels has a representation of one of the Five Cosmic Buddhas painted on the front and the mantra *Om Ah Hum* written on the back. The concept of the Five Cosmic Buddhas (or *Tathagatas*) is a later development in Buddhist philosophy based on the acceptance of a plurality of Buddhas presiding over the cosmic totality of all time and space. Individual Buddhas were associated with the various directions of the universe and conceived of as having specific separate responsibilities. (This is in marked contrast to earlier systems of Buddhist thought, which permitted one Buddha for each *kalpa,* or great world age, Shakyamuni being the Buddha for our historical period.) The Five Cosmic Buddhas are essential to Vajrayana Buddhism and are often depicted in the form of a mandala with Vairochana, the Supreme Buddha, in the center.

Following orthodox iconography, the four-headed Vairochana appears on the central panel of this crown. He sits in a cross-legged yogic position on an elaborate throne incorporating two small lions, the traditional vehicle for Vairochana. Flanking the back of the throne, in the usual Indian combination, are an elephant, a leogryph, and a *makara* (see No. 47), all depicted in a very lively fashion. Above Vairochana, a garuda supports a flaming *chakra,* or wheel, another iconographic attribute of the deity. The chart identifies the other Buddhas, who are all seated in similar fashion on the same kind of throne.

The rich coloration and the complexity of the design on the crown establish a distinct sense of sumptuousness. Within the limited palette employed, there is a conscious effort to introduce as much variety as possible. For example, the sequence of colors on the lotus petals on each throne is varied, as are the colors of the garments and some of the jewelry. The fine drawing, the plasticity of the garments, and the modulation of skin tones to establish volume are combined in a most effective manner indicative of a highly developed and skilled talent.

This crown is not only the finest painted one known to me, it is also probably the earliest surviving example of the type. A dating to around 1400 is not likely to be far off, and the conservative spread of the fourteenth to the fifteenth century would certainly encompass the period of origin.

[1] Paul Pelliot (1924, pl. cccLXXI) recorded the wearing of such a crown by a priest at Tun Huang.

The Five Cosmic Buddhas (or *Tathagatas*)					
Buddha	*Color*	*Vehicle*	*Attribute*	*Mudra*	*Direction*
Akshobhya	blue	elephants	*vajra* (thunderbolt)	*bhumisparshamudra*	east
Amoghasiddhi	green	garudas	*vishvavajra* (double thunderbolt)	*abhayamudra*	north
Vairochana	white	lions	garuda supporting a *chakra* (disk or wheel) surrounded by flames	*bodhyagrimudra*	center
Amitabha	red	peacocks	*padma* (lotus)	*dhyanamudra*	west
Ratnasambhava	yellow	horses	*chintamani* (flaming jewel)	*varadamudra*	south

33 BUST OF A DEITY, PERHAPS KUBERA
Cambodia or Vietnam (Funan),
ca. first half of 7th century
Calcareous sandstone, H. 14¼ in. (36.2 cm)
Gift of The Kronos Collections, 1983 (1983.550)

This is one of the earliest and most extraordinary of the Southeast Asian sculptures in the Kronos Collections, purported to have come from the area around Phnom Da in southern Cambodia, not far from the Vietnamese border. Even though it is enigmatic, it is a sufficiently significant addition to the corpus of pre-Angkor sculpture (that is, Cambodian sculpture dating prior to the establishment of the Khmer capital at Angkor during the ninth century) to warrant lengthy examination.

The sculpture dates to around the first half of the seventh century, a period early in the known history of Cambodian sculpture, and probably comes from the area that was once part of the ancient kingdom of Funan, which was situated along one of the major trade routes from India to China and justly regarded as the geographic cradle of Cambodian sculpture. Although at present we know the history of the Hindu and Buddhist sculpture from the area only from the sixth century, Funan was a highly important empire from perhaps as early as the first or second century.

This bust of a deity is both fascinating and perplexing. It is fragmentary, but enough has survived to permit a tentative reconstruction. From the proportions, it is clear that the figure was quite squat, with a short neck and a full, rounded face. The deity has thick lips and, despite the pronounced distention of the lobes, rather small ears. The hair is arranged in large, full curls. A flat, circular area on top of the head has two rectangular loops at the back and is surrounded by either smaller curls or, perhaps, jewels; the abraded surface makes the original design unclear. The sculpture would seem to be an image of a demigod or minor divinity.

The figure was most likely seated, partially supported by the straight left arm, with the left shoulder slightly higher than the right. There is a tension and compression of volumes that seems to verify the suggestion of a seated posture. The nature of the break at the right elbow clearly indicates that the right forearm projected toward the front, perhaps at an angle. The deity wears a necklace, jeweled armbands, and earrings. There is nothing on the chest that suggests a garment.

This brief description conveys neither the extraordinary rarity of this sculpture nor its importance. As nothing quite like it is known, perhaps citing the pat-

terns of occurrence of specific details will help to confirm the otherwise unverified provenance, which assigns the sculpture to an area around southwestern Cambodia and the western coast of southern Vietnam. Our comparisons would seem to localize the style more specifically to the Phnom Da-Angkor Borei (Ta Keo) area of southern Cambodia, not far from the Vietnamese border, and to Rach Gia, on the western coast of southern Vietnam.

One of the most unusual features of this sculpture is the hairstyle. The proportions of the large curls are not unusual; they appear on some seventh-century sculptures from Angkor Borei,[1] and become standard on seventh- and eighth-century Mon-style Buddha images from Thailand. The curls on the forehead, arranged in a thin rectangular row with the outer edges not extending beyond the middle of the eyes, are, however, very unusual. To my knowledge, this hair arrangement is confined to sculptures recovered from the area around southwestern Cambodia and the western coast of Vietnam. It is sufficiently distinctive to merit careful examination.

Locks of hair on the forehead are not unique to sixth- and seventh-century sculpture, and can be found on Mon-style terracotta and stucco sculptures of the seventh through the ninth century from Ku Bua, in Ratchaburi (Rajburi) Province in southwest Thailand.[2] The long horizontal panel of hair, however, seems to be a feature specific to sixth- and early seventh-century sculptures of ancient Funan. On the sixth-century sculpture of Phnom Da, the narrow panel of hair connects with rows of hanging ringlets that go back across the ears.[3] The closest example I know of where this frontal panel of hair is treated as a separate unit, as it is here, is the famous Avalokiteshvara from Rach Gia.[4] A stucco head from Angkor Borei, about three kilometers from Phnom Da, also has a frontal hair panel, but the proportions and type of the panel are closer to the Ku Bua variations.[5]

It has often been pointed out that the Phnom Da style, and indeed the art of Funan in general, was heavily indebted to Indian art, particularly the Gupta and post-Gupta styles. Some details found on this sculpture, for instance the jewelry, in particular the armbands, though only rarely encountered in the art of Funan, are standard in the Indian repertory. Even though the jewelry depicted

on this bust is quite rare, it can be found on a few Funanese sculptures. Perhaps the closest comparison for the necklace, as for the frontal hair panel, appears on the Rach Gia Avalokiteshvara.[6] Reviewing the corpus of extant pre-Angkor sculptures, one finds that the kind of earring worn by our figure was popular from the sixth through the ninth century throughout Southeast Asia from the Mekong Delta area of southern Vietnam[7] to Ku Bua in Thailand.[8] From the various illustrations consulted, it is difficult to determine if any of the earrings have the same outer perimeter of jewels or bosses as the ones worn by this deity. A seventh-century sculpture of Surya, the sun god, from Si Tep in north central Thailand (see No. 36) wears a necklace and earrings not far removed from those worn by this figure, although the Si Tep earrings are plainer and less sculpturesque.[9]

It is difficult to specify whether this sculpture is Buddhist or Brahmanical because its precise provenance is unknown, and it lacks any identifying attributes. Even the curls of hair, normally associated with Buddhist sculpture, provide no evidence for religious affiliation when they are worn by a minor deity.

A few interesting parallels to this type of figure and its posture can be found at Mon sites in southwestern Thailand. Whether they in any way open up avenues for further study can only be speculated. Along the base of Chula Paton, one of the chaityas at Nakhon Pathom, a rather corpulent figure is seated in a posture probably similar to that in which our stone sculpture once sat.[10] Another corpulent stucco figure from the same chaitya, wearing a necklace and crown, with a halo behind its head, has been identified as Kubera, the god of wealth.[11] Other corpulent figures from Nakhon Pathom wearing necklaces, and perhaps armbands, have been identified as *yakshas*.[12]

The examples from Nakhon Pathom are all attached to architectural monuments. That our stone figure is carved completely in the round is of particular importance since early pre-Angkor sculpture established both precedent and preference in Southeast Asia for stone sculpture in the round. Because this sculpture is carved in the round and was therefore a separate icon of worship, the likelihood of its being a *yaksha* is remote. *Yakshas,* at the time this sculpture was made, would normally have been of too minor importance to be worshiped individually. Kubera is a much stronger candidate for the identity of our figure, even though not many examples survive for comparison.[13]

Despite our comparisons to seventh- and eighth-century Thai sculptures, the weight of the somewhat meager evidence indicates that this figure fits most comfortably into a relatively small group of sculptures from southwest Cambodia and southwest Vietnam, the area that probably comprised the ancient kingdom of Funan until about the latter part of the sixth century. The Funan kingdom seems to have been absorbed into the equally mysterious kingdom of Chenla. We do not know exactly when this occurred, but we do know that by the middle of the seventh century, and perhaps earlier, Funan no longer existed as an autonomous state. Dupont has suggested the end of the sixth or the beginning of the seventh century as a date for the Rach Gia Avalokiteshvara.[14] Others prefer a somewhat later date. Our sculpture is probably only slightly later than the Rach Gia figure. It seems to fit quite well with a dating to the first half of the seventh century (which might turn out to be a bit on the conservative side), and probably belongs to the period representing the final chapter in the history of Funan.

As a final piece of evidence, an analysis of stone samples has shown that this figure is carved from exactly the same kind of calcareous sandstone as a pre-Angkor standing Hari-hara said to have been found slightly north of Phnom Da.[15] So similar is the stone, it could even have been quarried from the same rock formation.[16]

[1] Giteau 1965, pls. 6, 7.
[2] Bowie 1972, cat. nos. 6, 18b.
[3] Dupont 1955, pls. V-A, VI-A and B, X-A (from Tuol Dai Buon), XI-A.
[4] Ibid., pl. XIII-A.
[5] Ibid., pl. VII-C.
[6] Ibid., pl. XIII-A.
[7] Malleret 1960, pls. XCV, XCVII–XCIX, CIV.
[8] Boisselier 1975, pl. 21.
[9] Frédéric 1965, pl. 262.
[10] Härtel and Auboyer 1971, pl. 380.
[11] Bowie 1972, p. 51.
[12] Dupont 1959, pls. 202, 274.
[13] The likelihood that the head illustrated by Malleret (1963, pl. XXXVII) is a *yaksha* is problematic. It should be pointed out that there are other possibilities for the identification of the Kronos figure: in the Musée Guimet (acq. no. M.G.14947) there is a figure from Angkor Borei, seated on an animal, which is tentatively identified as the deity Agni.
[14] Dupont 1955, p. 54.
[15] Lerner 1979, p. 89.
[16] I am indebted to Richard E. Stone of the Museum's Objects Conservation Department for this information.

34 SEATED BUDDHA
Cambodia or Vietnam (Funan), style of
Angkor Borei, 7th century
Calcareous sandstone, H. 15⅞ in. (40.3 cm)
Gift of The Kronos Collections, 1980 (1980.526.3)

This rare Buddha comes from approximately the same area as No. 33. His eyes open in an alert gaze, he sits in a cross-legged yogic position with his hands on his lap in the attitude of meditation *(dhyanamudra)*. He is one of a small group of sculptures carved in a style associated with the lower Mekong River area. This group, assignable on the basis of style to the late sixth and seventh centuries, is known primarily from sculptures found at Tra Vinh,[1] in the southern part of South Vietnam at the mouths of the Mekong River, and further north at Angkor Borei,[2] near the southern border of Cambodia. Recently, a similar Buddha was discovered in Songkhla Province in peninsular Thailand.[3] Most of these pre-Angkor sculptures are today in the collections of the National Museum of South Vietnam, Saigon (formerly the Musée Albert Sarraut), the National Museum of Phnom Penh, and the Musée Guimet, Paris, and are hardly found elsewhere.

Some of the common stylistic features of this group are large curls of hair, *ushnishas* (upper cranial protuberances) that are not especially prominent, clearly outlined eyes and lips, and a particular upward turn to the corners of the mouth. In addition, the garments adhere tightly to the body with little indication of drapery folds, and the proportions of the double-lotus pedestals are often compressed. The face of this Buddha should be compared with the Buddha head of Tuol Chan and the standing Buddha of Tuol Lean, both in seventh-century Angkor Borei style.[4]

Published: Lerner 1981, p. 76.

[1] Malleret 1963, pls. XXVIII – XXXIV.
[2] Giteau 1965, pls. 6, 7.
[3] Krairiksh 1980, pp. 116 – 17.
[4] Giteau 1965, pls. 6, 7.

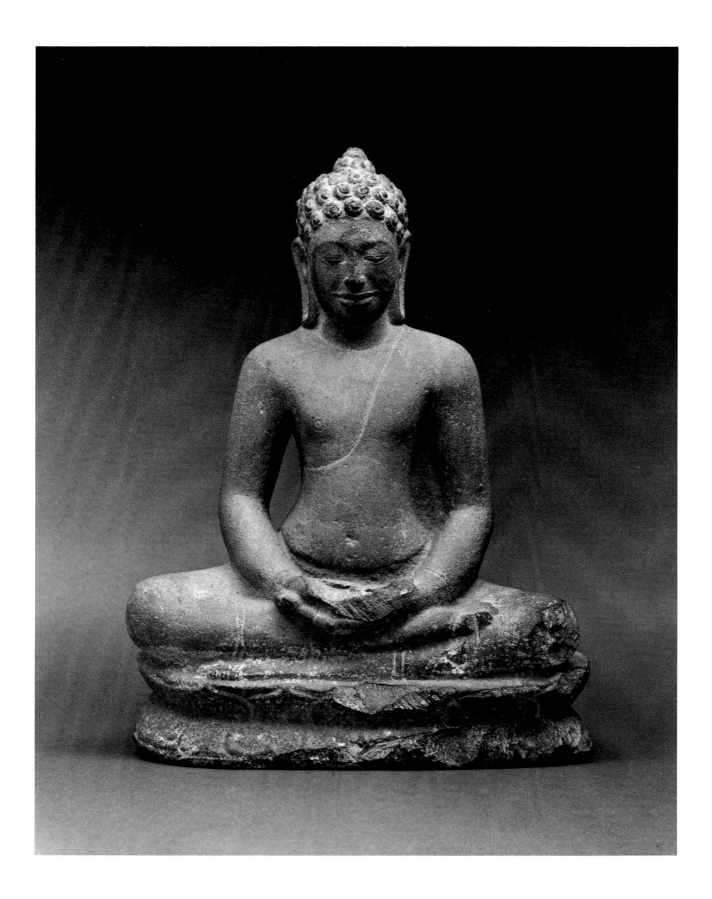

35 STANDING BODHISATTVA MAITREYA OR AVALOKITESHVARA
Thailand, Buriram Province, Pra Kon Chai,
7th – 8th century
Silver alloy, H. 3¾ in. (9.5 cm)

In 1964, a remarkable group of Buddhist bronze sculptures was accidently discovered at Pra Kon Chai in Buriram Province in southeast Thailand.[1] These sculptures reflect Cambodian, Thai, and Indian influences, and are clearly the mature products of very important workshops. Their stylistic affiliations with Si Tep and Lopburi — major centers for sculpture production in central Thailand — help to localize the style of most of them, and the influence of the pre-Angkor sculpture of Cambodia is also apparent.

Many large bronzes were found as part of the hoard;[2] the largest, measuring fifty-six inches, is in the collection of The Metropolitan Museum of Art (acc. no. 67.234).[3] There were even more small bronze sculptures and also, reportedly, a few small, rare sculptures in a silver alloy, including this one from the Kronos Collections.

The Kronos bodhisattva seems to be one of the few exceptions to the relatively consistent rule that the larger figures from the Pra Kon Chai hoard are by far finer in quality. In addition to its miniature size and the silver alloy it is made from, the Kronos figure is unusual in other ways. Most of the Pra Kon Chai sculptures are representations of standing bodhisattvas, either Avalokiteshvara or Maitreya; none, so far as I know, wears jewelry, and the larger figures are almost all four-armed. All but two[4] are dressed in short dhotis that are secured at the waist by a string and end above the knees, while this bodhisattva wears a much longer dhoti.

The central panel of cloth flaring beneath the cord securing the garment is unique, so far as I know, among the Pra Kon Chai sculptures. It appears, however, in Cambodian sculpture of the pre-Angkor period, and can be seen as part of the arrangement of a long dhoti worn by the famous stone Avalokiteshvara of Rach Gia.[5]

The hair on almost all of the Pra Kon Chai bodhisattvas is arranged in individual locks that are piled high on the head and then drop in loops, while the Kronos bodhisattva's hair is separated into locks arranged in a series of concentric rings on top of the head. This arrangement is quite rare in Thai and Cambodian sculpture, but it is not unknown. Of the various examples in bronze known to me, four are of particular interest. The first is a small seated Vajrasattva in the collection of the National Museum, Bangkok, the second a standing bodhisattva in the Museum Pusat, Jakarta (acq. no. 649.b). The third example, a recent gift to The Metropolitan Museum of Art (acc. no. 1982.468), is a pre-Angkor standing Maitreya perhaps datable to the seventh century. The fourth, formerly in the collection of Richard Bull, is a rare small Mon-style standing bodhisattva with stylistic affinities to Pra Kon Chai.[6] Both the third and fourth examples have in common with the Kronos bodhisattva not only the hair arrangement, but also the long dhoti. On the Maitreya in the Museum and on the Kronos figure, the stem of the lotus held in the right hand is attached to the right side of the body below the waist. The bodhisattva formerly in the Bull collection holds a vase in his left hand; the right hand is empty.

The gesture made by the left hand of the Kronos bodhisattva is not *vitarkamudra* (teaching), but rather *katakamukhamudra* (holding an object such as a lotus or vase). Positively identifying this bodhisattva as either Maitreya or Avalokiteshvara is not possible because, in the bronze sculpture of Cambodia and Thailand during the seventh and eighth centuries, both are shown holding a lotus in the right hand and a vase in the left. Identification can only be made if a stupa or a seated Buddha appears in the hairdo (a stupa would identify Maitreya, a Buddha, Avalokiteshvara).

[1] "Unique Early Cambodian Sculptures Discovered," 1965, p. 37.
[2] Bunker 1971 – 72, figs. 7, 8, 10, 16, 17, 19 – 22, 24, 25, 28.
[3] Ibid., fig. 21, and Lerner 1975b, p. 106.
[4] Bunker 1971 – 72, fig. 10, and fig. 12, which has the dhoti ending slightly below the knees.
[5] Dupont 1955, pl. xii-b.
[6] Sale cat., Sotheby's, New York, December 6, 1983, no. 257.

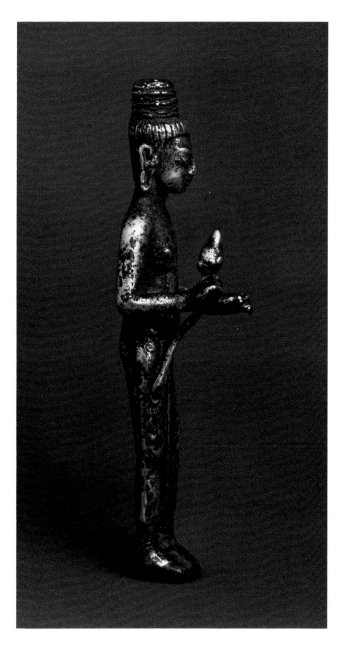

36 HEAD OF A BODHISATTVA
Thailand, Petchabun Province, Si Tep school,
ca. first half of 8th century
Stone, H. 10 1/16 in. (25.5 cm)

Although its existence was known in the first decade of this century, it was not until the 1930s that scholarly attention focused on the extraordinary site of Si Tep (Sri Deb) in the Petchabun Province of north central Thailand.[1] Based on the remarkably fine sculpture recovered from the area and on some inscriptions in Sanskrit found there, it is clear that Si Tep, situated along vital ancient trade routes, must have been a center of considerable importance.

The chronological sequences are still to be worked out, but it is not improbable that the artists of Si Tep owed their allegiences, first, for some unknown period, to India; then, during the sixth and seventh centuries, to Funan; slightly later, to Chenla; and, by the middle of the eighth century, to the Mon styles of Lopburi and Dvaravati.[2] Finally, with the resurgence of Khmer cultural domination in the tenth century, new Khmer styles of Cambodia (or, indirectly, the Khmer-inspired styles of Lopburi; see No. 53) asserted their influence on the Si Tep workshops. It is also not yet possible to determine the exact mix of these stylistic impulses or to hypothesize about the specific contributions from Si Tep itself, but a review of the stone sculptures clearly indicates that throughout its known history Si Tep maintained a distinctive and distinguished style.

The sculptures recovered from the Si Tep area, though relatively few in number, seem to indicate that sometime during the eighth century the Mon styles of Thailand replaced the older Funan-Chenla styles of Cambodia and southern Vietnam. This head seems poised at the point of supersession, for although the physiognomy is distinctively of Mon type, the rectangular shape of the face, the unconnected eyebrow ridge, and the tiara with three prominent attachments (two over the ears and a third above the forehead) all refer back to the earlier Funan-Chenla models. The closest comparison I know of for the physiognomy is a superb standing Buddha from Si Tep (now in the collection of The Cleveland Museum of Art), probably datable to the beginning of the eighth century, which I would place slightly earlier than the Kronos head.[3]

The tentative identification of this head as that of a bodhisattva is based on the unusual hair arrangement and adornment. Although I can cite no closely comparable instances, I am confident they exist. The hair is arranged in a high chignon tied with what appears to be a thick band of cloth knotted at the sides. A portion of the cloth protrudes slightly from the knot on each side, and the ends project upward on the chignon. Two more flat bands, of cloth or hair, encircle the head and are drawn under the front of the thick cloth around the chignon; the summary finishing on this part of the sculpture permits alternate interpretations.

While it is not impossible that a Brahmanical deity should have such a hair arrangement, it is not particularly suitable, and, through extrapolation rather than known cognate examples, we are identifying the head as being Buddhist. Recent excavations have made it apparent that both Hinduism and Buddhism flourished at Si Tep, but the earlier sculptures—those of the sixth and seventh centuries—from the area seem to be either specifically Vaishnavite or of other Brahmanical deities. Representations of Vishnu and Surya wearing high miters clearly predominate. A dating to the first half of the eighth century for this head of a bodhisattva would be entirely consistent with the religious affiliations of the area at that time.

Except on the face, which has suffered some damage, the surface of the sculpture seems to have been left unfinished. The consistently stippled surface suggests that it was meant to receive a coating of some sort, perhaps of polychrome. This seems also to be the case with other sculptures (formerly in the Thompson collection and now in the National Museum, Bangkok), found in a cave near Si Tep.[4]

This rare and remarkable head holds a secure position within the group of sculptures in this catalogue that seem to us to clearly reflect the deep inner calm and spiritual serenity that is the ultimate attainment in Asian religious philosophy. In addition, it is a significant supplement to the small corpus of stone sculptures of the Si Tep school and testifies to the very high aesthetic level achieved by the Si Tep sculptors.

[1] Coedès 1932, pp. 159–64, and Quaritch Wales 1937, pp. 40–43.
[2] I cannot agree with Jean Boisselier's assertion that the statuary found at Si Tep "on both stylistic and technical grounds . . . does not appear to be earlier than the eighth or ninth century" (Boisselier 1975, p. 104). See also Lerner 1976, color pl., p. 201.
[3] Czuma 1980, fig. 8.
[4] 6 *Soi Kasemsan 11,* 1962, p. 12.

37 RELIQUARY
Thailand, Mon style, 7th – 9th century
Bronze, H. 9⅛ in. (23.2 cm)

The high placement of the bowl of this very elegant and beautifully turned object has transformed a model of a stupa into a reliquary. On the original stupa form, the bowl would have been smaller and lower, and the spire would have included rings representing parasols. A similarly elongated representation of a stupa, with the bulbous portion placed further down, appears on a stone votive tablet found in Stupa 1 at the Mon site of Ku Bua, slightly southwest of Nakhon Pathom near the head of the Gulf of Thailand.[1]

Reliquaries of this sort are quite rare; this one is said to have been excavated at a Mon site. Among the relics found inside it were twenty-three glass beads, twenty-four small gold beads of varying shapes, a small metal disk, crystals of pink spinel (balas rubies), and some tiny pebbles. The gold base for the rock crystal cover has been restored.

[1] *Guide to Antiquities Found at Koo Bua,* 1961, p. 52, fig. 11.

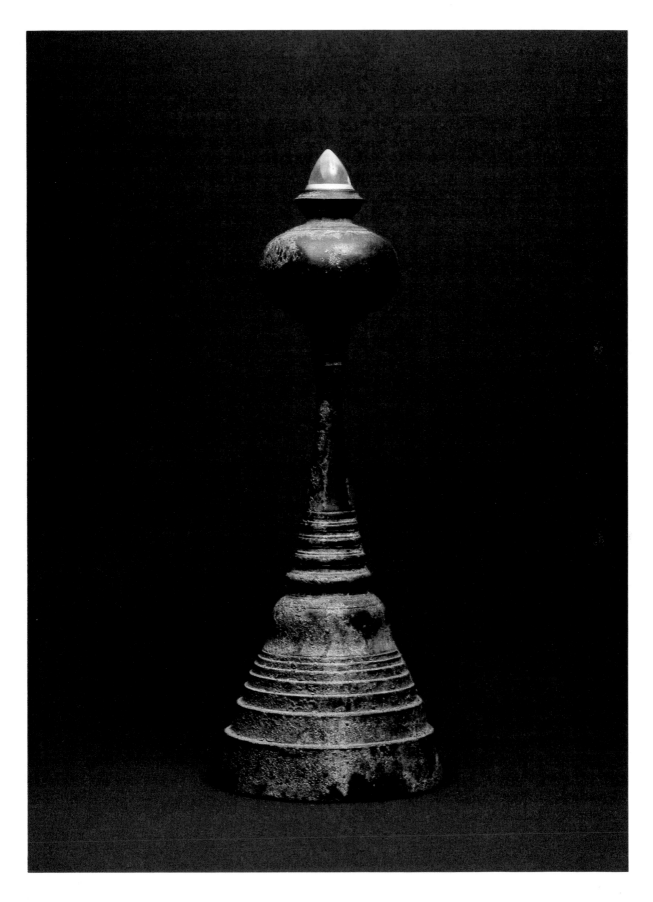

38 STANDING BUDDHA
Thailand, Mon style, 8th – 9th century
Bronze, H. 8¾ in. (22.2 cm)

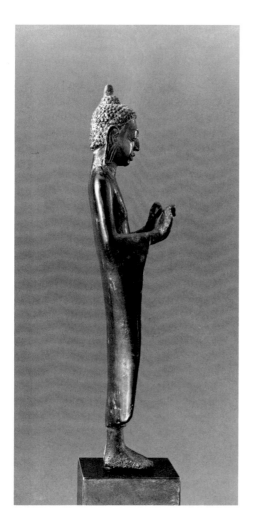

Judging from extant material, the single most popular image produced by the Mon people of Thailand during the seventh through the ninth century was the standing Buddha with both hands raised in the expository or teaching gesture *(vitarkamudra)*. Almost always, the emphasis is on the iconic nature of the image, stressing frontality and symmetry. Both shoulders are usually covered and, whereas the outlines of the garments are normally clearly delineated, indications of drapery folds appear only at the lowermost outer edges of the flaring robe (the Gupta traditions of Sarnath are the ultimate prototypes for this treatment of the garment). The garment adheres to the shallow and unassertive volumes of the body, making the image rather flat in profile. The attenuation of the body forms and the silhouette of the garments on these figures sometimes make them quite elegant, but they are clearly an iconic type stressing the head and large hands.

A large number of Mon-style Buddhas survive, but this standing Buddha is a particularly fine example. The facial features, of Mon type, are carefully and precisely articulated, as are the curls of the hair. The depiction of the arching eyebrow ridge as a continuous unbroken line is typical of eighth- to ninth-century Mon-style sculptures, as is the high finial topping the head.

A few other bronze images in this style, with the same carefully outlined eyes and lips and the same silver or gray-black (rather than green) patina, have appeared on the market with a putative Si Tep provenance.

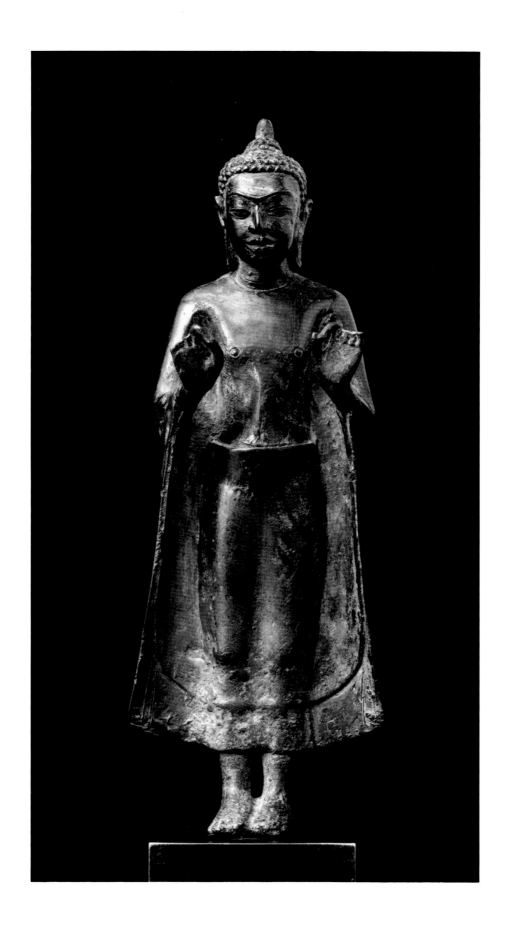

39 HEAD OF BUDDHA

Thailand, Ratchaburi Province, Mon style,
9th century
Stucco, H. 10¾ in. (27.3 cm)

This head of Buddha is part of a group of stucco heads in Mon style discovered in Ratchaburi Province in southwestern Thailand, above the Thai peninsula.[1] They are said to have come from Ku Bua,[2] but the reliability of this claim has not been verified, and it is entirely possible that they belong to another site in Ratchaburi.

On the basis of style, this head should be assigned to the last phases of Mon sculptural evolution in Thailand and probably dates to the ninth century.

Rather than the subdued spiritual serenity so often found on the faces of earlier Mon-style Buddhas, here there is a new feeling of boldness and power. One almost senses the sculptor pushing familiar forms to new limits, stopping just short of exaggeration and flamboyance. The pronounced arch of the eyebrow ridge, the very deep undercutting of the forceful upward curve of the corners of the mouth, the staring eyes, and the prominent nose all combine to produce a grand, powerful, somewhat extroverted visage rather than one suggesting an inner calm. This development in stucco has its counterpart in stone sculpture, which can perhaps best be seen in the monumental ninth-century stone Buddha in the Norton Simon Museum of Art, Pasadena.[3]

The curls of hair on this Buddha were formed with a mold or die, in the same manner as the hair on another Buddha head from the same group that is now in the Jim Thompson collection.[4] The three dots arranged vertically on the forehead appear on most of the heads from this group, including a head of an unidentified deity that has recently entered the collection of The Metropolitan Museum of Art (acc. no. 1982.214), and two heads in the Philadelphia Museum of Art (acc. nos. 64-179-6 and 7). The back of the Kronos Buddha head and of the head in the Metropolitan Museum are unfinished, suggesting they were originally attached to a building.

[1] 6 *Soi Kasemsan 11,* 1962, pp. 21–23, and Jeannerat 1978, no. 105.
[2] 6 *Soi Kasemsan 11,* 1962, pp. 8, 12.
[3] Lerner 1976, p. 202, pl. 9.
[4] 6 *Soi Kasemsan 11,* 1962, p. 21.

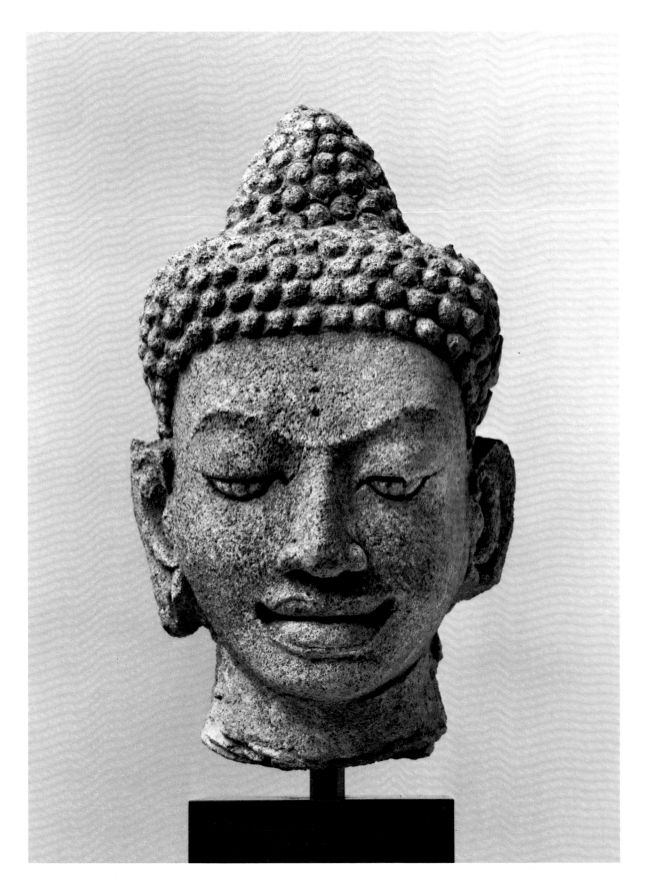

40 STANDING PRAJNAPARAMITA, THE GODDESS
OF TRANSCENDENT WISDOM
Thailand, Peninsular style, ca. 10th century
Bronze, H. 6¼ in. (15.9 cm)
Gift of The Kronos Collections, 1979 (1979.510.2)

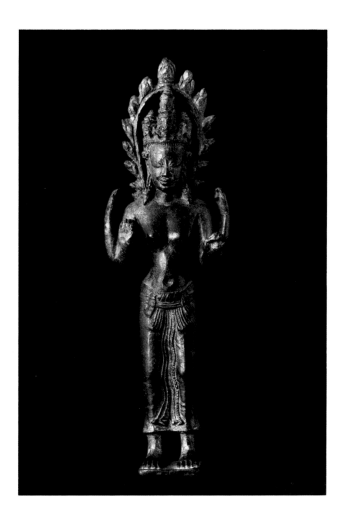

around the hips in a complex but symmetrical arrangement of knots and pendant pleats that is a variant of the late ninth- to early tenth-century Cambodian sarong arrangements. The halo rising from the shoulders recalls ninth-century Javanese halos. And the physiognomy and the elongated figure are in a style associated with the Mon people of Thailand.

This charming deity represents Prajnaparamita, the Buddhist goddess of transcendent wisdom. She has four arms, and her hands are in the teaching gesture *(vitarkamudra)* and the gesture of holding an object. Four diminutive heads on top of her head cover a Khmer-style tiered crown, which is visible from the back. Both the crown and the floral rosettes above the ears are consistent with a tenth-century dating. Like the faces on all of the finest South Asian sculptures, her face radiates a serenity indicative of her advanced state of spiritual bliss.

Prajnaparamita is considered to be the embodiment of the *Ashtasahasrika Prajnaparamita Sutra (The Perfection of Wisdom in Eight Thousand Verses),* one of the most important Buddhist texts. In India, worship of this deity was very popular, and she is represented by both two- and four-armed types. Multiheaded examples, however, were clearly not popular in India (if they occurred at all) and may also have been unknown in Nepal and Tibet. They do not seem to be included in standard Indian iconography,[1] or in that of Nepal and Tibet. Boisselier cites Cambodian examples of Prajnaparamitas with one, four, or five heads.[2] The deity seems to have been considered important in Cambodia from at least as early as the tenth century, and eventually, sometime during the second half of the twelfth century, she was elevated to a level of prime importance.[3] Nevertheless, the multiheaded variant, rather than being a Southeast Asian invention, probably has its origins in the tantric iconography of northeast India. In light of these iconographic considerations, this rare sculpture may provide a starting point for fresh research.

Published: Lerner 1980, pp. 67–68.

[1] Bhattacharyya (1924) does not include any mention of the multiheaded form.
[2] Boisselier 1966, p. 304.
[3] Woodward 1981, p. 58.

This beautiful sculpture with a most attractive patina is as enigmatic as it is aesthetically satisfying. It seems to be a composite of Cambodian, Thai, and Javanese styles in unequal admixture. One of the most likely places for this fascinating blend to have occurred was peninsular Thailand, which at the time this sculpture was created was responsive to strong stylistic impulses from both the Khmer empire and the Indonesian islands.

Some of the compositional elements are combined in unorthodox fashion. The sarong is secured by a sash

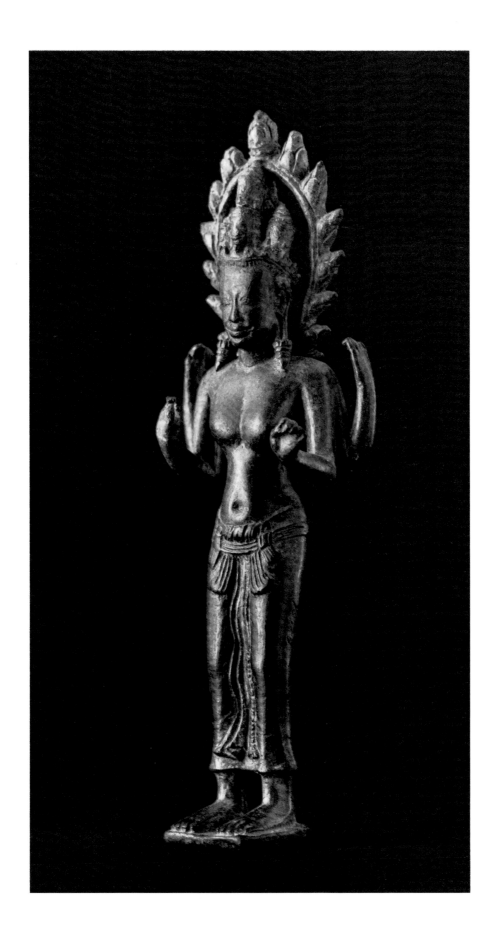

41 BUDDHIST TRINITY
Indonesia, Central Javanese or Shrivijaya style,
ca. 8th century
Bronze, H. 9⁹⁄₁₆ in. (23.7 cm)

This rare trinity has been attributed to the enigmatic Shrivijaya kingdom (ca. eighth to thirteenth century), whose capital was supposed to be on Sumatra, and which probably had a major outpost in peninsular Thailand during the eighth century.[1] The distribution of find spots of Shrivijaya-style bronze sculptures is so erratic, and the style seems to have been so susceptible to various outside influences, that no clear corpus of material has yet been isolated. Sculptures found in Indonesia, Malaysia, and Thailand have been assigned to the Shrivijaya school, but they continue to defy precise stylistic categorization. It is clear, however, that elements of the styles of northeast and southeast India, central Java, and southern Thailand are all discernable in the art of Shrivijaya. The sculpture of northeast India and, to an even greater degree, of the early Central Javanese period of the seventh and eighth centuries seem to have been the most significant contributors to this particular icon.

Standing on a double-lotus pedestal set on a rectangular base, the Buddha has both hands raised in the teaching or expository gesture *(vitarkamudra)*. He holds a portion of his garment in his left hand. To his right stands the Bodhisattva Avalokiteshvara, the Lord of Infinite Compassion, identifiable through the diminutive seated Buddha placed in his high chignon. To his left is the messianic Bodhisattva Maitreya, who can be identified by the small representation of a stupa in his hairdo. Avalokiteshvara holds a lotus in his left hand; the object Maitreya held in his left hand has been lost. Both bodhisattvas wear long dhotis secured at the waist by knotted sashes and scarves draped diagonally across their chests. They stand on double-lotus pedestals in the *tribhanga* (thrice bent) posture.

The bodhisattvas are dressed in a simpler manner—without the usual jewelries and multiplicity of jeweled sashes around the waist—than is normally encountered on ninth-century Central Javanese sculpture.

The style of the standing Buddha, as well as the way in which the garments are worn, is not far removed from seventh- and eighth-century examples from northeast India, but also appears in the Central Javanese repertory.

The *vitarkamudra* made by the Buddha is most commonly found on Thai sculpture, as is the composition of a standing Buddha flanked by two bodhisattvas, which derives from the Mahayana Buddhist art of India. The iconography of this trinity may call into question the identification of many of the Thai stone sculptures in Mon style that depict the Buddha, hands in *vitarkamudra*, standing on top of the composite creature called Vanaspati and flanked by two attendants who are sometimes identifiable as Indra and Brahma. When the identity of the attendants is unclear, it may be that they are Avalokiteshvara and Maitreya, as seen here.

Although earlier publications of this trinity have called it "Shrivijaya art in Thailand,"[2] and Indian,[3] I would prefer continuing to attribute it to Indonesia. Although I do not know if its style is more accurately described as early Central Javanese or Shrivijaya, many large collections of Central Javanese bronzes will yield close parallels. For example, the collection in the Rijksmuseum voor Volkenkunde, Leiden, includes three close comparisons: a standing bodhisattva (obj. no. 1403-1841), a seated bodhisattva (obj. no. 1403-3050), and a standing Buddha (obj. no. 1403-2463).

The three figures in the Kronos trinity were cast separately. The lotus pedestal of Avalokiteshvara has been partially restored.

Published: Prachoom 1969, p. 39; Diskul 1980, p. 28 and pl. 11.

[1] Diskul 1980, p. 28 and pl. 11.
[2] Ibid.
[3] Prachoom 1969, p. 39.

42 STANDING PADMAPANI LOKESHVARA
Indonesia, Shrivijaya style, ca. second half
of 9th – first half of 10th century
Bronze, H. 12¼ in. (31.1 cm)

This image of the Bodhisattva Padmapani Lokeshvara, identifiable by the lotus *(padma)* in his left hand and the miniscule representation of the seated Buddha Amitabha in his hairdo, stands in a slightly hipshot posture on a double-lotus pedestal. The long, subtly modeled legs — the right slightly bent and set forward, the left rigid — support a lean torso, full neck, and rounded head. The high hair arrangement surmounted by a flame completes the graceful and elegant figure, whose gentle volumes have a harmonious fluidity entirely in keeping with the serene aspect of the face. The body halo with its outer perimeter of stylized flames echoes the forms of the figure.

The bodhisattva wears a dhoti with a sash above the hips. A scarf knotted at the left shoulder flows down across the chest to the right hip. Except for the unusual pendants attached to the earrings, the jewelries are of a type commonly encountered on sculptures of the period. Looped curls fall from around the high chignon, and a long, thick coil of hair rests on each shoulder. Set into the intricate hair arrangement is a cursory image of a seated Buddha, and above each ear there is a rosette. Two lotuses grow from the side of the pedestal; the stalk of the larger one passes through the bodhisattva's left hand and its closed bloom appears near his face. The right hand (which would have been in *varadamudra*) has been broken off at the wrist, and parts of the fingers of the left hand have also not survived.

This magnificent sculpture is even closer to early Central Javanese styles than the preceding trinity. The physiognomy, in particular, is quite close to what one finds on ninth-century Central Javanese temples — Chandi Mendut, Prambanan, and others. As with many sculptures tentatively assigned to the Shrivijaya school, it is not impossible that this sculpture was created in central Java.

Shrivijaya bronze sculptures of this size and quality, though rare elsewhere, are not uncommon in Indonesia and Thailand. But even in those countries it is unusual to find an example with the body mandorla intact. In this case, the mandorla is particularly informative because its style is not Javanese but rather northeast Indian of the Pala period, although the pointed top is a local feature rather than Indian-inspired. The two loops on the reverse probably once held an umbrella. Another very unusual feature of this sculpture is the flame on top of the hairdo. In addition, one is more likely to encounter multiarmed representations of Padmapani Lokeshvara in the art of Shrivijaya than two-armed ones.

This sculpture is reported to have been found at Surat Thani in peninsular Thailand.

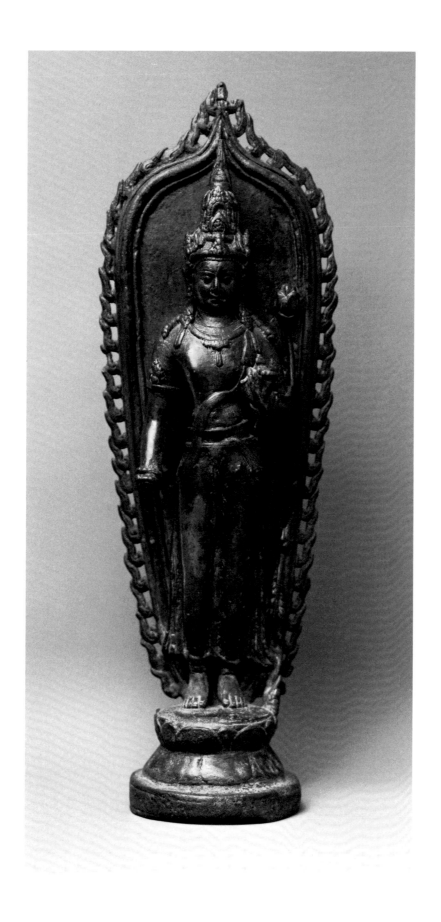

43 SEATED FOUR-ARMED GANESHA
Indonesia, Borneo, Shrivijaya style,
ca. second half of 9th century
Stone, H. 31⅞ in. (81 cm)

A description of this Ganesha was included in a remarkable report that appeared in 1926 concerning a group of sculptures found in a cave or grotto at Kombeng in eastern Borneo (Kalimantan). The report, by F. D. K. Bosch, Director General of Archaeology in the Dutch East Indies from 1916 to 1936, was titled "Archaeological Findings in Koetei."[1]

But the first mention of the cave and its contents appears in a letter of 1895 from a Lieutenant van der Star to the directors of the Batavia Company. It seems that during a visit to the Sultan of Kutei (Koetei), van der Star saw three "Buddha-statues,"[2] and was told by the Sultan that others existed. Further inquiry produced the location of the source of the sculptures. It was not until 1912, however, that the first European, a mining engineer named Witkamp, actually visited the site of Kombeng, northeast of Kutei, where the sculptures had been found. Witkamp returned with a detailed description and floor plan of the cave, along with sketches of the sculptures still there: "Here we found, dispersed over the floor-area, partially covered by earth, a number of separate Hindu statues that were obviously transported here from elsewhere. . . . Possibly one could find other caverns with sculptures in the Goenoeng Kombeng hidden by the Dayaks. . . ."[3]

In his 1926 article, Bosch discusses and evaluates photographs of the Kombeng sculptures taken the year before—at the time he wrote the article, he had not actually seen the sculptures. It is not easy to work through his report, with its strange iconographic and aesthetic presumptions made only from photographs. What clearly emerges, however, is Bosch's recognition that these sculptures form at least two very dissimilar groups. The first group comprises Shaivite sculptures relating to Central Javanese styles (eighth through tenth century) that, as Witkamp had suggested, probably came from a local temple no longer in existence.[4] The sculptures in the second group are in a very different style, and have been the subject of much speculation regarding both their iconography and the sculptors who carved them (see No. 54).

I will not burden the reader with the details of Bosch's hypothesis. Suffice it to say that he concludes that both groups were the products of sculptors living in Borneo, and not of immigrant artists. The Shaivite group (and the early seated Vajrapani, see note 4) was clearly influenced by the art of the Central Javanese period. By the time the second group was made (Bosch does not suggest a date), the sculptors had been out of touch with metropolitan centers of carving for so long that they no longer understood the iconography; they committed many errors and used unorthodox combinations of attributes and strange treatments of dress and adornment.

Who these artists in fact were, what their relationship to the art of central Java during the Central Javanese period was, and what the prior history of the sculpture of Borneo had been, are problems too complex to treat here, and we leave them for future investigations. It should be noted, however, that J. Vogel has suggested, based on Sanskrit inscriptions believed to belong to the fifth century found at Kutei, that "there existed in Eastern Borneo, the present Kutei, on the banks of the Muhakkam River, a state ruled by a line of Hindu or Hinduised *rajas*. . . ."[5]

We would, however, like to introduce the suggestion that the Shrivijaya empire contributed, at least in part, to the style of this seated Ganesha. It would not be at all surprising if strong stylistic influences of the maritime Shrivijaya empire were to be found on Borneo; some scholars have even suggested that at one time the capital of the empire was situated on its west coast.[6] In all events, a Shrivijaya connection for this sculpture is quite plausible. The Shrivijaya kingdom had not only Buddhist but also Brahmanical affiliations, so that the dedication of a temple complex devoted to Shiva in eastern Borneo during the ninth century would be entirely consistent.

The whole conception of this high-relief sculpture of Ganesha is totally outside the mainstream of representations of the elephant-headed deity in Indonesia. Rather than being the squat, compact creature with a bulky, powerful head repeated over and over again in the sculpture of Java and Bali, this Ganesha (within iconographic confines) appears both taller and closer to human proportions. In addition, the eyes are human and set close together. It is as if the sculptor sacrificed the usual humorous charm of the deity for a more regal and imposing feeling, for certainly this Ganesha has an unexpected sense of nobility rarely encountered in Indonesian representations, which is perhaps indicative of an uncommon prototype. The unusual sense of verticality within the tall pyramidal silhouette derives not only from the high hairdo, but also from the straight, slim trunk centered on the figure—a remarkable, perhaps unique, treatment.

Ganesha is seated in the fashion that is standard for Indonesian Ganeshas and not to be found in India, with both legs placed symmetrically beneath him and the soles of his feet touching each other. In his upper left hand he holds an elephant goad, and in his upper right a

rosary. His lowered left hand holds the usual ball of sweets; his lowered right hand rests palm downward on his knee. He wears a tiara, a necklace, armbands, and what appears to be a jeweled girdle beneath his pendulous stomach. The usual serpent, knotted above the left shoulder, serves as a sacred thread (see No. 51). Of all his adornments, it is his hair arrangement that is the most striking. The hair is separated into individual locks (*jatas*) that are piled high on top of the head and then descend in loops. This is a common Indian hairdo, normally associated with Shiva and seen to greatest advantage on Chola sculptures, but not restricted to Shiva or to Brahmanical deities. An even closer treatment of the hair arrangement, however, can be found on sculptures associated with the styles of Shrivijaya[7] (see No. 42). A crescent moon—a common attribute of

Ganesha's father, Shiva—supported by a lotus appears on the front of the hairdo.

Published: Bosch 1926, pl. 32b; Getty 1936, pl. 32b.

[1] Bosch 1926, pp. 132–53, pl. 32b.
[2] In the following year (1896), at their request, the Sultan donated the three sculptures to the museum in Batavia (now the Museum Pusat, Jakarta; acq. nos. 103f, g, h).
[3] Bosch 1926, p. 133.
[4] Included in the first group, but not supposed to have come from the hypothesized Shaivite temple complex, is a seated Vajrapani that was one of the three sculptures the Sultan of Kutei gave to the Museum Pusat (acq. no. 103h).
[5] Vogel 1925, p. 49.
[6] Diskul 1980, p. 1.
[7] Ibid., pls. 3–5, 8, 9, and others.

44 BODHISATTVA VAJRAPANI
Indonesia, Java, Central Javanese period, 9th century
Bronze, H. 4½ in. (11.4 cm)

Javanese sculptors have left a legacy of small bronzes—perhaps greater than that of any other Hindu or Buddhist culture—that has justly earned them the reputation of being the great miniaturists of South Asia. This superb image surely enhances that claim.

In a lengthy report prepared for a previous owner, J. E. van Lohuizen-de Leeuw convincingly theorizes that this seated deity is a representation of the Bodhisattva Vajrapani (the thunderbolt bearer). Her arguments revolve around the following points: the gestures of the hands, the highly arched eyebrows, the position of the legs, and the suggestion of a lotus, which may have supported a thunderbolt *(vajra),* near the left armband.

The deity is seated on a double lotus supported by a stepped pedestal, his right foot resting on a small lotus growing out of the lower part of the pedestal. He sits in the unusual attitude, "called *utkatika,* . . . adopted during the angry mood following immediately after a heroic fight. The attentive observer of our bronze figure will easily appreciate that this attitude expresses relaxed virility."[1] Vajrapani is dressed in the usual garments of a bodhisattva and wears a high crown of the type called *kiritamakuta* and elaborate jewelries, including two different types of earrings: the left in the shape of a *makara* (see No. 47) and the right a disk with a central strand of pearls.

Beautifully modeled, of elegant proportions, with finely crafted detailing and great artistic sensitivity, this seated deity has a sense of monumentality belying its size.

[1] From van Lohuizen-de Leeuw's report, which is dated January 1965.

45 BODHISATTVA VAJRAPANI(?)
Indonesia, Java, Central Javanese period,
9th – 10th century
Silver, H. 1¹⁵⁄₁₆ in. (4.9 cm)

This figure represents a category of sculpture further testifying to the Javanese delight in miniaturization: sculptures in silver, which, though rarer than the bronzes, have survived in sufficient numbers to indicate the popularity of the genre. Silver and gold were natural media for the craftsmen of central and eastern Java, and often these sculptures were set onto larger bronze pedestals with halos, which enhanced the precious look of the images.

This deity, whose hand positions and stern aspect are sufficiently similar to a Vajrapani in the Pan-Asian Collection to suggest the same identity,[1] is seated in a cross-legged yogic posture on a double-lotus pedestal. He is dressed in the same manner as the preceding Vajrapani (No. 44), and is bare-chested and adorned with elaborate jewelries. Here, however, more remains of the lotus flower originally placed near the left shoulder, and its stem can be seen curving gracefully along the left arm. This lotus may also have supported a *vajra* (thunderbolt). The *vajra* can still be seen on the example in the Pan-Asian Collection.[2]

The sensitive modeling, the swelling volumes of the chest and limbs, and the clarity of detail, along with the slight tilt of the head to the left, all lend a sense of great presence to this fine miniature.

[1] Pal 1977, cat. no. 116.
[2] Ibid.

120

46 SEATED FOUR-ARMED KUBERA
Indonesia, Java, late Central Javanese or early
Eastern Javanese period, 10th century or later
Bronze, H. 6³⁄₁₆ in. (15.7 cm)

Kubera, the god of wealth, is one of the most popular deities in the extensive Indonesian pantheon. In both Brahmanical and Buddhist art, he is encountered, either as Kubera or Jambhala, not only in small bronzes, as here, but in larger stone examples. He is traditionally depicted as a corpulent deity of squat proportions richly adorned with jewelries.

Kubera is seated in the posture of royal ease *(la-litasana)* on a lotus separated from the stepped, decorated pedestal by a vase with a projecting spout. Four vessels overflowing with precious objects are placed at the corners of the pedestal, and an overturned fifth vessel serves as support for the deity's pendant right foot. The most common attributes of Kubera—the lemon *(jambhara)* and the mongoose *(nakula)*—are held in the lowered right and left hands respectively. The mongoose, the vanquisher of serpents *(nagas),* is shown here in a most inventive and unusual manner: rather than spewing jewels from his mouth, as he is almost always encountered, this creature turns his long-snouted head toward Kubera. Depicted in a relatively naturalistic fashion, this elongated mongoose has a miraculously preserved long tail pointing backward behind the large halo.

The iconography of this deity in either a Brahmanical or Buddhist context is rather consistent, with variations, if they occur, usually limited to minor details. Kubera can, however, be represented with more than two arms, though four-armed representations are considerably rarer than two-armed ones. The attributes held in the extra hands vary somewhat: our Kubera holds a lotus in his raised right hand and a conch in his left; a sculpture of Kubera in Vienna also holds a conch and a lotus, but in the opposite hands;[1] and an unusual example in the Musée Guimet, Paris, has a war discus *(chakra)* in the raised right hand and what appears to be the stem of a lotus in the left.[2] The conch, the lotus, and the war discus are all standard attributes of Vishnu.

Vaishnavite associations of Kubera are clearly justifiable. In early Indian art, Kubera is sometimes present at the great Vaishnavite event, the churning of the primordial Ocean of Milk. One of the reasons for churning the Ocean of Milk was to recover the great treasures lost beneath it during the Great Deluge. The great serpents, who guarded the treasures beneath the sea, were defeated and the treasures recovered. Ultimately, it became Kubera's responsibility to look after some of these treasures. This story also offers an explanation for Kubera's association with the mongoose, a natural enemy of snakes.

The tenth-century transitional stylistic sequences from the Central Javanese period to the Eastern Javanese period are difficult to document or isolate. It is possible that this fine sculpture dates to the eleventh rather than the tenth century.

[1] Heine-Geldern 1925, pl. 15.
[2] Le Bonheur 1971, p. 193.

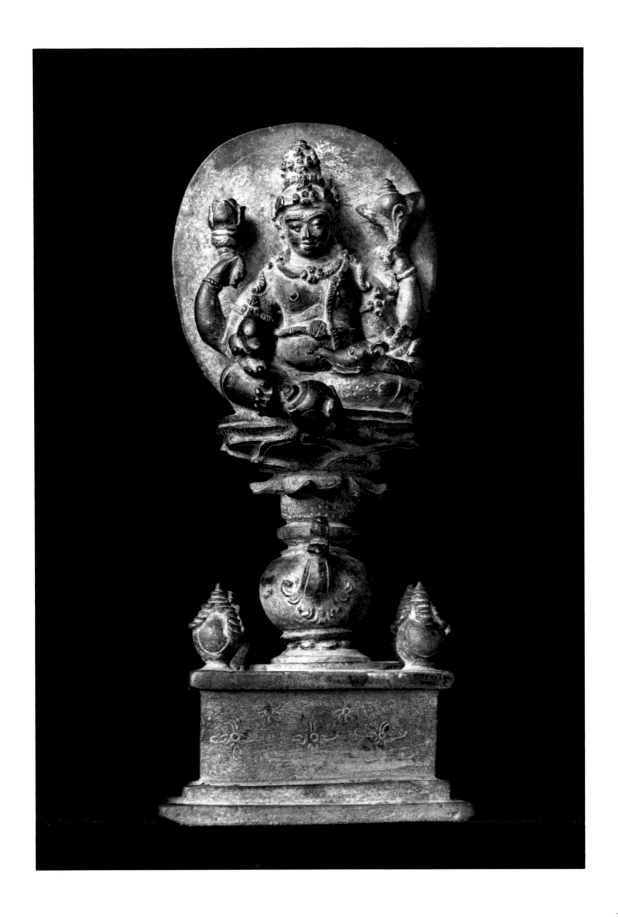

47 WATER SPOUT IN THE FORM OF A *MAKARA*
Indonesia, Java, Eastern Javanese period,
ca. 10th – 11th century
Bronze, H. 5¹¹/₁₆ in. (14.5 cm), L. 5½ in. (14 cm)

This extraordinary bronze object is, so far as I am aware, unique. As with many unique objects from South Asia, establishing a date becomes more difficult because, by definition, no cognate examples exist. Stone water spouts are a common architectural element on virtually all temples in Java; unfortunately, none is so close in shape and form as to be useful as a stylistic parallel.

Makaras are composite mythological creatures usually associated with water who have curling snouts and fancifully arranged teeth and ears. These aquatic monsters, at times rather humorous, derive from Indian prototypes. They sometimes resemble a combination of crocodile and elephant, but are encountered in a variety of shapes. This particular example is superbly modeled, with curving scaly forms and scrolling floral shapes. It has bulbous eyes and an upward-projecting curved snout topped with bold curling forms. There is a lotus on the tip of the snout and a floral shape suspended above the enigmatic owl-like bird perched on the projecting cylindrical opening. An altogether magnificent conception, beautifully executed, this appealing beast has great presence and charm, and is clearly the product of a highly accomplished metalworking atelier.

Although its shape corresponds very well with stone water spouts, it is not inconceivable that this object was used in a different context. The shape is such that it could have been part of a finial of some sort on either a throne back or some other large object.

48 MAHAKALA
Indonesia, Java, Eastern Javanese period,
11th – 12th century
Bronze, H. 6³/₁₆ in. (15.9 cm)

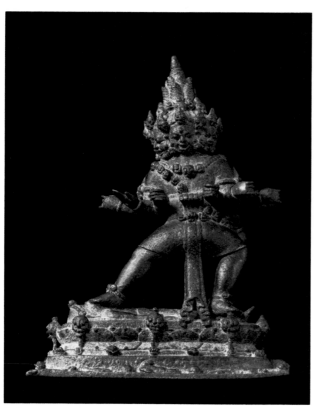

Back

Detail of base

According to certain traditional Indian systems of ico-
nography, Mahakala is one of the terrific and destructive
forms of Shiva. This deity was eventually claimed by both
Hindu and Buddhist tantric cults, though the latter be-
came the more important art-producing school, particu-
larly in northern India, Tibet, and Nepal.

As a guardian of the faith *(dharmapala),* Mahakala is
usually depicted trampling a nonbeliever; therefore, any
figure symbolic of a threatening rival sect could be
placed under his feet. Here, a prostrate male, wearing the
sacred Brahmanical thread and perhaps representing a
Brahmin, is being trampled.

The powerful, corpulent tantric deity adopts the
aggressive stance of *pratyalidha,* a posture often taken
by *dharmapalas* trampling foes. His lowered right hand is
in the boon-granting gesture *(varadamudra)* and his
raised left is in *tarjanimudra,* a gesture of warning or
menace. Mahakala is depicted with six heads, six legs, and
twelve arms. Of the six faces, only one is pacific; the rest
are wrathful, fanged, and terrifying. All six heads
wear diadems of skulls, and the deity wears a necklace
adorned with skulls as well as a sacred thread composed
of skulls alternating with lotuses. Additional jewelries
continue the skull motif, as does the oval double-lotus
pedestal. Mahakala's hair is arranged in a series of
spiraling, conical forms, which heighten the sense of a
great pyramidal mass being supported by the shoulders.
Only the attributes held in the front two hands have
survived; the rest have been lost.

Mahakala inhabits cemeteries, and his necropolitan
associations are graphically depicted around the base of
the sculpture — torsos, limbs, skulls, bones, and a flayed
skin litter the cremation-burial grounds. Amid this grisly
reminder of mortality, one macabre smiling head ap-
pears on the side of the base.

This sculpture is a tour de force of Javanese bronze
casting. The originality of conception, complexity of
composition, and superb craftsmanship and detailing
place it in the very first rank of important Javanese
bronze sculptures.

Published: van Lohuizen-de Leeuw 1982, pl. 1. (The thirteenth- to
fourteenth-century dating assigned to the sculpture in the
catalogue seems, on the basis of style, to be much too late.)

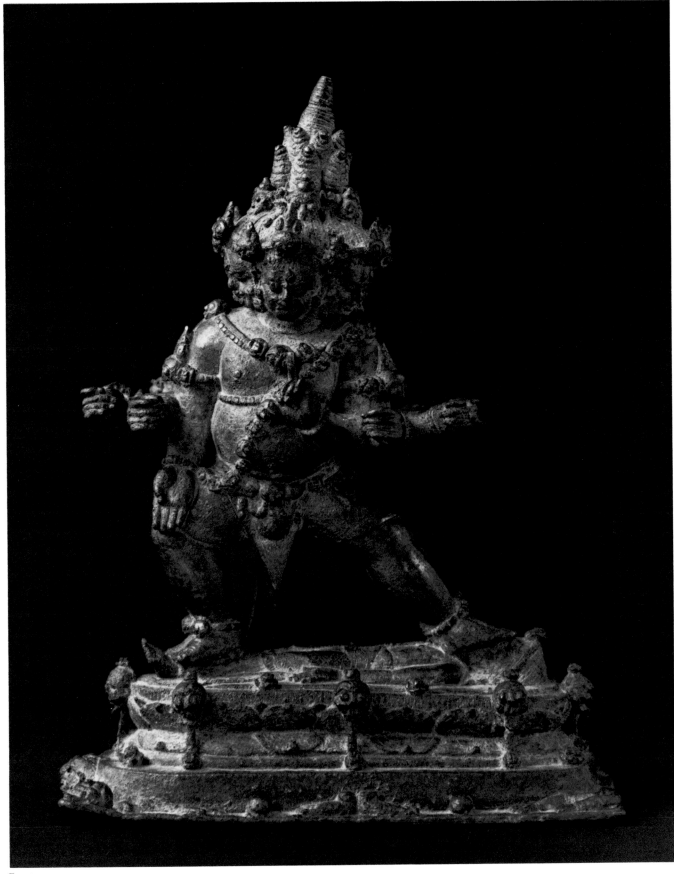

Front

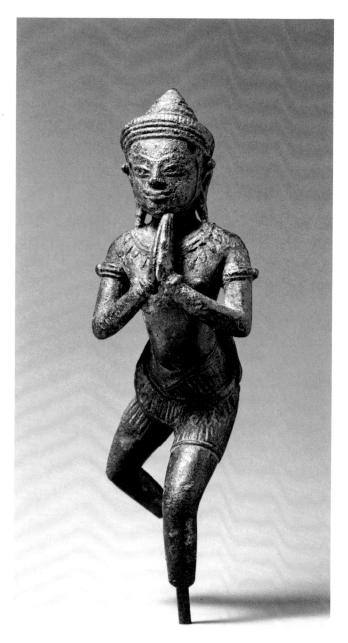

49 BATTLE STANDARD(?)
Cambodia, second half of 11th – first quarter of
12th century
Bronze, H. 5⅝ in. (14.2 cm)

Bronze male figures of approximately this type have
been identified as being battle standards the Khmers
carried into combat on poles.[1] Although clearly in Khmer
style, these battle standards have been excavated in
Thailand.[2] Whether this figure was also a battle standard
is uncertain, but it does differ from the others in
significant ways.

The figure originally stood on his left foot, with his
right leg raised behind him. His hands are joined in the
gesture of adoration *(anjalimudra)*. Both the posture
and the gesture are unusual: so far as I am aware, the
battle standard figures are more commonly shown in a
different stance, with their arms spread wide apart.[3]
Whatever its original purpose, this is a sculpture of
considerable aesthetic merit—well modeled and en-
tirely convincing in its depiction of a very complex
posture.

The figure wears a tiered, conical crown and various
jewelries. The pleated wraparound *sampot* is worn high
on the back, with the portion at the front right side
draped over the jeweled belt worn around the hips. Part
of the *sampot* is drawn between the legs and secured at
the back beneath the belt, terminating in a pronounced
bifurcation of the ends. This arrangement occurs on
sculptures of the second half of the eleventh century.

In terms of style, this figure seems sufficiently transi-
tional to typify the conservative nature of much of Khmer
sculpture. While it preserves the broad, bearded face,
with rosettes above the ears, found often in tenth-century
sculptures, specific details clearly indicate a later date.
For instance, earlier sculptures almost always have a
straight eyebrow ridge; here there is a pronounced arch.
Tenth-century sculptures invariably show the line of the
beard coming to a single point at the chin; here three
points are shown. The arrangement of the *sampot* and
the type of crown worn would seem to indicate a date
toward the end of the eleventh century.

Residue of ash and the nature of the patination
suggest that the figure was once in a fire.

[1] Bowie 1972, cat. nos. 36a, b, c.
[2] Ibid., p. 74, and Krairiksh 1977, p. 108.
[3] Krairiksh 1977, p. 109, and Bowie 1972, cat. nos. 36a, b, c.

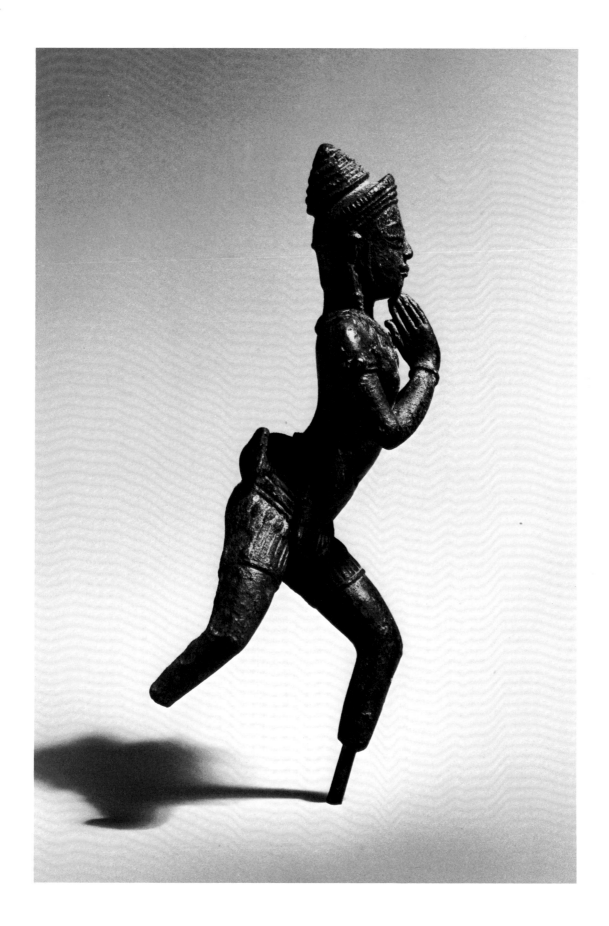

50 SEATED PRAJNAPARAMITA(?), THE GODDESS
OF TRANSCENDENT WISDOM
Thailand, Peninsular style(?), ca. second half of
12th – first half of 13th century
Bronze, H. 3⅝ in. (9.2 cm)

The identification of this rare, enigmatic deity is a tentative one since it is not entirely clear if the figure is male or female, nor is it clear what garments it is wearing. Complicating an understanding of this image are the unusual style and iconography.

The deity is seated in a cross-legged yogic posture, the right hand grasping the raised index finger of the left hand in the gesture of *bodhyagrimudra* (or *bodhyangi*).[1] If the deity is indeed a representation of Prajnaparamita, this would be an unorthodox gesture; she is normally depicted in Indian sculpture making the gesture of turning the wheel of the law *(dharmachakrapravartana-mudra)*, an appropriate *mudra* for the goddess of wisdom since it refers to the Buddha's first sermon and the dissemination of Buddhist wisdom. It is possible, however, that the gesture being made is *jnanamudra,* which is associated with knowledge.[2] In Southeast Asian sculpture, it is also appropriate for Prajnaparamita to make the expository or teaching gesture *(vitarkamudra)* (see No. 40).

The figure wears a simplified version of Khmer-style jewelries of the Angkor Vat period (first half of the twelfth century), and the influence of Khmer sculpture is also apparent in the four diminutive heads above the main one. The physiognomy of the main face bears some resemblance to a few of the *devatas* at Angkor Thom. The figure may be nude from the waist up. A sash around the waist secures a garment of some sort, and a second garment is indicated coming over the forearms and falling across the knees. It is not clear whether the area between the arms and the chest is cloth.

The proportions of the body are quite unusual, with a very summary treatment of the legs and a surprisingly elongated neck. There is a clear emphasis on the pyramidal shape of the icon, the steeply sloping shoulders leading the eye to the uppermost small head. In addition, there is a strong planimetric organization of the volumes, as well as an inventive arrangement of the masses: the full chest tapers dramatically as it disappears behind the hands, and even though the figure leans far back the face is set forward in an authoritative manner. All this combines to impart a decidedly energetic presence to this small bronze.

If the deity is male, he may represent a rare form of Vajrasattva or Vairochana.

[1] Pal 1975a, p. 120.
[2] Chandra and Rani 1978, p. 125, pl. 2.210.

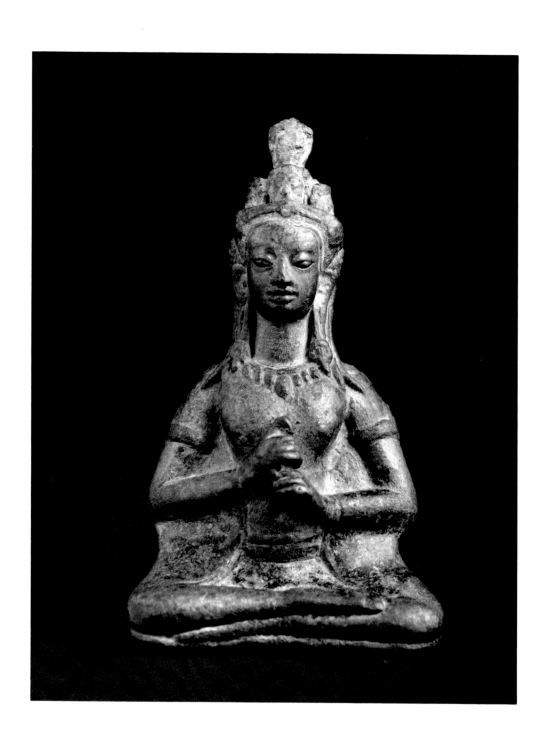

51 KNEELING GANESHA
Thailand or Cambodia, Khmer style of Angkor Thom,
ca. second half of 12th century
Bronze, H. 3⅝ in. (9.2 cm)

In India, Ganesha is one of the most beloved of all deities in the Hindu pantheon. His popularity clearly carried over to Southeast Asia, particularly Indonesia (see No. 43), but early examples are also to be found in Cambodia and Thailand. Ganesha is generally accepted as being the first "child" of Shiva and Parvati. He is the deity who controls obstacles by either inventing or removing them; consequently, he is invariably invoked prior to a major undertaking. This rare example in bronze depicts the bulky deity kneeling and wearing jewelries and a crown, with the vertical third eye of Shiva on his trunk.

Ganesha's wraparound *sampot* is arranged in a manner similar to No. 43's, but the surface patterning is different and the belt does not have pendant jewels. The part of the *sampot* that is drawn between the legs is separated at the back beneath the belt into sections that fall from individual knots. The treatment of the front of the *sampot* is not unlike eleventh-century Cambodian examples.[1]

Ganesha holds his right tusk in his right hand. What at first appears to be the sacred thread across his chest is in fact part of the hooded serpent *(naga)* peering over his left shoulder. The same legend that explains the loss of Ganesha's right tusk explains the serpent often tied across his inflated stomach. One night, after devouring an inordinate amount of sacrificial cake, Ganesha was riding home on his vehicle, the mouse (or rat). A serpent frightened the rodent and it fell, causing Ganesha to tumble off and his stomach to burst, whereupon all the cake fell out. Ganesha put the cake back into his split stomach and fastened the serpent around him to keep it closed. The moon, who was watching this episode, started to laugh. The enraged Ganesha broke off his right tusk and hurled it at the moon.

To my knowledge, the *naga* appearing above the left shoulder does not occur in Indian art and seems to be a delightful Southeast Asian invention. It is also very rare in Southeast Asian examples, but this may be due to the susceptibility of these *naga* hoods to being snapped off and lost. The kneeling posture is also a Southeast Asian preference rarely occurring in Indian art, and certainly never with Ganesha. Rare, also, are the particularly small ears.

The diagrammatic treatment of the eyes and parts of the face and trunk may indicate a Thai origin for this bronze, but that suggestion is tentative and not meant to imply that this splendid creature was made in a provincial workshop. The style is clearly a twelfth-century Khmer one, of either Angkor Vat or Angkor Thom; the treatment of the necklace and crown suggests the latter.

This charming Ganesha is one of the finest early bronze versions in Khmer style to have survived. An attractive green patina enhances its appearance.

[1] Groslier 1925, pl. 25.

132

52 GARUDA FINIAL
Thailand, Khmer style, ca. 13th century
Gilded bronze, H. 9¾ in. (24.8 cm)

This remarkable finial preserves the ancient myth of the antagonism between the great birds and the serpents. Here, in one of the most complex and baroque representations of the theme — bristling with pointed appendages representing feathers and scales — Garuda, the great anthropomorphic bird, is clearly depicted in full command. In his two hands he holds the tails of the conquered serpents *(nagas)* who have been reduced to serving as his attendants.

Aside from being a tour de force of casting, this extraordinary object is a masterful exercise in the manipulation of decorative elements. There is a complex evolution of both the curling forms and the pointed appendages and projecting elements: the small forms at the bottom grow larger and more aggressive until they culminate in flamelike fashion in the final point at the top. The metamorphosis of shapes is most clearly seen in the evolution of the lower curling motifs into *naga* heads. The interplay of forms is handled in an imaginative and accomplished manner. The undecorated part of Garuda's body provides the only respite for the eye; everything else is a turbulent mass of bristling, aggressive shapes.

Reduced to its most basic components, the upper portion of the finial shows Garuda flanked by four *naga* heads: two at his shoulders and two smaller ones at the level of his raised hands. The lower section depicts another Garuda head (its beak broken off) crowned by three *nagas.*

The Garuda terminals of Khmer temple balustrades from the second half of the twelfth and early thirteenth century provide the compositional and stylistic prototypes for finials like this.[1] This bronze finial was probably originally attached to the top of a wooden pole and carried in procession, or it might have been part of a chariot's fittings. Perhaps the most well-known example of a Khmer-style bronze Garuda of this type is now in the collection of the National Museum, Bangkok.[2]

[1] Deneck 1962, pl. 237, and Boisselier 1966, pl. LIII 3.
[2] Boisselier 1975, pl. 85.

53 BUDDHIST SHRINE
Thailand, Lopburi style, ca. 13th century
Bronze, H. 16 in. (40.7 cm)
Gift of The Kronos Collections, 1980 (1980.526.1)

This shrine is one of a well-known group of Thai sculptures that all consist of an assemblage of elaborate pedestals and halos in addition to the main deity.[1] The iconography of these shrines usually records the *mara-vijaya* episode in the life of the Buddha: the triumph over the forces of evil (see No. 26).

The Buddha is seated on this shrine in the *virasana* position, the right leg over the left. His left hand rests on his lap in the meditative *dhyanamudra;* his lowered right hand is in *bhumisparshamudra.*

The three garments *(tricivara)* of the Buddha are worn in the usual thirteenth-century fashion. The robe *(uttarasanga)* covers the left shoulder, leaving the right shoulder bare. The shawl *(sanghati),* draped over the left shoulder with a portion folded to create a long rectangular panel, descends diagonally toward the left knee, crossing the left wrist. The skirt, or undercloth *(anta-ravasaka),* is worn high at the sides of the waist but is lowered in front across the stomach, with a slightly raised point just below the navel.

In the Khmer-inspired Lopburi style of Thailand, Buddha images of this iconographic type can be depicted either as crowned and jeweled Buddhas (of the sort often found in the Pala sculpture of northeast India and in Kashmiri sculpture; see No. 26) or they can be shown in the more orthodox undecorated fashion. Here, hinting at the first type, the Buddha wears a discreet diadem with three raised elements: one at the front and two smaller ones over the ears. Each element was originally inlaid with a small jewel or piece of glass (or glass paste). The conical section of the hairdo is also suggestive of a crown.

It is not unusual for Lopburi shrines to have pedestals and halos so rich and complex as to almost visually overwhelm the main deity. Here, the high pedestal sits on six legs and is composed of a series of decorated sections. The halo has an outer perimeter of abstract flame patterns enclosing the decorated, elongated tails of mythical *makaras* spewing *naga* heads and a separate upper section representing the stylized branches and leaves of the *bodhi* tree under which Siddhartha attained enlightenment. An attractive blue azurite patina has developed on the two halo sections. It is interesting to note that, as on the large Bayon period shrine datable to around the late twelfth or early thirteenth century now in the collection of the Kimbell Art Museum, Fort Worth,[2] this Buddha is seated directly on top of the pedestal rather than on the ubiquitous lotus throne.

While impressive in bronze casting technique, and still retaining considerable spiritual conviction, Lopburi-style sculptures of this type, with their emphasis on subsidiary decorative elements and subordination of interest in the forms of the body to a concern for surface patterning, clearly represent the end of a long tradition of Khmer-inspired styles in Thailand.

Recent scholarship has properly reminded us that the common application of the term "Lopburi" to cover all Khmer-style sculpture found in Thailand is both misleading and inaccurate.[3] While it is certainly true that many Khmer-style sculptures datable to the eleventh through the thirteenth century have been found around the area of Lopburi—Lopburi having been a vice-regal seat of the Khmer empire—it is also true that many sculptures in various Khmer styles have been excavated in other parts of Thailand. It would seem, therefore, that the name "Lopburi" for an art style must be used judiciously, preferably only to refer to sculptures found at Lopburi that exhibit specific stylistic tendencies that are distinct from those of the metropolitan centers of Cambodia.

[1] Prachoom 1969, pp. 101–103, 110–14.
[2] Ibid., p. 103.
[3] Krairiksh 1977, pp. 39–41.

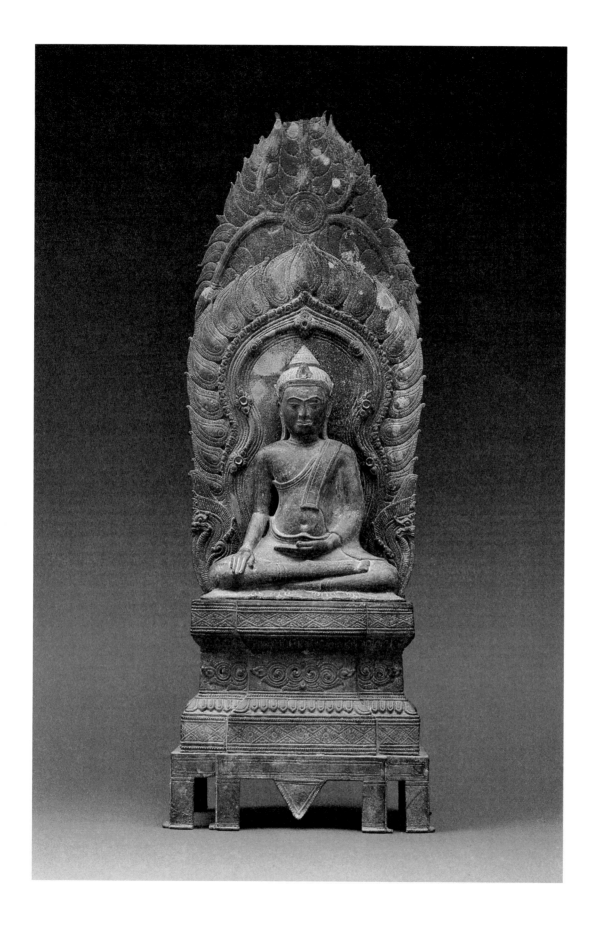

Indonesia, Borneo, Majapahit style, ca. 14th century
Stone, H. 18⅛ in. (46 cm)

This head comes from a seated four-armed deity that was illustrated in situ in a cave in Mount Kombeng in eastern Borneo.[1] A discussion of the site and of some of the speculations regarding this and other sculptures found there appears in No. 43.

F. D. K. Bosch suggested that this sculpture was from the second, later group found in the cave, and that it is Buddhist, as opposed to Shaivite like the earlier group. His less than flattering remarks concerning this second group revolve around their surprising iconography and strange combinations of dress and adornment, which he attributes to an unfamiliarity on the part of the sculptors resulting from a lack of contact, over a significant period of time, with the major carving centers of Java (and perhaps Bali).

The original published illustration of the almost complete sculpture permits the following description.[2] The deity was seated in the cross-legged position on a double-lotus pedestal. He wore armbands, bracelets, necklaces, earrings, the sacred thread, and a jeweled belt. In his raised right hand he held a *chamara* (flywhisk) and in his raised left, a *chakra* (disk). His lowered right hand rested on his right knee and made the boon-bestowing gesture *(varadamudra),* while his lowered left hand held the stalk of the *utpala* (blue lotus or water

lily) that ascended his arm. The flower of the *utpala* can be seen above the left shoulder on the surviving head, which wears a three-lobed tiara and has a very high, elaborately decorated hairdo.

If Bosch is correct in his assumption that the later group of sculptures from Kombeng was the product of artists whose understanding of the established iconography was deficient, then any unorthodox combinations of gestures and attributes could occur. On the other hand, further investigation might prove Bosch wrong, and we may be dealing with rare and unusual variants that are indeed iconographically correct but infrequently used. B. Bhattacharyya cites, for example, an unusual two-armed variant of Lokeshvara holding both the *chakra* and the *chamara.*[3]

In his report, Bosch did not suggest a date for this sculpture. On the basis of style, it would seem to fit in well with the fourteenth-century sculptures of the Majapahit period.

Published: Bosch 1926, pl. 30c.

[1] Bosch 1926, pl. 30c.
[2] Ibid., pl. 33c.
[3] Bhattacharyya 1924, pl. LXIV, fig. 87 (described on p. 187).

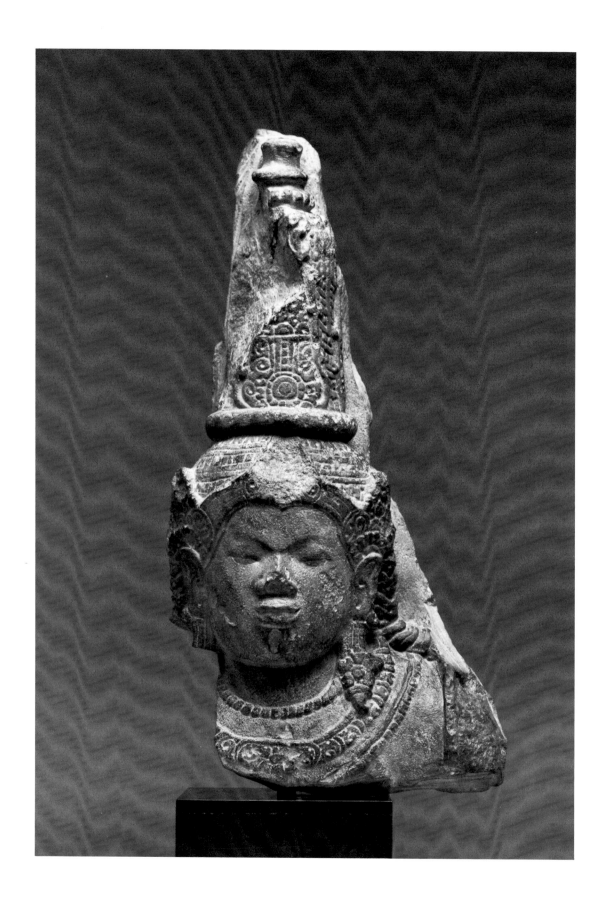

55 SEATED GANESHA
Thailand, Sukhothai or Chieng Sen style,
ca. 15th century
Bronze, H. 12¼ in. (31.1 cm)
Gift of The Kronos Collections, 1983 (1983.512)

The history of Thai sculpture from sometime during the thirteenth century, when a distinct national school started to evolve and broke away from Cambodian and Mon influences, is written in terms of the stylistic evolution of Buddha images. Specific schools and sub-styles are defined on the basis of relatively slight variations in the prescribed dress, the treatment of the hair, the position of the legs, and so on. Brahmanical images, on the other hand, are quite rare, and when they are partially nonhuman in form—as the corpulent, elephant-headed deity Ganesha must be—dating and stylistic evaluations are extremely difficult. Such is the case with the sculpture at hand.

Ganesha is seated in a cross-legged yogic posture on a raised pedestal with a decorated molding. His dress and adornments are treated in a very restrained fashion that emphasizes the sculptor's concern with pure modeling and manipulation of volumes: he wears the short *sampot,* a threefold flap of the cloth draped over the right ankle, as well as bracelets, anklets, and snake armbands (both missing their heads). In proper iconographic fashion, the sacred thread is a serpent tied at the left shoulder, and in his right hand Ganesha holds his broken right tusk, in his left an elephant goad (see No. 51). His crown, which originally contained a gem in front and back, is of approximately the same shape as crowns found on sculptures from the later Sukhothai period as well as from the northern schools. Ganesha's trunk comes straight down, curving only at the very end. This is somewhat reminiscent of the Shrivijaya Ganesha (No. 43).

Suggestions of late Khmer motifs can still be seen in the schematic treatment of the folds of skin along the cheeks, the rear arrangement of the section of garment drawn between the legs, and, to a lesser extent, the crown. But there is also the sense of the sculptor's delight in emphasizing the corpulence and sheer bulk of the shoulders, chest, stomach, and thighs that one finds in south Indian representations of Ganesha.

I cannot cite any examples similar to this Ganesha, but I am confident they must exist, although there cannot be very many of them. Alice Getty, in her 1936 monograph on Ganesha, wrote, "Not until the Ayuthian period in central Siam is a Siamese representation of [Ganesha] to be found which is worthy of study."[1] Despite some confusion on Getty's part regarding Thai history, and the possibility that the Khmer-inspired four-armed Ganesha she illustrates[2] might owe its stylistic allegiances to Sukhothai rather than to Ayudhya, her point is well taken. Though the corpus of known Thai sculpture has dramatically increased since 1936, the task of assembling a group of fine examples of sculptures of Ganesha dating from the thirteenth to the fifteenth century would even today be both formidable and relatively unrewarding. But certainly one of the highlights of what could be assembled would be this Ganesha from the Kronos Collections.

[1] Getty 1936, p. 47.
[2] Ibid., pls. 27a and b.

56 THE GODS AND THE EARTH COW PRAY FOR
THE ASSISTANCE OF VISHNU
Page from a dispersed *Bhagavata Purana*
manuscript
India, Delhi (Palam?), ca. 1540
Opaque watercolor on paper, H. 6⅞ in. (17.5 cm),
W. 9¹/₁₆ in. (23 cm)

The later history of painting in India revolves around
interests very different from those associated with the
palm-leaf manuscript tradition (Nos. 30 and 31). Along
with a different format and medium, we find a new world
of expanded subject matter, which is well represented in
the Kronos Collections.

The first chapter in this later history is most provoca-
tive in that it concerns a group of fully developed native,
or indigenous, Indian styles practiced prior to the estab-
lishment of the great court ateliers of the Mughal dynasty
in the second half of the sixteenth century. For our
present purposes, we are excluding the Jain painting
traditions of western India and paintings of Turkish or
Persian inspiration in order to concentrate on those
styles dating from the end of the fifteenth century to
around the end of the third quarter of the sixteenth
century. These styles have been accepted as having
enough in common to constitute a basic pictorial idiom
free from Mughal influences. Nos. 56, 57, and 58 all
belong to this group.

The pre-Mughal, or pre-Akbari, indigenous style is
represented by a group of manuscripts and individual
paintings often referred to as the *Chaurapanchasika*
group after a Sanskrit manuscript of lyric love poems
now in the N. C. Mehta Collection in Ahmedabad. (The
manuscript is not the earliest in the series but rather the
most well known).[1] A small group of rare illustrated
manuscripts datable from around 1515 to 1575 have been
associated with the *Chaurapanchasika* style. The in-
terested reader is referred to the pioneering works of
Karl Khandalavala and the late Moti Chandra, where all
the pertinent manuscripts, along with suggested dates
and problems of provenance, are carefully examined.[2]

The chronological parameters originally employed
for the *Chaurapanchasika* group were 1525 to 1570. But
the discovery and subsequent publication by Khan-
dalavala and Chandra of an illustrated manuscript of the
Aranyaka Parvan dated to 1516 not only extended the
early limit for the style, but also helped to confirm the
approximate area where the other illustrated manu-
scripts in *Chaurapanchasika* style were most likely
produced: northern India, particularly a geographic belt
extending north from Jaunpur (slightly northwest of

Benares in the southeast part of the state of Uttar Pradesh) to Delhi and including Agra.[3]

Khandalavala and Chandra further suggest that the style should be referred to as "the Lodi school" because from 1451 to 1526 this area was primarily ruled by the Lodi sultans, a dynasty of Afghan nobility with courts at Jaunpur and Delhi. Although the dynasty ended in 1526 with Ibrahim Lodi's defeat at the battle of Panipat by Babur (the founder of the Mughal dynasty), Khandalavala and Chandra claim that since there is no evidence for the establishment of imperial Mughal ateliers prior to that of the great emperor Akbar around 1563, the paintings of the 1526–63 period must represent a continuation of the styles of the artists who were working at the time of Lodi rule.

The pre-Mughal styles of the Lodi school, or the *Chaurapanchasika* group, have a freshness, vivacity, and vitality that makes them particularly appealing. Working with a limited palette and a relatively naive sense of composition and figural arrangement, the artists produced pictures of enormous charm and directness. As we shall see, within this group not only are there varying levels of technical competency and originality, but there is also a stylistic sequential progression as the artists became more sophisticated in their understanding and mastery of compositional and spatial possibilities.

One of the *Chaurapanchasika* manuscripts, perhaps as well known as the one for which the series was named, is an illustrated manuscript of part of the great Hindu epic, the *Bhagavata Purana* (the *Ancient Story of God*). The manuscript, from which this illustration comes, has been dated to around 1540 on the basis of stylistic extrapolation within the *Chaurapanchasika* group. Although this date could be off either way by a decade, it is both sensible and reasonable. The manuscript originally had more than 150 illustrations, now widely dispersed in private and public collections in India, Europe, and the United States. It is often referred to as the "Palam" *Bhagavata Purana* because one of its pages (whose present location is unknown) bears an inscription connecting the manuscript with Palam, a suburb of Delhi.[4] Palam seems to have been an important center for illustrated manuscript production; one other dated

Chaurapanchasika-style manuscript seems to have been painted there.[5] The manuscript is often colloquially referred to as the "Scotch Tape Set" because before the manuscript was dispersed an early owner put scotch tape along the ragged and flaking borders of the paintings. Many paintings from this manuscript bear the name Sa Nana or Sa Mitharam. Originally it was assumed that these were the names of artists; it is now generally believed that they are the names of the original owners of the manuscript, probably brothers who divided the pages between them.[6] This painting bears the name Sa Mitharam.

Books Ten and Eleven of the *Bhagavata Purana,* describing the life of Krishna (the eighth incarnation or avatar of Vishnu), are most commonly illustrated, and Book Ten, concerned with Krishna's youth, was particularly beloved and popular. This scene is from the opening of the tenth book, which recounts the plight of Mother Earth, who has been overrun by the forces of evil "in the disguise of arrogant kings."[7]

The Earth, who has assumed the shape of a cow, tearfully seeks the assistance of Brahma, the Creator. The Earth Cow and Brahma, along with the gods Shiva, Indra, and Kubera, go to the shore of the Ocean of Milk to worship Vishnu, the Supreme Being, in order to gain his intercession. Their devout meditations are successful, for Vishnu promises them that "Lord Vishnu himself will be manifested in the house of Vasudeva,"[8] and the promise is honored when Krishna is born to Vasudeva's wife, Devaki. All of Vishnu's avatars appear on earth to save the world from some great impending calamity by removing the source of evil, traditionally personified in the form of a great demon king.

In contrast to the great majority of extant pages from this manuscript, which have many scenes in small individual compartments set against an area of flat color, here a single episode is depicted, with both large figures and other compositional elements. In addition, unlike the frenetic, overcrowded scenes most often encountered (see No. 57), this episode requires a mood of calm and solemnity.

The large elements of this painting—the Earth Cow, the single tree with its curved trunk balancing the Ocean

of Milk, and the four gods—are carefully composed and balanced. The gods, descending in height, are neatly centered. The multiheaded, bearded Brahma leads the group, followed by Shiva, dressed in a tiger skin, with two of his common attributes—the serpent and the trident—prominently displayed and his neck blue from having swallowed the poison from the Ocean of Milk when it was churned. Next is Indra, the god of thunder and the commander-in-chief of the armies of the gods, covered with extra eyes; and then comes Kubera, to whom, according to some accounts, the treasures recovered at the time of the churning of the Ocean of Milk were entrusted (see No. 46). Behind the gods stands the Earth Cow, "whose prominent ribs and shrunken udder symbolize the distress that only Vishnu can alleviate."[9]

While this page displays the bold patterning, large areas of contrasting flat colors, and sense of two-dimensionality common to the illustrations in the Palam manuscript, it is one of the most accomplished of the set. Its formalism, dignity, confident drawing, and sense of restrained balance set it apart from most of the others.

Published: Hutchins 1980, pl. 2, and Kramrisch 1981, p. 180.

[1] Shiveshwarkar 1967.
[2] Khandalavala and Chandra 1969, 1974.
[3] Idem 1974.
[4] Ibid., p. 5, and Khandalavala and Mittal 1974, pp. 28–29.
[5] Khandalavala and Chandra 1969, pp. 69–78.
[6] Idem 1974, pp. 4–5; Khandalavala and Mittal 1974, pp. 28–29.
[7] Goswami 1971, pt. 2, p. 1043.
[8] Ibid., p. 1044.
[9] Hutchins 1980, p. 115.

57 FRAGMENT FROM AN UNIDENTIFIED
BATTLE SCENE
India, Delhi area(?), ca. 1540
Opaque watercolor on paper, H. 6¾ in. (17.1 cm),
W. 9 in. (22.9 cm)

This extraordinary picture is part of a large painting depicting a great battle. When this fragment is joined with three others now in famous private collections of Indian paintings (the collections of Stuart Cary Welch, J. P. Goenka, and Jagdish Mittal),[1] the composition seems to be almost complete. Together, the four fragments make up one of the most remarkable pictures in the *Chaurapanchasika* group. Not only is it the largest single known picture from the group — suggesting that large-format individual pictures may not have been un-common — and unique in format and scope, but, unlike the others, it may represent an historical battle rather than one from traditional Hindu literature.

These four fragments have an interesting history. It seems that they were interspersed with the rest of the pages from the circa 1540 Palam *Bhagavata Purana* and assumed to be individual paintings from the series.[2] The four paintings are so close in size and style to the other pages, one could hardly have thought differently, but perhaps the one clue suggesting that they were some-thing else was their lack of the usual painted borders. The large composition evidently was folded in four. As the paper deteriorated, it came apart at the folds, and the four parts were separated. The style of the painting is so similar to that of the circa 1540 manuscript, however, that there is little doubt that it was the product of the same (Palam?) workshop and executed at approximately the same time.

The Kronos Collections fragment is the lower right quarter of the painting, fitting below the section in the Welch collection.[3] It is an exuberant, wonderfully rich scene, packed with soldiers mounted on war elephants engaged in pitched battle. The contrast of the decorated elephant blankets and the soldiers' costumes and faces with the flat red background and the bulky elephants establishes the bold surface patterning that is the main pictorial idiom for the style. Minor rhythms are created by the white of the curved elephant tusks, weapons, sashes, and turbans. Despite the fearful and gruesome activity, all of the soldiers have the same expression on their faces. This is a characteristic of Indian painting, where emotions, sometimes even great passion, are represented not by facial expressions but by color or pictorial allusion.

[1] I am indebted to Stuart C. Welch for providing slides of the frag-ments in the Goenka and Mittal collections.
[2] Welch and Beach 1965, cat. 3a, pp. 115–16.
[3] Ibid.

146

58 BALARAMA CARRIED BY THE DEMON PRALAMBA
Page from a dispersed *Bhagavata Purana*
manuscript
India, Delhi-Agra area(?), ca. 1560 – 65
Opaque watercolor on paper, H. 7½ in. (19.1 cm),
W. 10⅜ in. (26.4 cm)

Discourse Eighteen of Book Ten of the *Bhagavata Purana,* which this painting partially illustrates, recounts the story of the slaying of the demon Pralamba by Krishna's older brother, Balarama (himself considered an avatar of Vishnu).

Krishna and Balarama, along with the cowherders of Brindaban, are playing in the forest, amusing themselves with a series of games, one of which is a game of "blindman's buff" in which the loser is required to carry the winner on his back. Pralamba, who has disguised himself as a cowherder, loses the game and has to carry Balarama. He starts to run off with Balarama, who, realizing the danger he is in, assumes the weight of Mount Meru, forcing Pralamba to revert to his demonic form. Balarama, initially afraid, is reminded of his divinity and smashes the demon's head. It is not the business of traditional Hindu epics to be restrained in the description of such events: "With his head smashed forthwith and deprived of his consciousness when struck (by Balarama), and vomiting blood, the said demon fell dead, uttering a loud cry, as a mountain struck with the weapon of Indra."[1] Both the cowherders and the gods watching from heaven applaud Balarama's victory.

The manuscript from which this illustration comes is considerably smaller than the Palam *Bhagavata Purana* — probably fewer than thirty illustrations from it are known. The painting represents the style of the *Chaurapanchasika* group at its most mature stage of development. It is likely to have been painted between 1560 and 1570, which would place it very close to the beginnings of the imperial Mughal atelier of Emperor Akbar in 1563. Whether there was any contact between the artists of this series and Mughal artists is difficult to ascertain, but there can be no question that these paintings are still completely within the pre-Mughal native Hindu idiom.

The manuscript came from the *thikana* (akin to a small fiefdom) of Isarda, south of Jaipur, near Bhagwatgarh in the eastern part of the state of Rajasthan. Naturally enough, it has been named the "Isarda *Bhagavata Purana.*" But, as Khandalavala and Mittal state, "the fact that the series came from the Isarda collection is no guide to its provenance. In fact, the Palam

149

Bhagavata was found . . . in Hyderabad and yet it is by no means a product of the Deccan."[2] They suggest that the Isarda *Bhagavata Purana* may have been painted in the Delhi-Agra region, and they consider it representative of the pre-Mughal Lodi style at its best.[3]

The Isarda paintings are without question qualitatively superior to the Palam series. Not only is the drawing more skillful, but there are significant advances in terms of the conceptual logic of the composition and the clarity of the figural groupings and their relationships to the architectural settings and the landscape. While continuing the pictorial richness of the *Chaurapanchasika* style, the artists of the Isarda series clearly had a greater control over and understanding of compositional possibilities and the rendering of figures in space.

The composition of this painting seems at first glance rather symmetrical and static. In fact, there is a sophisticated, subtle shifting of groups of figures and trees to disrupt the symmetry, which gives a sense of everything being slightly off center but well balanced. Skillful though the composition may be, it is not one of the most innovative of the Isarda manuscript paintings; some are very boldly composed and show a river flowing diagonally across the whole page (the painting in the collection of the Metropolitan Museum, for example).[4] In addition, some paintings from the series show a greater concern with spatial recessions into the picture plane; the trees in this "Pralamba Carrying Balarama" painting are clearly set behind the figures, but the figural groups themselves, though varying in height, are all lined up on a single plane. The beginnings of an attempt at modeling through color can be seen on Pralamba's legs and on the leaves of the last tree to the right of the picture. The use of red for the sky, only occasionally found in the Palam *Bhagavata Purana,*[5] is very unusual for the Isarda series.

The heads all shown in profile, the emphasis on the strong contrast between large areas of flat color and small details such as leaves and flowering creepers, and the very rich coloration are all elements of *Chaurapanchasika* style. Looking at the same scene from the Palam *Bhagavata Purana*[6] provides a particularly graphic comparison that shows just how much more advanced the Isarda manuscript is than the earlier set. There is no reason to credit influences from the Mughal court of Akbar for these advances; it seems more reasonable to attribute them to the natural growth of the *Chaurapanchasika* style.

In their article on the Isarda *Bhagavata Purana,* Khandalavala and Mittal, writing about the way in which the water is depicted, wonder if the Isarda artists borrowed the convention from the painters of the early Akbar atelier or vice versa. They conclude that the answer depends on one's dating of the Isarda manuscript.[7]

It would seem to us that it would have taken no enormous leap of the artistic imagination to improve on the old formula for depicting swirls of water found on the earlier Palam *Bhagavata Purana,* particularly if one were making advances in many other directions, as the Isarda artists certainly were. And if one were devoting a considerable part of a composition to a flowing river, it is also almost inconceivable that one would rely on conventions perhaps twenty or thirty years old for depicting the water. Since the Isarda manuscript seems to be free of any other specifically Mughal conventions, perhaps this indicates that it should indeed be dated closer to 1560 than 1570, prior therefore to the establishment of Akbar's imperial atelier.

This suggestion is reinforced by the recent discovery of another manuscript that is very close in style to the Isarda *Bhagavata Purana* but was clearly created slightly later.[8] I would think it should be dated to about 1575–80. This manuscript, like the Isarda, illustrates Book Ten of the *Bhagavata Purana.* Unlike the Isarda, however, it contains quite a few elements directly borrowed from the Mughal styles of Akbar's ateliers.

If one accepts a circa 1560 date for the Isarda manuscript, then Ratan Parimoo, in his article on the newly discovered *Bhagavata Purana,*[9] is mistaken when he includes the treatment of the water among the features he isolates as having come from the Mughal school. The treatment of the water,[10] rather than being Mughal-inspired, derives directly from the Isarda tradition and can be seen on the Isarda painting in the collection of The Metropolitan Museum of Art[11] as well as on others in the series.[12]

[1] Goswami 1971, pt. 2, p. 1138.
[2] Khandalavala and Mittal 1974, p. 32.
[3] Ibid., pp. 30–31.
[4] "Gopis Beseeching Krishna to Return Their Stolen Clothing" (acc. no. 1972.260); see Lerner 1975b, p. 107.
[5] Khandalavala and Chandra 1969, pl. 21.
[6] Hutchins 1980, pl. 14.
[7] Khandalavala and Mittal 1974, p. 31; see also p. 53.
[8] Parimoo 1974, pp. 9–13.
[9] Ibid.
[10] Ibid., p. 13.
[11] See note 4.
[12] Spink 1971, fig. 117.

Balarama Carried by the Demon Pralamba (detail)

When Babur defeated Sultan Ibrahim Lodi at Panipat in 1526 and gained the throne of Delhi to become the first Mughal emperor in India, the stage was set for the dramatic dissemination of a new culture on Indian soil. Babur, who was descended from Chingis Khan and Timur (Tamerlane), brought his troops down from Central Asia across Afghanistan into northwest India, following the routes used by earlier invading foreign armies, to take possession of both Delhi and Agra.

Babur's son Humayun inherited his father's rule and an unsettled political situation. Around 1540, after suffering defeat at the hand of the Afghan Sher Shah, Humayan was forced to leave the Delhi-Agra area, but he remained in India until 1543, when he fled to Persia. After an interlude in Kabul, in 1555 Humayan returned to India with Persian assistance and once again occupied Delhi and Agra. His thirteen-year-old son Akbar and a small group of Persian artists who had become disaffected with the artistic climate at the Persian court returned with him. Soon after their return, following Humayan's accidental death in Delhi in 1556, Akbar became the third Mughal emperor.

Akbar the Great reigned from 1556 to 1605 and during that half-century built up one of the richest and most powerful empires the world has ever known. Clearly a brilliant administrator in addition to his other virtues, he established an enlightened policy of religious tolerance and quickly forged political alliances with many of the Hindu rulers: the obstinate were conquered; the more realistic rewarded.

We do not know precisely when, but it was probably sometime after 1560, when he had had time to consolidate his power, that Akbar became interested in painting. Whatever his early experience with painting, it would have been with Persian painting, and it was under the direction of the Persian artists his father had brought to India that an atelier was formed. Although the Mughal school had only the second half of the sixteenth century to evolve and to develop a coherent system of pictorial representation, by the time Akbar died it had become one of the great painting styles in the history of art. Such a relatively short period of maturation could only have been possible with the most extraordinarily lavish impe-

rial patronage as a catalyst. Indeed, the painting projects of the Emperor's ateliers were legendary, producing manuscripts the scope of which was entirely unprecedented. Both Mughal and Hindu artists were employed at the court, permitting a variety of stylistic interactions, and manuscripts of Hindu subjects were produced alongside those of Muslim themes.

While the imperial or court style of Akbar's brilliant ateliers was redefining the history of Indian painting, lesser projects were being produced for clients less exalted than the Emperor. These sub-imperial Mughal-style manuscripts, at times produced by Hindu artists trained in the Mughal tradition, or by Muslim artists working for Hindu patrons, often display more of the native idiom. Because these paintings were produced with provincial patronage, their style is sometimes referred to as provincial Mughal. Whichever label one prefers (and both are valid), it is clear that, rather than comparing the sub-imperial, or provincial, Mughal paintings to the very different imperial pictures, one should enjoy them for their own special qualities.

The style of these two sub-imperial Mughal paintings derives from the Muslim Mughal court; the subject, however, is a traditional Hindu one. The paintings are part of a *Ragamala* series, or "Garland of Musical Modes," which usually consists of thirty-six individual *ragas* and *raginis,* each the personification of the mood and spirit of one of the male *(raga)* or female *(ragini)* melodies that are the source for the improvisation of Indian music.

During the early development of Indian music, each of these melodic modes was assigned a theme evocative of its flavor and "color," and eventually, codified systems for pictorial interpretation of the individual *ragas* and *raginis* evolved and became sufficiently established to be repeated over the centuries with some degree of regularity. Transferring music into pictorial representation is a complex concept. To assign a gender to a melody, and then try to capture its sentiment and mood, is an undertaking of the most esoteric order, and unique to the Indian imagination.

The specific iconography of the *ragas* and *raginis* is as complicated as it is richly poetic. Some melodies

Dakshina Gurjari Ragini

आलस्यमोनमुडा निजासंपूर्णमाननयनासौ निसिसरत्रयम
खिन्नादशावराडीनवकोरी राधी दशीरागिनीा ॥ ॥ ॥

Desvarati Ragini

conjure up visions of Shiva, others hint at the sorrow of unrequited love. Gender rarely provides a clue to subject matter. *Nat Ragini,* for example, although feminine, is almost always depicted as a warrior on horseback, sword drawn, fighting a foot soldier, with a dead, often decapitated, soldier sprawled in the foreground. There is nothing inconsistent in this since these illustrations are not literal but evocative of a mood. Early designations also codified the proper time for listening to the melodies. Thus it may be suitable for a specific *raga* to be played only in the evening during the rainy season, while another may be restricted to the morning during the months of January and February. Because more than one iconographic tradition existed—the one favored in Rajasthan, for example, is different from that preferred by the hill courts in Himachal Pradesh—identifications can be confusing, particularly when paintings are mislabeled.

The composition of the first painting is one that is repeated often for the *Dakshina Gurjari Ragini.*[1] It depicts a lady in the forest resting on a carpet of lotus leaves between two pairs of trees. She is holding a *vina,* and her right hand is raised. She gazes up at a large dark bird in one of the trees, while two cranes or storks fly through the air above. A stream flows from between two of the trees to the river in the foreground. Klaus Ebeling informs us that "according to an old text, *Gurjari* is a sixteen-year-old girl composing or practicing a song while waiting for her lover."[2]

Subtle erotic and romantic pictorial allusions abound in this picture. The passionate red background, the paired trees with their intermingled leaves, and the stream flowing between the two tree trunks are all common Indian pictorial devices alluding to romantic love. Birds in a pair are a standard metaphor for fidelity.

In many respects, this painting exhibits the dynamic interaction between the Mughal and native styles. The flat red background is out of *Chaurapanchasika* traditions, whereas the attempt at spatial recessions derives from the Mughal tradition. The blending of these two seemingly antithetical compositional elements here is surprising only in that they work so well together.

The second painting depicts a woman kneeling on a decorated cushion, her joined hands raised over her head as she appears to gaze sadly at the unoccupied bed in the open pavilion nearby. As in the *Dakshina Gurjari Ragini,* the woman is dressed in a mustard-yellow skirt and a blue bodice, and two birds fly overhead.

The *ragini* illustrated is *Desvarati,*[3] described by Ebeling as "a lady, holding her arms over her head and twisting her body."[4] An inscription on the painting identifies the *ragini* with the variant name *Desi* and describes the scene as "a lady whose gesture is one of languor and silence, whose eyes are restless from lack of sleep, who is exhausted by the effort of love-making at night, also known as *Desavaradi.*"[5]

These two paintings are from a well-known dispersed *Ragamala* manuscript[6] commonly referred to as the "Berlin *Ragamala*" because four paintings from the series are in the Museum für Indische Kunst, Berlin.[7] One of the paintings in Berlin, the *Asavari Ragini,* bears the date *samvat* 1662, which corresponds to A.D. 1605– 1606.[8]

[1] Ebeling 1973, pp. 93; 254, ills. 234, 235.
[2] Ibid., p. 92.
[3] Ibid., pp. 87; 171; 200, ill. 89; 248, ill. 210; 250, ill. 218.
[4] Ibid., p. 60.
[5] The inscription was translated by Barbara Stoler Miller.
[6] Two paintings from this set are in the collection of The Metropolitan Museum of Art (acc. nos. 1981.460.3, 1981.464.1), and the *Gunakali Ragini* from the series is in the Binney Collection (Binney 1973, cat. no. 33a).
[7] Waldschmidt and Waldschmidt 1975, pp. 427–31, figs. 1, 63, 109, 133.
[8] Ibid., p. 427 and n. 2.

60 *JALI* SCREEN
India, probably Agra, Mughal period of
Emperor Shah Jahan, ca. 1631 – 48
White marble inlaid with semiprecious stone,
H. 57 in. (144.8 cm), W. 43 ⅝ in. (110.9 cm)

In Indian architecture there is a long history of the use of pierced stone windows and screens. But the genre attained remarkable levels of sophistication in the hands of the Mughal craftsmen of the seventeenth century, and reached its zenith during the reign (1627 – 58) of Shah Jahan, the grandson of Akbar.

The multifunctional screens kept the sun out while permitting one to look through them. They maintained privacy and acted as physical barriers to preserve the security and sanctity of holy areas. They were also an integral part of the architectural design, enhancing the beauty of buildings not only with their beautiful designs but also with the shadows they cast.

The perforated white marble screens of *jali* (literally, a net) work represent the apex of this tradition. Quite a few *jali* screens from various mosques and mausoleums have survived. The Mughal craftsmen who so excelled in the carving of these screens were eventually able to attain effects reminiscent of the complexity of fine lace, "spinning" fanciful designs in white marble that are seen to greatest advantage in the *jali* screen masterpieces of Shah Jahan's most exalted conceptions: the Red Fort at Delhi and the Taj Mahal in Agra.

To get a sense of the great advances in carving technique and conception of design made in just a short period of time, one has only to compare the rather traditional geometric designs of the *jali* screens around the cenotaph in the mausoleum of Jahangir (Shah Jahan's father) at Lahore with the slightly later *jali* screens commissioned by Shah Jahan. Jahangir began his mausoleum late in his life, and it was finished by his favorite queen, Nur Jahan, approximately ten years after his death in 1627.

The famous Scales of Justice screen in the Diwan-i-Khas (Hall of Private Audience) in the Red Fort at Delhi was completed sometime after 1638, when Shah Jahan started to lay out his new capital in Delhi. It represents a quantum leap forward from the *jali* screens of Jahangir's mausoleum, and is surely one of the most lavish and intricate of these creations.

The exquisite *jali* screens surrounding the cenotaphs in the Taj Mahal are more restrained than the Scales of Justice screen and display a tighter, more intricate system of floral decoration. The Taj, Shah Jahan's fantastic love poem in white marble to his beloved Mumtaz Mahal, is not only the most magnificent mausoleum ever conceived, it is also one of the most admired structures in the history of world architecture. Mumtaz Mahal died in 1630, and work on the fabulous building began about a year later. The work took about seventeen years — the date of completion is usually accepted as being around 1648. This *jali* screen from the Kronos Collections is so close to the twenty-two rectangular screens around Mumtaz Mahal's and Shah Jahan's cenotaphs that a date of about 1630 to 1650 for it is more than likely.

The crisp carving and highly imaginative sense of design of this screen represent the artistic skill and imagination of Shah Jahan's imperial atelier at their height. The stylized floral forms interwoven around the central lily stalk are brilliantly conceived and executed. The beautiful *pietra dura* inlay work, though never completed, further enhances the richness of the screen. (This embellishment does not appear on the Taj Mahal screens, but is integrated into the surrounding supports.)

The history of this *jali* screen, one of the most magnificent imperial Mughal carvings outside India, is an open invitation for speculation. It is said to have come from the court treasury of Bharatpur, which is south of Delhi and slightly west of Agra. With the collapse of the Mughal empire early in the eighteenth century, many of the Hindu Rajputs, Raja Jawahar Singh of Bharatpur among them, revolted against their Mughal overlords. In 1764, after amassing a large force of Sikh cavalry, Jawahar Singh attacked the imperial city of Delhi and sacked it, carrying an enormous amount of booty back to Bharatpur (and Deeg). This screen is purported to have been part of that booty, but Jawahar Singh also occupied Agra, and it is more likely that the screen was taken from there, though not from the Taj Mahal itself.

61 (a) WORSHIP OF THE DEVI AS THE BLESSED
 DARK GODDESS BHADRAKALI
 (b) BHADRAKALI STANDING ON THE CORPSE
 OF A GIANT BRAHMIN
 Two pages from a dispersed *Tantric Devi* manuscript
 India, Punjab Hills, Basohli, ca. 1660–70
 Opaque watercolor, gold, and beetle-wing cases on
 paper; (a) H. 7 in. (17.7 cm), W. 6⁹⁄₁₆ in. (16.7 cm),
 (b) H. 7⅛ in. (18.1 cm), W. 6¾ in. (17.1 cm), both
 excluding borders

The Muslim Mughals participated relatively late in the glorious pageant that was Indian history. Although they left an architectural legacy that included the Taj Mahal and a painting tradition built on the great illuminated manuscripts of the ateliers of Akbar and Jahangir, the approximately two hundred years of effective Mughal supremacy must be considered a relatively minor interlude, given India's vast artistic past.

The celebrated paintings from the approximately thirty-five old states, varying in size and importance, scattered in the Punjab Hills of northern India (the modern states of Himachal Pradesh and Jammu and Kashmir) are collectively one of India's major artistic contributions. Often referred to as the "Pahari" (Hill) school, most of these paintings, while reflecting the absorption of some of the technical advances of the Mughal painting traditions, were in their early stages of development as different from Mughal paintings as the Pahari rulers were from the Mughal emperors.

The small feudal territories that made up the hill states were ruled by native Indian warrior princes who were members of the various Hindu Rajput clans. The Rajput rulers had controlled the Punjab Hills for centuries before the appearance of the Mughals, and also ruled parts of central India and Rajasthan. The Hindu Rajputs, who traced their ancestry to ancient times, were the product of a culture and tradition different from the Mughals' in virtually every respect.

The military might of the Mughal empire, however, forced the Rajputs into a variety of political accommodations with the new Muslim rulers. The nature of these alliances varied, some Rajput rulers being closer to the Mughal emperors than others. Raja Sangram Pal (r. 1635–73), of the small state of Basohli in the Punjab Hills, had particularly close ties to the Mughal court.

Among connoisseurs of Pahari paintings, the styles of which are as varied as the many hill states from which they come, the paintings of Basohli are often acknowledged to be the prime achievement. Only about twenty miles long and fifteen miles wide,[1] Basohli was a major power in the hills during much of the seventeenth and early eighteenth centuries primarily because of the favored status its rulers enjoyed at the Mughal court. M. S.

Worship of the Devi as the Blessed Dark Goddess Bhadrakali

Randhawa, in his pioneering study on Basohli painting, wrote, "It is evident that Sangram Pal was in fairly intimate contact with the Moghul Court, and it is likely that he came to know Moghul artists during his stay in Delhi, and encouraged some of them to migrate to Basohli."[2] This poses some interesting questions not only about the early history of Basohli painting but also about the extent and nature of Mughal–Rajput stylistic borrowings.

Recent scholarship seems to agree that the earliest phase of Basohli painting, Archer's "Phase One,"[3] should be dated to about 1660–80 or even 1660–70.[4] The Basohli paintings assigned a 1660–70 date are among the most aesthetically satisfying of all Pahari paintings, and are representative of a very distinctive style in a decidedly mature phase of development. This would present no problems were it not for the fact that the whole history of Pahari painting begins with these already mature pictures. If these Basohli paintings were close to Mughal styles, as are the slightly later paintings of Bilaspur (see No. 62), they would be stylistically understandable. But, despite Raja Sangram Pal's close affiliation with the Mughal court, the earliest Basohli pictures — apart from relatively minor details of dress, textile design, and some architectural elements — have surprisingly little in common with Mughal styles. The presumption of strong Mughal stylistic influences on early Basohli painting therefore turns out to be invalid, and finding an explanation for this seemingly contradictory state of affairs remains one of the pivotal problems in the study of Pahari painting.

In most respects, the concerns of the early Basohli artists are decidedly closer to those of the native Indian artists working in *Chaurapanchasika* style about a century earlier than they are to Persian-Mughal traditions. It would therefore seem much more historically sound and logical to hypothesize that there was an important phase of earlier development, examples of which have yet to be discovered, than to accept that a fully developed style suddenly appeared at the Basohli court, as most scholars of Indian paintings insist. Archer, looking for the source of the early Basohli style, leaves the Punjab Hills and cites earlier Rajput Rajasthani painting and the *Chaurapan-*

chasika and Palam *Bhagavata Purana* manuscripts.[5] He is undoubtedly correct in this pursuit, but the stylistic affiliations must have been established earlier than 1650, at Basohli itself, and it would seem that we are missing the history of Basohli painting during the first half of the seventeenth century. Despite the decades of research on Pahari painting, there are undoubtedly important manuscripts still to be discovered that will greatly affect our interpretation and understanding of the early phases of the school. A recently published page from a newly discovered (or recognized?) *Devimahatmya* manuscript in *Chaurapanchasika* style (now in the Simla State Museum) from the Punjab Hills dated to around 1550–70 serves as testimony to the possibilities of important new discoveries.[6]

Despite Archer's assertion that there is no evidence of painting at Basohli prior to the reign of Raja Sangram Pal,[7] and Aijazuddin's claim that "early Basohli painting begins, like some introductory libation, with [the] series..."[8] from which these two paintings in the Kronos Collections came, Basohli will some day have its pre-1650 manuscripts to explain the early evolution of the style. By the middle of the seventeenth century, Basohli already had a long history, and one wonders if it is at all likely that there could have been many Indian courts where painting in some form or another was not practiced. Whatever painting tradition existed at the Basohli court prior to Sangram Pal, there is little doubt that it was due to the patronage of this illustrious ruler that the Basohli school took on a new importance and flourished. Sangram Pal was reputed to be an astute politician and statesman, a renowned warrior and devout Vaishnavite.

These two paintings come from a famous *Tantric Devi* series, which may originally have had as many as eighty paintings.[9] Six paintings were acquired by the Lahore Museum in 1920, and two of these were sent to India at the time of partition in 1947 and are now in the Chandigarh Museum.[10] Others from the series are in public and private collections.[11] The importance of this set of pictures can hardly be overemphasized; apart from their aesthetic merit, "these paintings have come to be regarded as the earliest examples of work done in..."

भद्रकाली

Bhadrakali Standing on the Corpse of a Giant Brahmin

161

Basohli.[12] They were consequently the earliest of all the known Pahari paintings until the recent discovery of the earlier *Devimahatmya* manuscript painting.

The worship of the Devi (the Great Goddess) in some form or another is one of the most ancient of all Indian religious concepts. In the *Markandeya Purana,* it is said that the combined cosmic energies of all the gods were needed to create her. Whether Devi is thought to be representative of the collective power of the gods or symbolic of the female energies of Lord Shiva, she is all-encompassing: she is Kali, Durga, Parvati; she is Absolute Woman, the Great Mother, the Female Energy of the Cosmos. Her forms are innumerable. Even though *Tantric Devi* series are rare, and the popularity of Devi worship varied as much as that of other cults, it would seem that, judging from the many paintings surviving from the various Punjab Hill states, a relatively consistent interest was sustained.

The first painting depicts the adoration of Bhadrakali (the Blessed Dark Goddess), one of the tantric forms of the Devi. Bhadrakali, her skin an ashen blue, stands on a golden platform in the center of the picture. She is elaborately dressed and bejeweled, with a golden rayed halo behind her head. Her resolute gaze is directed at the three terrifying black Kalis standing to her right (identified in the borders as Shrikali, Kali, Kali),[13] who are dressed in leopard skins and hold tantric emblems: skull cups filled with blood, a severed human head, swords, and a trident. To her left, as large as Bhadrakali herself, is a rare representation of Bhima-devi[14] (or Bhairavi?) holding a sword and a blood-filled skull cup and dressed in a leopard skin. The powerful, ogresslike deity has pendulous breasts and a large round head. She has small side tusks and dilated, almost hypnotic eyes. Her hair, standing on end and shaped like a nimbus, adds to her ferocious aspect. Like many of the forms of the Devi, Bhima has a male counterpart among the terrific aspects of Shiva.[15] Standing next to Bhima-devi is an unidentified pacific form of the Devi who wears a lotus-topped crown similar to Bhadrakali's and the standard dress of a woman of nobility. Thin strands of flame emanate from behind her, and in her hands she holds two tantric ritual instruments that end in hands.

Two representations of Shiva, depicted in orthodox fashion, worship at Bhadrakali's feet. They wear leopard skins, serpents around their necks, and other, jeweled adornments. Crescent moons appear in their high hairdos, which are composed of individual strands, with a single uncut hair falling down the face and body. Some of the other figures in the painting also have the long, uncut strand of hair, and all of them wear the crescent moon associated with Shiva and are shown with Shiva's vertical third eye, flanked by the *tripundra* markings in ashes, on their foreheads—all reminders of the Devi's Shaivite affiliation.[16]

Though all the figures in this painting are placed at the front of the picture plane, they are arranged in a visually intelligible and convincing manner. It is clear who stands in front of whom, and the variation in their sizes and postures adds interest to the composition. The sword and skirt extending beyond the border heighten the sense of planimetric clarity, just as the restrained shading on the skin and the skirts conveys a sense of volume and plasticity. There are obvious variations within the groups of figures—the three Kalis, for example, have different facial expressions, and their teeth and the placement of the pupils of their eyes also differ.

Typical of the early Basohli style are the large dilated eyes, the determined profiles, the use of applied beetle-wing cases to simulate emeralds, and the intense, bold palette.

Most of the known paintings from this series have either one or two figures. This painting, with eight figures, may be the most complex and ambitious of them all. With their confident drawing and complexity of composition and figural groupings, both of these paintings, as Archer so aptly put it, "glow and flash with Basohliesque bravura."[17] It hardly bears repeating that they cannot represent the earliest stages of the painting style at Basohli.

The second painting repeats a composition that recurs throughout the series: the Devi as Bhadrakali standing on a dead nude male giant.[18] Both Archer and Kramrisch have identified similar corpses as being Brahmins based on the shaved head and the *chati,* the long strand of hair worn by members of the caste.[19] The

corpse in this painting, unlike many of the others, is shown from the rear. Bhadrakali, shown in three-quarter profile, wears the same costume and elaborate jewelry as in the first painting, but the colors of her garments, instead of contrasting with her skin, are subtle blue-gray tones that echo its ashen blue color. Despite their being limited to the two figures, the contrasts and interplay of the forms and colors are more daring and confident here than in the first painting.

It is not surprising that a *Tantric Devi* series should be currently accepted as being at the chronological forefront of the known Basohli paintings. Raja Sangram Pal is known to have supplemented traditional worship of Shiva, the Devi, and Vishnu with a form of ardent Vaishnavism, "a cult of instant salvation through praise and love of God."[20] Despite the unpredictability and vicissitudes of sectarian rivalries, it is unlikely that such an elaborate manuscript as this *Tantric Devi* would have been commissioned after the introduction of ardent Vaishnavism had altered the religious climate at the Basohli court.

[1] Archer 1973, vol. 1, p. 16.
[2] Randhawa 1959, p. 18.
[3] Archer 1973, vol. 1, p. 33.
[4] Archer 1976, p. 10.
[5] Archer 1973, vol. 1, p. 34.
[6] *In the Image of Man,* 1982, no. 448.
[7] Archer 1976, p. 10.
[8] Aijazuddin 1977, p. 3.
[9] Polsky and McInerney 1982, p. 29.
[10] Aijazuddin 1977, p. 4.
[11] Polsky and McInerney 1982, p. 29.
[12] Aijazuddin 1977, p. 4.
[13] Translated by Barbara Stoler Miller.
[14] See Dowson 1972, p. 87. The name written on the border is "Bhima" (again read by Stoler Miller), but there is some question about when these titles were added, as traces of other titles appear on the same side of the border.
[15] Rao 1968, p. 406.
[16] See Kramrisch 1981, p. 161.
[17] Archer 1976, p. 14.
[18] Kramrisch 1981, pp. 216–17; Archer 1973, vol. 1, p. 34; vol. 2, p. 16, 1(iii).
[19] Ibid.
[20] Archer 1976, p. 10.

Page from a dispersed *Ragamala* manuscript
India, Punjab Hills, Bilaspur, ca. 1680–90
Opaque watercolor on paper, H. 8⅛ in. (20.6 cm),
W. 5¹¹/₁₆ in. (15.1 cm) excluding border

The history of painting at Bilaspur (Kahlur), another of the important Punjab Hills states, so far as is presently known, seems to begin during the reign (1650–67) of Raja Dip Chand. The Raja had campaigned for the Mughal emperor Aurangzeb (the son of Shah Jahan), and almost definitely spent some time at the Mughal court in Delhi. It is likely that this association led to some Mughal artists migrating to Bilaspur, particularly given the inhospitable artistic climate that characterized the later years of Aurangzeb's reign.

Mughal influences on the early styles at Bilaspur — from around 1660 to the end of the century — are quite clear. This *Ragamala* (see No. 59) painting has very definite stylistic affiliations with Mughal painting traditions, particularly in the dress of the three figures, the treatment of the grass, and the relatively naturalistic portrayal of the faces.

On a low grassy knoll, set against an olive-green background, a solitary male figure dances to the accompaniment of two female musicians. One of the women plays a drum and the other a stringed instrument. This is not a spatially expansive picture; the tightly cropped sides and the interaction of the borders of sky and grass tend to compress the composition. Despite the spatial augmentation provided by the contrasting yellow border and the stringed-instrument player gazing beyond it, the sense of confinement is almost palpable. Working within this restrictive format, the artist has arranged the four major elements of the painting — the tree and the three figures — and the minor detailing of costumes, instruments, and so on, with meticulous precision, as one might compose a still life. The dynamic contrasts between Mughal and Rajput stylistic elements usually found in Pahari painting can be seen here in such details as the Mughal-style turban of the dancer versus the massed-leaf arrangement of the Rajput Basohliesque tree.

Quite a few early *Ragamala* series from Bilaspur are known.[1] This painting does not seem to belong to any of them, but further conscientious research may eventually assign it to one of the known sets. The painting does, however, seem to be very close in style to what Archer calls "the first and possibly the earliest of the various *Ragamala* series,"[2] which is represented by three paintings in the Binney Collection.[3]

The treatment of male and female faces, the details of the costumes, and the tree, as well as the handling of grass and sky, can all be closely matched in the Binney paintings. In addition, the same rich yellow border and the compression of space, particularly at the sides (perhaps the result of cropping), can be seen in two of the Binney paintings. Were it not for a discrepancy in size, I would suggest that the Kronos Collections painting was in fact from the Binney set. Some pages from a *Ragamala* series of approximately the same date, now in the Los Angeles County Museum of Art, are also similar in style.[4] The use of strips of white and blue for the sky instead of individual clouds is typical of these early paintings.

Just as *raginis* are considered the wives of *ragas,* so the musical mode variants called *putras* are considered the sons of the various *ragas.* Many different *ragaputras* are known, and quite a few are included in the *Ragamala* systems of both Rajasthan and the Punjab Hills. *Madhava* is a *putra* of the *raga* called *Bhairava.*[5]

Although this painting is not titled on either front or back, it is unlikely to represent any other *Ragamala* subject.[6] The closest other possibility where a male dancer is represented, *Bhramarananda Ragaputra,* is a less likely candidate because with that subject one usually finds a female playing the tambourine, and bees are often included in the composition.[7]

[1] Archer 1973, vol. 2, pp. 172–73, 176–81; Archer 1976, p. 61; and Pal 1982, pl. IX.
[2] Archer 1973, vol. 1, p. 231.
[3] Ibid., vol. 2, p. 172, 8(i–iii).
[4] Pal 1982, pl. IX.
[5] The Waldschmidts remind us that the olive-green background color is used for *Raga Bhairava's* family (Waldschmidt and Waldschmidt 1967, p. 149).
[6] For another example, see ibid., fig. 26.
[7] Ibid., fig. 62.

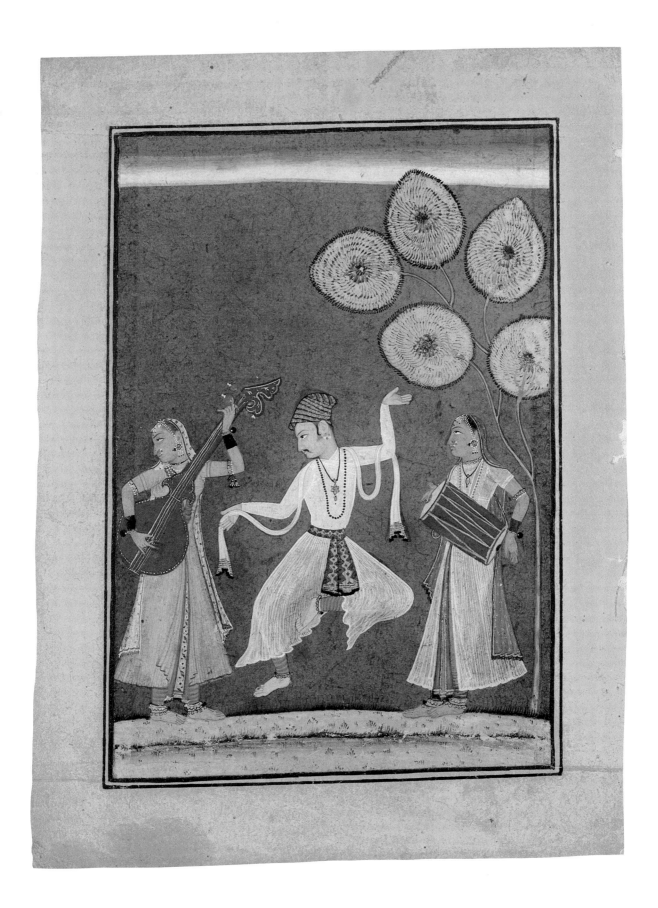

63 (a) MATSYA SLAYING THE CONCH DEMON
(b) PARASHURAMA SLAYING KARTHAVIRYA
Two pages from a dispersed *Vishnu Avatara* or
Gita Govinda manuscript
India, Punjab Hills, probably Mankot, ca. 1690–1710
Opaque watercolor, gold, and beetle-wing cases on
paper; (a) H. 6 5/16 in. (16 cm), W. 7 3/16 in. (18.3 cm),
(b) H. 6 1/4 in. (15.9 cm), W. 7 1/8 in. (18.2 cm), both
excluding borders

Matsya, the fish avatar of Vishnu, is usually considered the first of the great god's descents from his heaven to preserve mankind. Vishnu takes the form of a great fish to save the universe from being overwhelmed by the Great Deluge. The purpose of the avatar is sometimes narrowed to Vishnu's recovering the ancient *Vedas* (the Sacred Word or Teachings pronounced by Brahma) after a demon had stolen them from Brahma and hidden them beneath the primordial ocean.

In the first painting, Vishnu is shown emerging from his great fish form to slay the conch demon (Hayagriva?). Matsya tears open the demon, releasing four diminutive crowned figures (perhaps representing the four Sana brothers),[1] each of whom holds a manuscript, symbolizing the *Vedas,* under his arm.[2]

This painting shows a particularly skillful blending of naturalistic and stylized elements. The fish scales, the conch, and the figures of Vishnu and the demon are rendered in a manner surprisingly naturalistic for an early eighteenth-century Mankot painting, which contrasts vividly with the more abstract treatment of the trees and the water.

The three stylized trees with thin trunks, two of which support masses of leaves arranged in compact, rounded forms, are a continuation of a convention established in early Basohli painting.[3] This method of rendering trees seems to have been abandoned at Basohli by 1730 in favor of thicker-trunked trees with more natural branching habits.[4]

The treatment of the water in the painting is a fanciful stroke of genius. It is depicted as a great expanse of transparent, gauzelike fabric, of the sort often worn by Indian women as an overgarment.[5] The triangular three-dot motif appearing on those transparent cloths, and seen here,[6] may be a variation on an ancient Indian symbol for water, a trefoil, which appears on occasion on Indian sculpture.[7]

A system of major and minor visual rhythms is established throughout the painting by combinations of shapes and colors such as the three large, white shapes of the conch and the fish's head and tail, the colors of the demon's body and the tree trunks, the contrast between the gray water and brown background, and the rounded

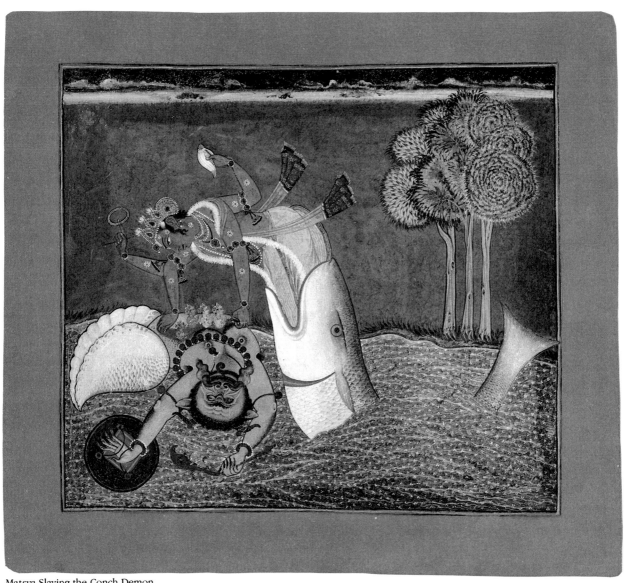

Matsya Slaying the Conch Demon

shapes of the demon's shield and the massed leaves. The volumes, foreshortened forms, and spatial relationships are convincingly rendered, and reflect the confidence and skill of an artist of the first rank.

In the second painting, Parashurama (Rama with the *parashu* [ax]), the sixth avatar of Vishnu, is shown killing the thousand-armed king, Karthavirya. The evil king had visited the hermitage of the sage Jamadagni while he was away. The sage's wife Renuka welcomed him, but he repaid her hospitality by stealing their wish-fulfilling "cow of plenty," Surabhi (or Kamadhenu). Parashurama (who was born as the son of Jamadagni and Renuka) then killed Karthavirya, setting off a chain of events that led to the sage's being killed by the sons of Karthavirya and Parashurama's ultimately destroying the whole race of the evil king in revenge.

The composition seen here is known from many other Pahari paintings.[8] It combines two different events: Parashurama slaying Karthavirya and Renuka supporting her dead husband. As in all the similar paintings known to me, the magic cow is shown running or flying away at the upper corner.

Parashurama, brandishing the *parashu* given to him by Shiva, holds the evil king by his hair. He has already hacked off some of Karthavirya's arms, each holding a weapon. In the moving scene in the lower left corner of the painting, Renuka tenderly cradles her dead husband's head in her lap.

Perhaps the most surprising elements of this painting are the exquisite refinement of the drawing and the extraordinary way in which spatial relationships have been handled. The drawing is confident, precise, and in a way rather adventuresome. If one carefully examines the white turban, so meticulously placed and so surprisingly tactile, the drawing skill of the artist becomes evident. The artist has also been remarkably successful in establishing a coherent system of rational spatial relationships within the confines of a large monochromatic background. Rather than being superimposed on the background, the individual elements of the composition have been carved out of the space, and a spatial continuum developed according to a clear planimetric formula. As in the painting of Matsya avatar, the foreshortening and the definition of volumes are very skillful and convincing. The painting abounds in touches of pure genius such as the pinwheel arrangement of the severed arms.

Like the trees in the Matsya avatar painting, the use of beetle-wing cases is a borrowing from the Basohli idiom. Mankot is only about twenty miles northwest of Basohli and the two hill states had close relations, including matrimonial alliances. Mankot, like Basohli, had acknowledged the supremacy of Akbar the Great's empire by the late sixteenth century and was in contact with the Mughal court.

These two paintings depicting avatars of Vishnu seem to be the only ones currently known from what must have been a very beautiful series. They are part of either a dispersed *Vishnu Avatara* manuscript or a *Gita Govinda* manuscript incorporating the avatars.[9] The artist seems not to be represented by any other paintings known to me, but, judging from the sophisticated drawing and handling of complex spatial relationships, he would appear to have been trained at the Mughal court or to have thoroughly digested the lessons of Mughal painting styles. So skillful an artist must surely have painted many other pictures, some of which will eventually be identified.

The borders on both paintings are recent replacements.

[1] Goswami 1971, pt. 1, p. 123.

[2] For another, later example that includes the four crowned figures, see Archer 1973, vol. 2, p. 70, pl. 62.

[3] Ibid., p. 17, pl. 3, and p. 20.

[4] Ibid., p. 33

[5] Archer 1976, pp. 102, 104, 115.

[6] This motif appears on another Mankot painting of the same approximate date (ibid., p. 127).

[7] Kramrisch 1960, p. 89, pl. 21. This motif also appears on the coils of *naga* deities on a Kushan period sculpture in the National Museum, New Delhi (acq. no. 49.151).

[8] Archer 1973, vol. 2, pp. 52, pl. 8; 61, pl. 34; Aijazuddin 1977, plates, p. 11, 4(v); Skelton 1961, pl. 33.

[9] Aijazuddin 1977, Basohli set 4 is such a series.

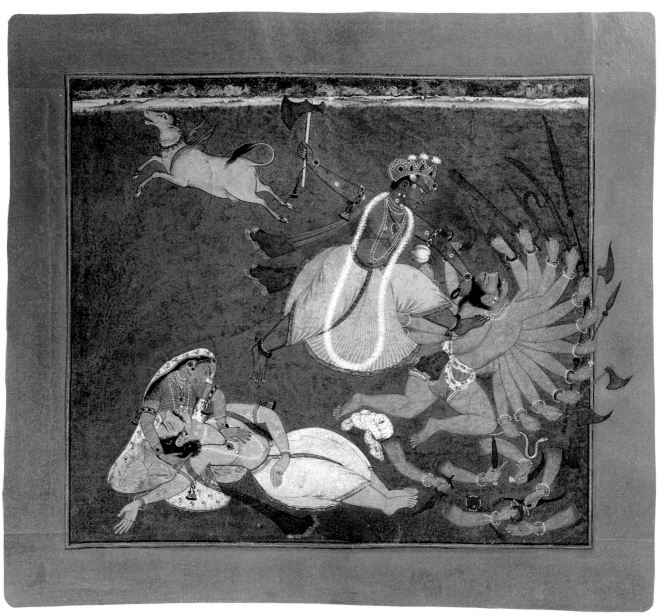

Parashurama Slaying Karthavirya

64 THE ABSENT LOVERS
India, Punjab Hills, Mankot(?), ca. 1710–25
Opaque watercolor on paper, H. 7⅝ in. (19.4 cm),
W. 7 7/16 in. (18.9 cm) excluding border

This painting, also from the Punjab Hills, depicts five women standing on a terrace outside a small pavilion. To the right of the pavilion, providing a strong contrast to its muted tones and simple architectural elements, is part of a green garden in which a large tree, whose slim trunk tapers to elegant branches, grows next to two cypresses. The austerity of the pavilion is offset by the plates holding fruits, flasks, and a melon set into its niches, by the silhouetted tree forms, and by the use of the same color for the trunk and branches as for the pavilion.

The women have just come from bathing and have wet hair. They are nude from the waist up and wear long wraparound skirts that swirl beneath their feet in fluid, almost cloudlike forms. The three figures dressed in white are attendants. One holds a flower, the second a hookah bowl, while the third comforts the two figures clad in pink, who gaze ardently down at the small pool with its single jet of water — no doubt an allusion to their absent lovers.

It is clear that the artist was not concerned with attempting to suggest either spatial recessions or three-dimensionality through perspective: witness, for example, the flat facade of the pavilion and the treatment of the small pool. Compositionally, the painting is not very adventurous; its impact derives instead from the very definite emphasis on the mood. A sense of lyrical tenderness pervades throughout — partially achieved through the expressions of the women, the gentle way in which the three women in the center touch each other, the psychological interaction of the figures, and the overall muted palette.

This painting, although probably slightly later in date than the preceding two, is in many ways closer to earlier Basohli styles. The physiognomy of the women, with their rounded foreheads, long noses, and receding chins, is very much within the Basohli idiom, as are their large eyes and arched brows. But the painting is much more subtle and delicate in terms of palette, drawing, and composition, and there is a decided restraint that is very different from the bravura of the Basohli style. The color contrasts are less violent and there is none of the insistence on elaborately decorated minor motifs such as carpets and tilework. Not only is this picture in a gentler idiom, aesthetically it is more disciplined than the paintings one normally encounters from Basohli.

This picture does not seem to be part of a larger painting series, or at least I do not know of any others that might be related to it.

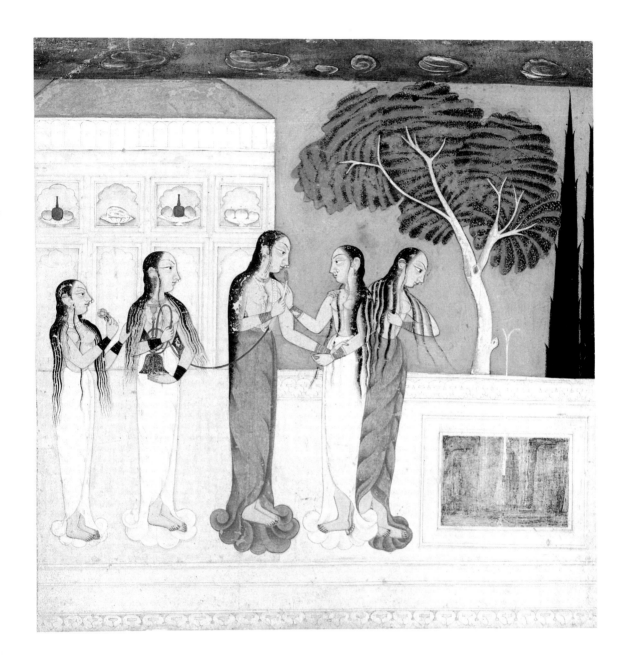

65 RAMA, SITA, AND LAKSHMANA IN THE FOREST
Page from a dispersed *Ramayana* manuscript
India, Punjab Hills, Kangra, ca. 1800–1825
Opaque watercolor and gold on paper, H. 8¼ in.
(21 cm), W. 5¹⁵⁄₁₆ in. (15.1 cm) excluding border

Perhaps the most famous of the Pahari schools of painting is that of the large state of Kangra, which is some eighty miles long and thirty-five miles wide.[1] The history of the Kangra styles, which are relatively late by Basohli or Bilaspur standards, remains the subject for considerable art historical speculation—probably because there is more information about this school than the others, and little unanimity regarding how that information should be interpreted.

The armies of the Mughal emperor Jahangir conquered the great castle of Kangra in the 1620s. The subsequent Mughal occupation has often been suggested as the main reason for the suppression of artistic activity at Kangra, for not until the second half of the eighteenth century does the history of painting at Kangra commence. The period of 1786–1806, the height of the reign of Sansar Chand, is usually considered the golden age of Kangra painting.

In 1775, at the age of ten, Raja Sansar Chand became the new ruler of Kangra. In 1786, with Sikh support, he recaptured Kangra castle and reestablished the power of the ancient kingdom. And until 1806, when Kangra was overrun by the combined forces of the Gurkhas of Nepal and other hill states, including Chamba and Bilaspur, Sansar Chand ruled over one of the greatest courts in the history of the hills. Sansar Chand loved painting and music; the wealth of his court, coupled with his own artistic interests and patronage, prompted many artists to migrate to Kangra. But it was primarily the artists from the neighboring state of Guler who provided the foundation for the painting styles at Kangra.

If it can be said that one of the major stylistic tendencies of Pahari painting during the eighteenth century was an irresistible march toward greater naturalism, then by around 1775 at Guler the goal had nearly been reached. The Guler artists not only were more comfortable with the manipulation of complex figural groupings in a variety of spatial situations, they had also abandoned the emphasis on large decorative elements that was so much a part of the earlier styles. Color was employed in a more realistic fashion, an understanding of perspective had been assimilated, there was concern for naturalistic spatial recessions, and figures were depicted with a more convincing sense of volume. As has happened throughout the history of art, concepts of physical beauty changed—in this case, away from exaggerated features toward a more harmonious, sometimes lyrical system of depiction of the human face and form.

What was retained from the traditional repertory is basic to all Indian painting: the subject matter, the love of landscape, the understanding of the emotive nature of color, the fondness for playing large areas of a single color against small detailing, the romantic pictorial metaphors, and the psychological interaction among figures. And all of this the artists from Guler brought to Kangra. The Kangra school blossomed, and soon became one of the most potent styles in the hills.

This exquisite painting, from a *Ramayana* manuscript, demonstrates the continuation of the refined and sensitive styles of the Kangra school in the later years of Sansar Chand's reign, despite the political upheavals at the Kangra court. The painting shows Rama, his wife Sita, and his brother Lakshmana in the forest, after intrigues at the court of Ayodhya had resulted in their banishment. They are dressed in costumes of leaves, appropriate for forest dwellers. The large monkey drinking from the stream is Hanuman, the prime minister of the great monkey clan. His appearance suggests that the *Ramayana* series from which this painting came was a condensed version that combined several episodes. Hanuman does not appear in the *Ramayana* until after Sita has been abducted and carried off to Sri Lanka; his premature presence here is perhaps meant to portend the disasters to follow.[2]

Rama languidly reclines on the ground, resting on Sita, who fans him. Lakshmana seems to be removing a thorn from the sole of Rama's foot. It is a peaceful scene set into a beautiful idealized landscape; the trees are in full bloom, and one of them, in the embrace of a vine, echoes the love theme of Rama and Sita. The sylvan surroundings and the relaxed mood of the figures give no suggestion of the misfortunes that will later befall the trio.

The composition and spatial relationships are handled very skillfully. The eye is drawn beyond the figures to the small shrubs at the point where the high ground meets the sky. There is a distinct circular movement in the composition: the eye travels from Hanuman to the dead deer, then to the three main figures and off into the distance. The large white stones in the foreground and the curvature of the land where it joins the water and the hill behind the figures emphasize the circular visual rhythms, and minor elements such as the curved bows and tree trunks echo the movement.

The linear patterns of the tree leaves and the leaf costumes of the figures and the silhouetted forms of the

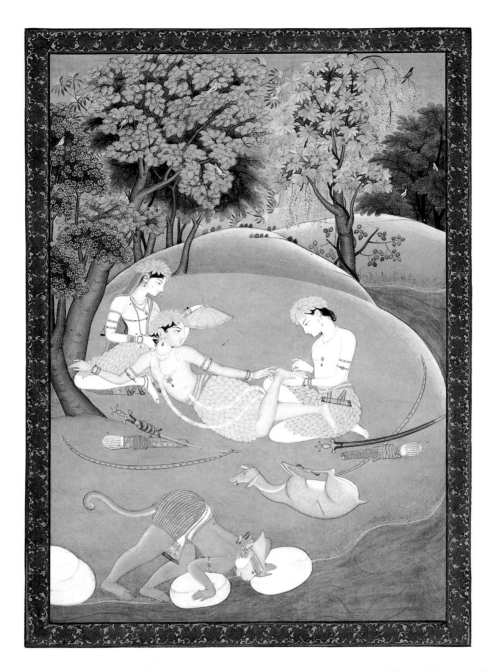

monkey, the deer, and the main trio, aside from being superbly drawn, intensify the rich surface variety of the picture.

Played against the soft green background, the cool tones of the figures' skin, repeated in the white rocks, along with the gray and blue water and sky, enhance the peaceful atmosphere. As we shall see in No. 66, this subdued coloration can become almost ethereal in Kangra paintings.

Douglas Barrett has dated this painting to about 1780.[3] What appears to be the only other published painting from the set, or at least quite close to it, has been dated by W. G. Archer to about 1840.[4] That these two interpretations of the evidence on the Kangra school should have resulted in such diverse dates is not surprising. Nevertheless, it seems to me that, although Archer had a considerably larger body of evidence and much greater experience from decades of research on the painting of the Punjab Hills to draw upon, his dating is too late, perhaps by as much as forty years.

Published: Barrett and Gray 1963, p. 184.

[1] Archer 1973, vol. 1, p. 244.
[2] It is possible that some other story where Hanuman appears, such as Tulsidasa's *Rama Charita Manasa*, is the source for this painting.
[3] Barrett and Gray 1963, p. 184.
[4] Archer 1973, vol. 2, p. 232, pl. 70.

66 KING BHIMA LEARNS OF
DAMAYANTI'S CONDITION
Page from a dispersed *Nala-Damayanti*(?)
manuscript
India, Punjab Hills, Kangra, ca. 1830
Opaque watercolor and gold on paper, H. 11¹⁵/₁₆ in.
(30.3 cm), W. 17¹/₁₆ in. (43.3 cm) excluding border

Although some rare series of paintings (like the well-known Guler *Ramayana* of ca. 1725–30)[1] were executed on very large sheets of paper, it was not until around 1775 that these large-format series began to be produced with some degree of regularity: at Guler, Kangra, and Tehri Garhwal, for example. The expanded format seemed to spur the artists to more ambitious pictorial conceptions. The subject matter — the popular sections of some of the great Hindu epics and love poetry — was the same, but the complex multifigural compositions became so much more elaborate that the traditional scenes took on a new appearance.

In this painting, it is obvious that the artist's compositional concerns were with shifts in perspective and contrasts in scale. From the bird's-eye view of the city, filled with many small buildings set at various angles, to the view of the figures in full profile, the way in which the variations in perspective are played against one another is both accomplished and very convincingly integrated into the total composition. The shift in scale — from the miniature buildings to the large figures of the main scene — is handled in so skillful and balanced a manner that we accept it as an artistic essential.

The strong contrast between the large expanse of sky and the densely packed lower half of the picture is partly muted by the overall pale tonality. The silver moon reflected in the silver pool not only adds a whimsical touch, but also helps to relate the upper half of the picture to the lower. The distribution of the trees, the silver-gray pool and the gray pavilion behind the larger figures, and other compositional and coloristic relationships help to preserve the balance of the painting. The drawing is confident and refined; with the imaginative composition and sensitive handling of color, it suggests the work of an artist of great taste and talent.

It is not quite clear whether the woman on the bed who is cloaked from head to toe is dead. One of her attendants rubs her foot, attempting to revive her, and there seems to be a flurry of activity among some of the handmaidens in the background. There is no question that the king (perhaps her father) depicted in the upper left corner has fainted from grief. He is shown again prostrate at the entranceway to the women's courtyard.

If, indeed, this painting is from a *Nala-Damayanti* series, then the scene depicts the love-stricken Damayanti, who has swooned from the pain of separation from her lover, Nala, and it is she who lies completely covered while her attendants attempt to revive her. In the story, her father, King Bhima, learning of his daughter's condition, is overcome with grief, as is the rest of his court. This scene does not follow the standard story line, in which King Bhima is accompanied by his minister and physician.[2]

[1] Archer 1973, vol. 2, pp. 98–99, pls. 9(i–iii).
[2] See Goswamy 1975, pp. 88–89.

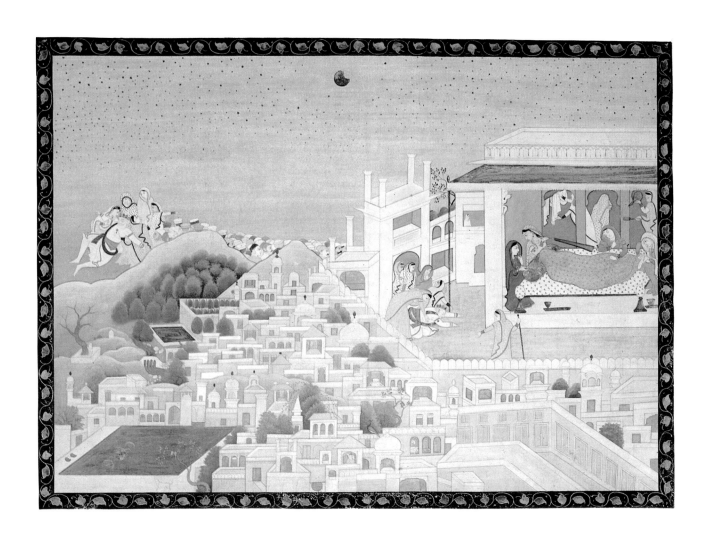

Page from a dispersed *Bhagavata Purana*
manuscript
India, Rajasthan, Bikaner, ca. 1690
Opaque watercolor and gold on paper, H. 8¾ in.
(22.2 cm), W. 12 in. (30.5 cm) excluding border

The Rajput desert kingdom of Bikaner, founded toward the end of the fifteenth century, had as rich a history as any of the states in Rajasthan. Bikaner was closely allied to Emperor Akbar's court through matrimonial alliances and its participation in Akbar's military campaigns. Kalyanmal, the ruler of Bikaner from 1542 to 1571, gave one of his daughters in marriage to Akbar, and Kalyanmal's son, Rai Singh (r. 1571–1612), was one of Akbar's most distinguished generals. Bikaner flourished because of its close association with the Mughal court and its location along a significant trade route. Many artists migrated to Bikaner to take advantage of its prosperity and patronage of the arts: particularly during the second half of the seventeenth century, the court played host to many Muslim artists who had been trained at the various Mughal courts. During the reign of Maharaja Anup Singh (ca. 1675–98), the arts thrived, and the Bikaner court was renowned for the great proficiency of its artists. It was toward the end of the reign of this illustrious ruler that the *Bhagavata Purana* series from which this painting comes was begun.

This scene is from Book Ten of the *Bhagavata Purana,* which is concerned with Krishna's youth, and depicts one of the many episodes in which the blue god destroys a demon.[1] One day shortly after Krishna and the cowherders had moved to the forest of Brindaban, they brought their herds to a pond. There they saw a monstrous *asura* (demon) named Baka who had assumed the form of a colossal crane, or heron. Suddenly the demon-bird rushed up to Krishna and swallowed him. Krishna, however, emitted so much heat that he burned the insides of Baka, who was then forced to disgorge him. Krishna seized the demon-bird by the two halves of his long bill and tore him apart.

In this painting, Bakasura is disgorging the flaming Krishna while Krishna's brother Balarama, his right arm raised, looks on in astonishment. Two cowherders are also present with four of their cattle, one of whom, a frightened bull, is bolting away from the demon.

The pale wash of gold on the distant hill, the rock formations above it, and the sky—a borrowing from Mughal painting—is nicely balanced by the silver water with its incised wave patterns. The attention lavished on the cloud formations and the anthropomorphized sun helps to keep the composition in balance and the eye focused on the main scene.

The painting comes from a large series that had perhaps as many as a hundred paintings, which are now widely dispersed in public and private collections. Work on the series started around 1690 and probably continued for about half a century. Even though it was an ambitious undertaking—the paintings being large, immaculately detailed, and highly finished—the reason for its sporadic production is unknown.

Among the hallmarks of the early part of the series are a meticulous precision of line, very fine detailing, and a high level of sophistication in the treatment of pictorial elements, particularly small elements such as lotuses and ducks in the water, which are arranged and presented almost like still lifes. It is apparent that these paintings are the work of a highly developed atelier. The compositions tend to be imaginative, sometimes innovative, and very skillfully balanced. Overall color tonalities are restrained, and there is little of the insistent stark contrast found in the earlier Rajput styles in the *Chaurapanchasika* tradition—at times imparting a blandness to some of the pictures from the series. The debt to the imperial Mughal painting idiom is readily apparent; many of these pictures must have been painted by Mughal-trained artists.

[1] Goswami 1971, pt. 2, p. 1097.

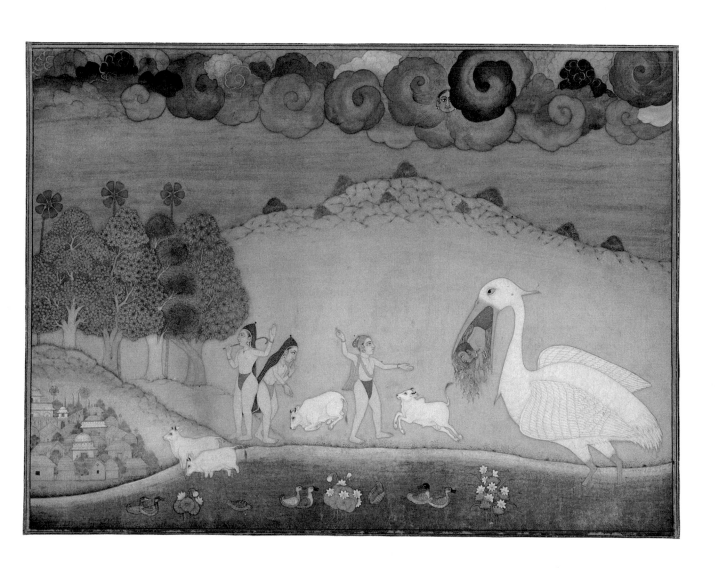

68 KRISHNA AND RADHA
India, Rajasthan, Bundi(?),
late 17th – early 18th century
Opaque watercolor and gold on paper, H. 6½ in.
(16.5 cm), W. 4¼ in. (10.8 cm) excluding border

The Rajput rulers of the state of Bundi, in southeast Rajasthan, allied themselves early on to the expanding Mughal empire, and maintained close relations from around the middle of the sixteenth to the beginning of the eighteenth century. During much of the eighteenth century, Bundi suffered through a series of complicated intrigues involving both neighboring states and the Marathas in the Deccan. The nearly anarchic conditions accompanying the breakup of the Mughal government and the collapse of empire after the death of Aurangzeb in 1707 proved to be politically disastrous for Bundi. Throughout both the peaceful and the troubled periods of Bundi's history, however, its artists produced paintings of superior quality and great charm. This painting is surprisingly restrained for Bundi and it is possible that the attribution is inaccurate.

Krishna and Radha, his cowherdess mistress, are seated outdoors on a golden couch covered with lotus leaves, Krishna partially supported by a large pillow. At the foot of the couch, bunches of flowers are arrayed in formalized arrangements; one pair of intertwined flowers alludes to the devotion of the lovers. Krishna, the divine lover, tenderly holds Radha's head as she gazes shyly downward. The lovers are elaborately dressed in the contemporary costume of royalty.

Pictures of this sort, which also appear with only minor variations in the paintings of other Rajasthani courts such as Bikaner, in many respects represent the triumph of the dissemination of Mughal styles. Whether this picture was painted by a Mughal artist or by a Rajput trained at a Mughal court, the stylistic debt is very apparent—the shallow space and single-color background may be the only concessions to Rajput traditions.

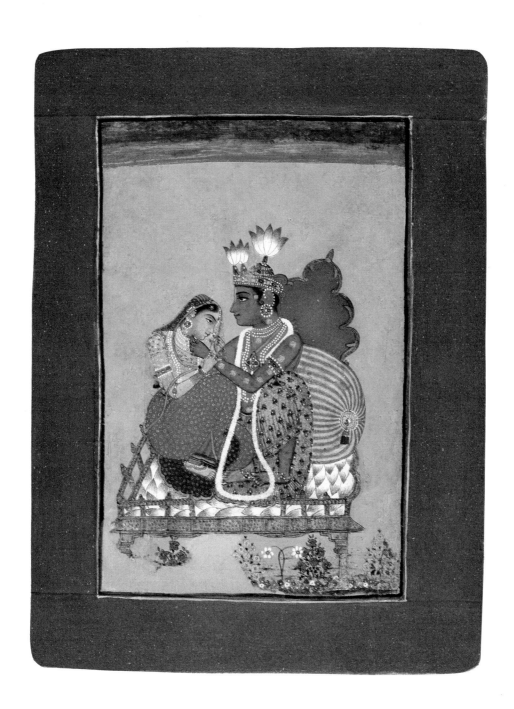

The small Rajput state of Kishangarh is situated next to Jaipur in the center of Rajasthan. Early in the seventeenth century, Kishan Singh, to whom Akbar had given the territory, founded the city of Kishangarh on the bank of Gundalao Lake, a locale prominently featured in many paintings of the Kishangarh school. The rajas of Kishangarh participated in various Mughal military campaigns and maintained close alliances with the Mughal court throughout the seventeenth century.

During the later years of the reign of Raj Singh (1706–48), Kishangarh artists relied heavily on Mughal styles of the late seventeenth and early eighteenth century, and evidence of the Mughal contribution abounds in the paintings they produced: deep perspectives, tiny figures set into a naturalistic landscape, expansive compositions depicting spatial recessions of great depth, the color range, a delicacy of detail, and refined drawing. It is also probable that the artists were influenced by the Mughal-inspired paintings of Bikaner. Nevertheless, the Kishangarh school in the second quarter of the eighteenth century was already exhibiting a distinctive style of its own.

It is commonly accepted that Kishangarh painting was at its greatest from around 1730 to 1780. It was during this brief fifty-year span that the paintings that make up the heart of the Kishangarh style were produced. The names of a few of the master artists of the period are known, but it is Nihal Chand who is acknowledged to be the premier Kishangarh artist.

Savant Singh, the eldest of Raj Singh's sons, inherited the reign in 1748, at the age of forty-nine. But Savant Singh was in Delhi when his father died, and the throne was usurped by his younger brother. Despite his legal claim to the throne, Savant Singh spent the rest of his life, except for a brief return in 1756, away from Kishangarh. Nevertheless, it is to Savant Singh's extraordinary personality, his career while still heir apparent, his probable association with the artist Nihal Chand, and his love affair with a beautiful woman that we owe so much of what became the high point in Kishangarh painting.

Savant Singh was born in 1699. As a prince, he led an exemplary Rajput warrior existence. Trained in literature and the arts, he turned out to be a poet of considerable talent; writing under the name of Nagari Das, he composed many poems in praise of Krishna. But what set him aside in the annals of Rajput history was his celebrated romance with a beautiful commoner called Bani-Thani.

The lovers were pious adherents of the Krishna cult, and it has often been said that they so closely associated themselves with Krishna and his cowherdess mistress Radha that their life together must be understood to be not only a great paean to the divine lover and Radha, but as close a parallel as it was possible for mortals to attain.

Savant Singh's mother came from the area around Braj, "the homeland of Krishna, the countryside that had become inseparable from the exploits and the romantic escapades of the cowherd god."[1] Because of his irresistible affinity for the sacred place, Savant Singh spent a good deal of time there, particularly after his father's death in 1748. Around 1751, or soon after, he and Bani-Thani retired to Brindaban, the fabled groves of Krishna's youth, where they devoted the rest of their lives to the worship of Krishna. Savant Singh died in 1764 and his beautiful mistress a year later.

It is believed that from Savant Singh's consuming devotion came not only a new vision with which he wrote poems of Krishna and Radha, but also a new perception of how Radha should be depicted in painting. It is assumed that the inspiration for this new image of Radha was Bani-Thani.

We know almost nothing about Savant Singh's relations with the artist Nihal Chand, but the presumption of a close association is probably accurate. Here we can do no better than to quote Karl Khandalavala, who said that it was Savant Singh

> who influenced Nihal Chand to translate into pictorial form the allegory of the blue god and Radha.... It is fairly evident that neither the patron nor the artist was content with the prevailing pictorial treatment of the Krishna theme. They both sought to transcend the norm for such paintings.... In this endeavor the high-souled, exquisite Bani-Thani became their greatest inspiration. In her image they fashioned the divine Radha and everything beautiful in womanhood.[2]

A distinctive Kishangarh physiognomy developed through this presumed collaboration of Savant Singh and Nihal Chand: a very long, pulled-back eye, curving upward as it approaches the hairline; a full, heavy upper lid; a high, delicately arched brow; thin lips; a sharp chin; a receding forehead; and a long, pointed nose. This special physiognomy was usually reserved, as in this painting, for representations of Radha and Krishna, but on occasion it was also used to depict other figures.

Set before the viewer, in a vast panoramic landscape,

is a romantically idealized scene probably representing Gundalao Lake and the environs of the city of Kishangarh. It is a magical place, suitable not only for the court of the rulers of Kishangarh, but also as an appropriate setting in which to depict the episodes concerning the love of Krishna and Radha. In the lower right corner, the blue Krishna, his long tresses flowing behind him, swims toward his waiting mistress. The picture is composed of alternating water and hills rising to a fiery sunset. The focal point is not Krishna and Radha but the intense purple-pink wall in the middle ground. The diminutive figures sporting along the river's edge might lead one to interpret the painting as the artist's attempt to symbolize man's relative cosmological position in some all-encompassing natural scheme, but it is more likely that it was simply his admiration for the landscape that prompted him to create this magical lake country setting with gentle, rolling hills and fairy palaces and pavilions.

Whatever the artist's intention, his blending of landscape, architecture, and people (in that order of importance) has resulted in a picture of enchanting originality.

The painting serving as the most remunerative parallel is one that is commonly accepted as being one of the greatest and most important of the Kishangarh school—"The Boat of Love" by Nihal Chand.[3] Although the figures in Nihal Chand's painting are much larger in relation to the landscape, the alternating registers of water and land, the brilliant sunset, the purple walls along the water, the spatial distances, and the orange boat all have parallels in our picture. Nihal Chand's hand cannot be claimed for the painting in the Kronos Collections, but an association with his atelier is not unlikely.

[1] Dickinson and Khandalavala 1959, p. 11.
[2] Ibid., p. 15.
[3] Ibid., pl. IX.

70 FLORAL DECORATION
Study for a wall painting(?)
India, Rajasthan, Jaipur(?), ca. 1800
Opaque watercolor on board, H. 6¼ in. (15.8 cm),
W. 5⁵⁄₁₆ in. (13.5 cm) excluding side borders

Around 1800, Maharaja Pratap Singh of Jaipur (r. 1779–1803) had the library in the City Palace redecorated. It has been suggested that this painting was part of a series of floral studies prepared for that redecoration. Although the arrangement and sizes of some of the floral motifs might suggest a study for *pietra dura* inlay, the overall conception seems more appropriate for a wall painting. Unfortunately, I know of no other floral paintings of this type.

The composition is surprisingly rich and dynamic, the individual elements very skillfully and imaginatively arranged. The major circular rhythm of the scrolling frond is echoed by the fine green line of the vine, and other visual rhythms are developed through the subtle placement of different flowers. Many of the floral motifs have a very tangible three-dimensionality, established by skillful shading, overlapping forms, and juxtaposition of rich colors. The inventiveness of the design and its superb execution transcend the merely decorative, elevating this finished study to a fanciful, spatially shallow still life. The very accomplished blending of naturalistic forms with whimsically abstracted shapes probably reflects local Rajput taste.

Selected Bibliography

Agrawala, P. K.
1967–68. "A Prehistoric Bronze Anthropomorph in the Patna Museum and Its Identification," *Puratattva: Bulletin of the Indian Archaeological Society,* no. 1.
1977. *Early Indian Bronzes.* Varanasi.

Aijazuddin, F. S.
1977. *Pahari Paintings and Sikh Portraits in the Lahore Museum.* London.

Allchin, F. R.
1972. "A Cruciform Reliquary from Shaikhan Dheri," in *Aspects of Indian Art.* Leiden.

Annual Bibliography of Indian Archaeology for the Year 1934.
1936. Leiden.

Archaeological Survey of India: Annual Report, 1904–1905.
1908. Calcutta.

Archaeological Survey of India: Reports, vol. 1 [Report of 1861–62]. 1871. Simla.

Archer, W. G.
1973. *Indian Paintings from the Punjab Hills.* 2 vols. London.
1976. *Visions of Courtly India.* Washington, D.C.

Asher, F. M.
1980. *The Art of Eastern India, 300–800.* Minneapolis, Minn.

Bachhofer, L.
1929. *Early Indian Sculpture,* vol. 2. New York.

Banerji, R. D.
1933. *Eastern Indian School of Mediaeval Sculpture.* Archaeological Survey of India, New Imperial Ser., vol. 47. Delhi.

Barrett, D.
1967. "An Ivory Diptych," *Lalit Kala,* no. 13.

Barrett, D., and Gray, B.
1963. *Painting of India.* Cleveland.

Bhattacharyya, B.
1924. *The Indian Buddhist Iconography.* Calcutta.

Binney, E., 3rd.
1973. *Indian Miniature Painting from the Collection of Edwin Binney 3rd: The Mughal and Deccani Schools.* Portland, Ore.

Boisselier, J.
1966. *Le Cambodge,* vol. 1. Paris.
1975. *The Heritage of Thai Sculpture.* New York.

Bosch, F. D. K.
1926. "Oudheden in Koetei," in *Oudheidkundig Verslag, Derde en Vierde Kwartaal 1925 (Quarterly Reports of the Archaeological Service of the Dutch East Indies 1925).*

Bowie, T., ed.
1972. *The Sculpture of Thailand.* New York.

Bulletin of The Cleveland Museum of Art, February 1974.

Bunker, E. C.
1971–72. "Pre-Angkor Period Bronzes from Pra Kon Chai," *Archives of Asian Art,* 25, pp. 67–76.

Chandra, L., and Rani, S.
1978. *Mudras in Japan.* New Delhi.

Coedès, G.
1932. "Note sur quelques sculptures provenant de Srideb (Siam)," in *Etudes d'orientalisme.* Paris.

Coomaraswamy, A. K.
1965. *History of Indian and Indonesian Art,* Dover ed. New York.

Czuma, S.
1980. "Mon-Dvaravati Buddha," *Bulletin of The Cleveland Museum of Art,* September.

Dalton, O. M.
1926. *The Treasure of the Oxus,* 2nd ed. London.

Dani, A. H.
1959. *Buddhist Sculpture in East Pakistan.* Karachi.

de Silva, P. H. D. H.
1976. *Illustrated Guide to the Colombo Museum.* Colombo.

Deneck, M. M.
1962. *Indian Sculpture: Masterpieces of Indian, Khmer and Cham Art.* London.

Dickinson, E., and Khandalavala, K.
1959. *Kishangarh Painting.* New Delhi.

Diskul, M. C. S., ed.
1980. "Srivijaya Art in Thailand," in *The Art of Srivijaya.* Oxford.

Dohanian, D. K.
1977. *The Mahayana Buddhist Sculpture of Ceylon.* New York.

Dowson, J.
1972. *A Classical Dictionary of Hindu Mythology,* 12th ed. London.

Dupont, P.
1955. *La Statuaire préangkorienne*. Ascona.
1959. *L'Archéologie mône de Dvaravati*. Paris.

Dwivedi, V. P.
1976. *Indian Ivories*. Delhi.

Ebeling, K.
1973. *Ragamala Painting*. Basel.

Foucher, A.
1918. *L'Art gréco-bouddhique de Gandhara,* vol. 2. Paris.

Francke, A. H.
1914. *Antiquities of Indian Tibet*. Archaeological Survey of India, New Imperial Ser., vol. 38. Calcutta.

Franz, H. G.
1978. "Der Buddistische Stupa in Afghanistan . . . ," *Afghanistan Journal,* 5, no. 1, pp. 26–38.

Frédéric, L.
1965. *The Art of Southeast Asia*. New York.

Getty, A.
1936. *Ganesa*. Oxford.

Ghosh, M.
1980. *Development of Buddhist Iconography in Eastern India*. New Delhi.

Giteau, M.
1965. *Khmer Sculpture*. New York.

Goetz, H.
1955. *The Early Wooden Temples of Chamba*. Leiden.

Gordon, D. H.
1958. *The Pre-historic Background of Indian Culture*. Bombay.

Goswami, C. L., transl.
1971. *Srimad Bhagavata Mahapurana,* parts 1 and 2. Gorakhpur.

Goswamy, B. N.
1975. *Pahari Paintings of the Nala-Damayanti Theme*. New Delhi.

Groslier, G.
1925. *La Sculpture khmère ancienne*. Paris.

Guide to Antiquities Found at Koo Bua, Rathuri. 1961. Bangkok.

Harle, J. C.
1974. *Gupta Sculpture*. Oxford.

Härtel, H., and Auboyer, J.
1971. *Indian und Südostasian*. Propyläen Kunstgeschichte, vol. 16. Berlin.

Heine-Geldern, R.
1925. *Altjavanische Bronzen*. Vienna.

Hutchins, F. G.
1980. *Young Krishna*. West Franklin, N.H.

In the Image of Man, exh. cat. 1982. Hayward Gallery, London.

Jeannerat, P.
1978. *Indian and South East Asian Art,* exh. cat. Spink & Son, Ltd., London.

Kak, R. C.
1923. *Handbook of the Archaeological and Numismatic Sections of the Sri Pratap Singh Museum*. Srinagar.

Khandalavala, K., and Chandra, M.
1969. *New Documents of Indian Painting: A Reappraisal*. Bombay.
1974. *An Illustrated Aranyaka Parvan in the Asiatic Society of Bombay*. Bombay.

Khandalavala, K., and Mittal, J.
1974. "The *Bhagavata* Mss from Palam and Isarda: A Consideration in Style," *Lalit Kala,* no. 16.

Klimburg-Salter, D.
1982. *The Silk Route and the Diamond Path*. Los Angeles.
In press. *The Kingdom of Bamiyan*. Boulder, Colo.

Krairiksh, P.
1977. *Art Styles in Thailand*. Bangkok.
1980. *Art in Peninsular Thailand Prior to the Fourteenth Century* A.D. Bangkok.

Kramrisch, S.
1929. "Pala and Sena Sculpture," *Rupam,* no. 40, October.
1960. *Indian Sculpture in the Philadelphia Museum of Art*. Philadelphia.
1964. *The Art of Nepal*. New York.
1981. *Manifestations of Shiva*. Philadelphia.

Lal, B. B.
1951. "Further Copper Hoards from the Gangetic Basin and a Review of the Problem," *Ancient India: Bulletin of the Archaeological Survey of India,* no. 7, January.
1971–72. "A Note on the Excavation at Saipai," *Puratattva: Bulletin of the Indian Archaeological Society,* no. 5.

Le Bonheur, A.
1971. *La Sculpture indonésienne au Musée Guimet.* Paris.

Lee, S.
1975. *Asian Art: Selections from the Collection of Mr. and Mrs. John D. Rockefeller 3rd,* part 2. New York.

Lerner, M.
1975a. *Bronze Sculptures from Asia.* New York.
1975b. In *Notable Acquisitions 1965–1975.* The Metropolitan Museum of Art, New York. (Note that the same publication data apply to the vols. of *Notable Acquisitions* cited below.)
1976. "Treasures of South Asian Sculpture," *Connoisseur,* November.
1979. In *Notable Acquisitions 1975–1979.*
1980. In *Notable Acquisitions 1979–1980.*
1981. In *Notable Acquisitions 1980–1981.*
1982a. In *Along the Ancient Silk Routes,* exh. cat. The Metropolitan Museum of Art, New York.
1982b. "A Bronze Uma-Mahesvara in The Metropolitan Museum of Art," *Lalit Kala,* no. 20.
1982c. In *Notable Acquisitions 1981–1982.*

Loth, A. M.
1972. *La Vie publique et privée dans l'Inde ancienne,* vol. 9: *Les Bijoux.* Paris.

Luce, G. H.
1969–70. *Old Burma–Early Pagan.* 3 vols. New York.

Lyons, I., and Ingholt, H.
1957. *Gandharan Art in Pakistan.* New York.

Malleret, L.
1960. *L'Archéologie du Delta du Mékong,* vol. 2. Paris.
1963. *L'Archéologie du Delta du Mékong,* vol. 4. Paris.

Mallmann, M. T. de
1948. *Introduction à l'étudʳ d'Avalokitecvara.* Paris.

Marshall, J.
1951. *Taxila,* vol. 3: Plates. Cambridge.

Mayuyama, Seventy Years, vol. 2. 1976. Tokyo.

Mitra, D.
1977. *Pandrethan, Avantipur and Martand.* New Delhi.
1982. *ᴊronzes from Bangladesh.* Delhi.

Pal, P.
1967–68. "The Iconography of Cintamani Cakra Avalokitesvara," *Journal of the Indian Society of Oriental Art,* n.s. 2.
1969. *The Art of Tibet.* New York.
1970. *Vaisnava Iconology in Nepal.* Calcutta.
1974. *The Arts of Nepal: Sculpture.* Leiden.
1975a. *Bronzes of Kashmir.* New York.
1975b. *Nepal: Where the Gods are Young.* New York.
1977. *The Sensuous Immortals.* Los Angeles.
1978a. *The Arts of Nepal: Painting.* Leiden.
1978b. *The Ideal Image.* New York.
1979. "A Kushan Indra and Some Related Problems," *Oriental Art,* n.s. 25, no. 2, Summer.
1982. *Indian Paintings in the Los Angeles County Museum of Art.* New Delhi.

Paranavitana, S.
1971. *Art of the Ancient Sinhalese.* Colombo.

Parimoo, R.
1974. "A New Set of Early Rajasthani Paintings," *Lalit Kala,* no. 17.

Paul, P. G.
1979. "Some Terracotta Plaques from the Swat-Indus Region," *South Asian Archaeology,* pp. 411–28.

Pelliot, P.
1924. *Les Grottes de Touen-Houang,* vol. 6. Paris.

Polsky, C. H., and McInerney, T.
1982. *Indian Paintings from the Polsky Collections.* Princeton, N.J.

Prachoom, K.
1969. *Buddha Images.* Bangkok.

Quaritch Wales, H. G.
1937. "The Exploration of Sri Deva," in *Annual Bibliography of Indian Archaeology for the Year 1935,* vol. 10. Leiden.

Randhawa, M. S.
1959. *Basohli Painting.* Delhi.

Rao, T. A. G.
1968. *Elements of Hindu Iconography,* vol. 2, part 2, 2nd ed. Delhi.

Rarities of the Musée Guimet. 1975. Asia House, New York.

Rowland, B.
1963. *The Evolution of the Buddha Image.* New York.

Saunders, E. Dale
1960. *Mudra.* New York.

Sharma, B. N.
1979. "Pala Bronzes from Fatehpur, Gaya," *East and West,* n.s. 29, December.

Sharma, R. C.
1976a. *Mathura Museum and Art,* 2nd rev. and enl. ed. Mathura.
1976b. "New Buddhist Sculptures from Mathura," *Bulletin, Government Museum, Mathura,* no. 17–18, June–December.

Shere, S. A.
1956. *Select Buddhist Sculptures in Patna Museum.* Patna.

Shiveshwarkar, L.
1967. *The Pictures of Chaurapanchasika.* New Delhi.

Sivaramamurti, C.
1963. *South Indian Bronzes.* New Delhi.

6 Soi Kasemsan 11: An Illustrated Survey of the Bangkok Home of James H. W. Thompson, 2nd rev. ed. 1962. Bangkok.

Skelton, R.
1961. *Indian Miniatures from the XVth to XIXth Centuries.* Venice.

Snellgrove, D. L., ed.
1978. *The Image of the Buddha.* Tokyo.

Snellgrove, D. L., and Skorupski, T.
1977. *The Cultural Heritage of Ladakh,* vol. 1. Boulder, Colo.

Soper, A. C.
1959. *Literary Evidence for Early Buddhist Art in China.* Ascona.

Spink, W.
1971. *Krishnamandala.* Ann Arbor, Mich.

Stoler Miller, B., ed.
In press (1984). *The Ring of Memory: Plays of Kalidasa.* New York.

Taddei, M.
1970. *India.* Ancient Civilizations Series. London.

Tokiwa, D., and Sekino, T.
1925–26. *Buddhist Monuments in China,* Plates, part 2. Tokyo.

Tucci, G.
1973. *Transhimalaya.* Geneva.

van Lohuizen-de Leeuw, J. E.
1982. *Some Buddhist Sculptures and Indian Paintings,* exh. cat. J. Polak Gallery, Amsterdam.

"Unique Early Cambodian Sculptures Discovered,"*Illustrated London News,* August 28, 1965, p. 37.

Vogel, J. Ph.
1912. "Naga Worship in Ancient Mathura," in *Archaeological Survey of India: Annual Report, 1908–1909.* Calcutta.
1925. *The Influences of Indian Art.* London.
1930. *La Sculpture de Mathura.* Paris and Brussels.

von Schroeder, U.
1981. *Indo-Tibetan Bronzes.* Hong Kong.

Waldschmidt, E., and Waldschmidt, R. L.
1967. *Miniatures of Musical Inspiration,* part 1. Berlin.
1975. *Miniatures of Musical Inspiration,* part 2. Berlin.

Welch, S. C., and Beach, M. C.
1965. *Gods, Thrones, and Peacocks.* New York.

Wijesekera, N.
1962. *Early Sinhalese Sculpture.* Colombo.

Williams, J.
1975. "Sarnath Gupta Steles of the Buddha's Life," *Ars Orientalis,* 10.

Woodward, H. W., Jr.
1981. "Tantric Buddhism at Angkor Thom," *Ars Orientalis,* 12.

Yazdani, G.
1930. *Ajanta,* Plates, part 3. Oxford.

Zimmer, H.
1955. *The Art of Indian Asia,* vol. 2. New York.

List of Works of Art

Catalogue numbers are given in
italic, followed by page numbers.

Sculpture and carvings

A

Amitayus, the Buddha of Eternal Life, seated; northern Burma(?), ca. 11th–12th century; *25*, 70

Anthropomorphs; India, ca. 1500 B.C.; *1*, 16

Ashtamahabhaya Tara, eight-armed, standing; India, 10th–11th century; *28,* 80

B

Bangle; India, 9th–10th century or earlier; *22*, 64

Battle standard(?); Cambodia, 11th–12th century; *49*, 128

Bodhisattva(?), head of a; India, 3rd–4th century; *11*, 42

Bodhisattva, head of a; Thailand, 8th century; *36,* 102

The Bodhisattva Avalokiteshvara seated in meditation; India, 2nd century; *7,* 30

Bodhisattva Maitreya or Avalokiteshvara, standing; Thailand, 7th–8th century; *35,* 100

Bodhisattva Vajrapani (seated); Indonesia, 9th century; *44*, 118

Bodhisattva Vajrapani(?) (seated); Indonesia, 9th–10th century; *45*, 120

Bodhisattva Vajrapani, standing; Nepal, 6th–7th century; *16*, 52

Buddha, head of; Sri Lanka, ca. 5th century; *12*, 44

Buddha, head of; Thailand, 9th century; *39*, 108

Buddha, seated; Cambodia or Vietnam, 7th century; *34*, 98

Buddha, seated; Sri Lanka, ca. 7th century; *13*, 46

Buddha, seated; India, 8th century; *19*, 58

Buddha, seated; Burma or northeast India, 11th–12th century; *24*, 68

Buddha, standing; Thailand, 8th–9th century; *38*, 106

The Buddha Akshobhya; Bangladesh, 8th century or later; *21*, 62

Buddhist trinity; Indonesia, ca. 8th century; *41*, 112

C

Central Asian female; Pakistan, 4th–5th century; *9*, 38

Chalice; India, 2nd–4th century; *5*, 26

Chalice; India, 9th–10th century or earlier; *22*, 64

Conch shells, carved; northern India, ca. 11th–12th century or earlier; *29*, 82

Crown, five-paneled ritual; Nepal, 14th–15th century, *32*, 92

D

Deity, bust of a (perhaps Kubera); Cambodia or Vietnam, 7th century; *33*, 94

Deity, female; Pakistan, ca. 2nd–3rd century; *4*, 24

Deity, female, standing (perhaps Tara); India, 11th century; *23*, 66

Deity, male, head of a; Indonesia, ca. 14th century; *54*, 138

Diadem with *kinnaris*; India or Pakistan, 9th–10th century; *27*, 78

E

Earring(?) with male head; Pakistan, ca. 4th century; *6*, 28

Earrings, pair of royal; India, ca. 1st century B.C.; *2*, 20

G

Ganesha, four-armed, seated; Indonesia, 9th century; *43*, 116

Ganesha, kneeling; Thailand or Cambodia, 12th century; *51*, 132

Ganesha, seated; Thailand, ca. 15th century; *55*, 140

Garuda, kneeling; Nepal, ca. 11th century; *18*, 56

Garuda finial; Thailand, ca. 13th century; *52*, 134

H

Harpoons; India, ca. 1500 B.C.; *1*, 16

Heads (three); Pakistan, 4th–5th century; *9*, 38

J

Jali screen; India, ca. 1631–48; *60*, 156

K

Kubera, four-armed, seated; Indonesia, 10th century or later; *46*, 122

M

Mahakala; Indonesia, 11th–12th century; *48*, 126

Male with mustache; Pakistan, 4th–5th century; *9*, 38

N

Nagaraja and *Nagini* (Serpent King and consort); India, 5th century; *14*, 48

P

Padmapani Lokeshvara, standing; Indonesia, 9th–10th century; *42*, 114

Patron goddess of a city; Pakistan, 4th–5th century; *9*, 38

Prajnaparamita(?), the Goddess of Transcendent Wisdom, seated; Thailand, 12th–13th century; *50*, 130

Prajnaparamita, the Goddess of Transcendent Wisdom, standing; Thailand, ca. 10th century; *40*, 110

R

Reliquary; Thailand, 7th–9th century; *37*, 104

Reliquary(?) with scenes from the life of the Buddha; India or Pakistan, 9th–10th century; *26*, 72

Rondel with seated Hariti; Pakistan, 1st–2nd century; *3*, 22

S

Shrine, Buddhist; Thailand, ca. 13th century; *53*, 136

Shrine, section of a portable, with scenes from the life of the Buddha; Pakistan, ca. 5th–6th century; *10*, 40

T

Tara, seated; Bangladesh, 8th century; *20*, 60

V

Vishnu, four-armed, standing; India, 7th century; *15*, 50

Vishnu, four-armed, standing; Nepal, 10th century; *17*, 54

W

Water spout in the form of a *makara*; Indonesia, ca. 10th–11th century; *47*, 124

Y

Yakshi, standing; India, 2nd–3rd century; *8*, 36

Paintings

A

The Absent Lovers; India, Punjab Hills, Mankot(?), ca. 1710 – 25; *64*, 170

B

Bakasura Disgorges Krishna; India, Rajasthan, Bikaner, ca. 1690; *67*, 176

Balarama Carried by the Demon Pralamba; India, Delhi-Agra area(?), ca. 1560 – 65; *58*, 148

Battle scene, fragment from an unidentified; India, Delhi area(?), ca. 1540; *57, 146*

Bhadrakali Standing on the Corpse of a Giant Brahmin; India, Punjab Hills, Basohli, ca. 1660 – 70; *61*, 158

D

Dakshina Gurjari Ragini; India, 1605 – 1606; *59*, 152

Desvarati Ragini; India, 1605 – 1606; *59*, 152

F

Floral decoration; India, Rajasthan, Jaipur(?), ca. 1800; *70*, 182

G

The Gods and the Earth Cow Pray for the Assistance of Vishnu; India, Delhi (Palam?), ca. 1540; *56*, 142

The Gundalao Lake and the Environs of the City of Kishangarh; India, Rajasthan, Kishangarh, ca. 1760 – 65; *69*, 180

K

King Bhima Learns of Damayanti's Condition; India, Punjab Hills, Kangra, ca. 1830; *66*, 174

Krishna and Radha; India, Rajasthan, Bundi(?); 17th – 18th century, *68*, 178

M

Madhava Ragaputra; India, Punjab Hills, Bilaspur, ca. 1680 – 90; *62*, 164

Manuscript cover with scenes from the life of the Buddha; India, 9th century; *30*, 86

Manuscript cover with scenes from Kalidasa's play, *Shakuntala;* Nepal, 12th century; *31*, 90

Matsya Slaying the Conch Demon; India, Punjab Hills, probably Mankot, ca. 1690 – 1710; *63*, 166

P

Parashurama Slaying Karthavirya; India, Punjab Hills, probably Mankot, ca. 1690 – 1710; *63*, 166

R

Rama, Sita, and Lakshmana in the Forest; India, Punjab Hills, Kangra, ca. 1800 – 1825; *65*, 172

W

Worship of the Devi as the Blessed Dark Goddess Bhadrakali; India, Punjab Hills, Basohli, ca. 1660 – 70; *61*, 158